I was a bad girl - please punish me !

Spanking & BDSM Pictures from the early times of nude photography

Jürgen Prommersberger: I was a bad girl – Please punish me !
Regenstauf, Januar 2016

All rights reserved:
Jürgen Prommersberger
Händelstr 17
93128 Regenstauf

First Edition by
CreateSpace Independent Publishing Platform

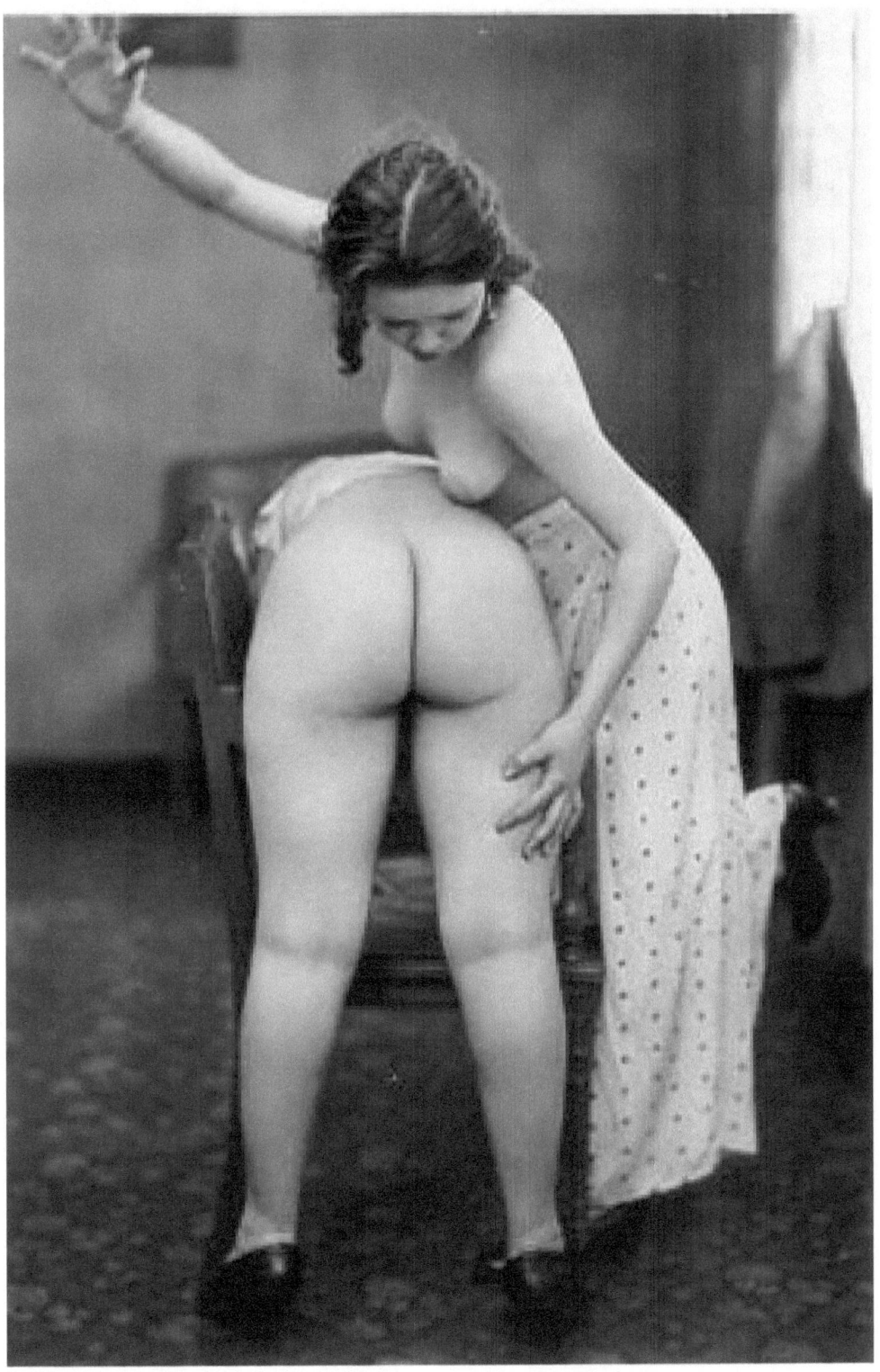

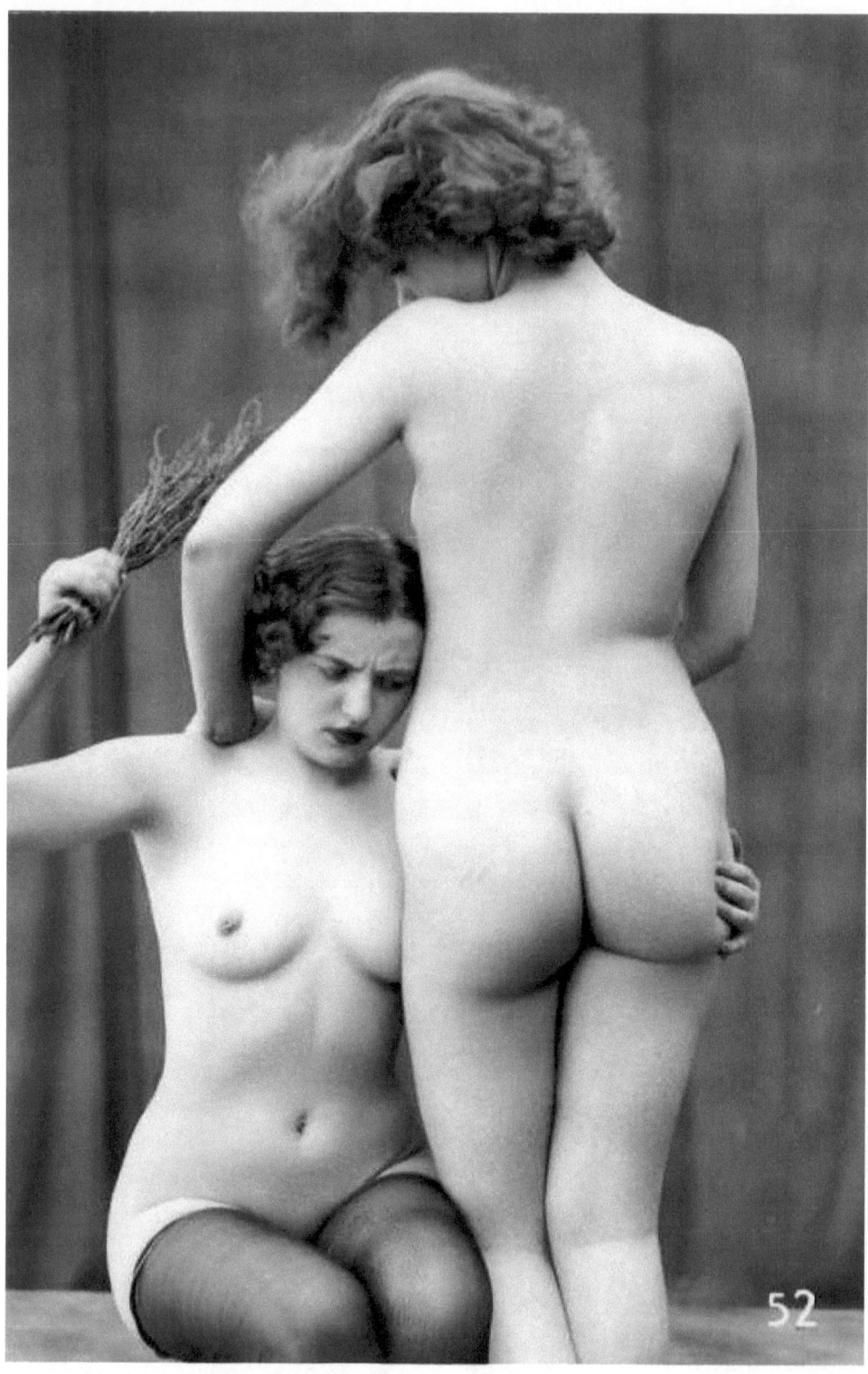

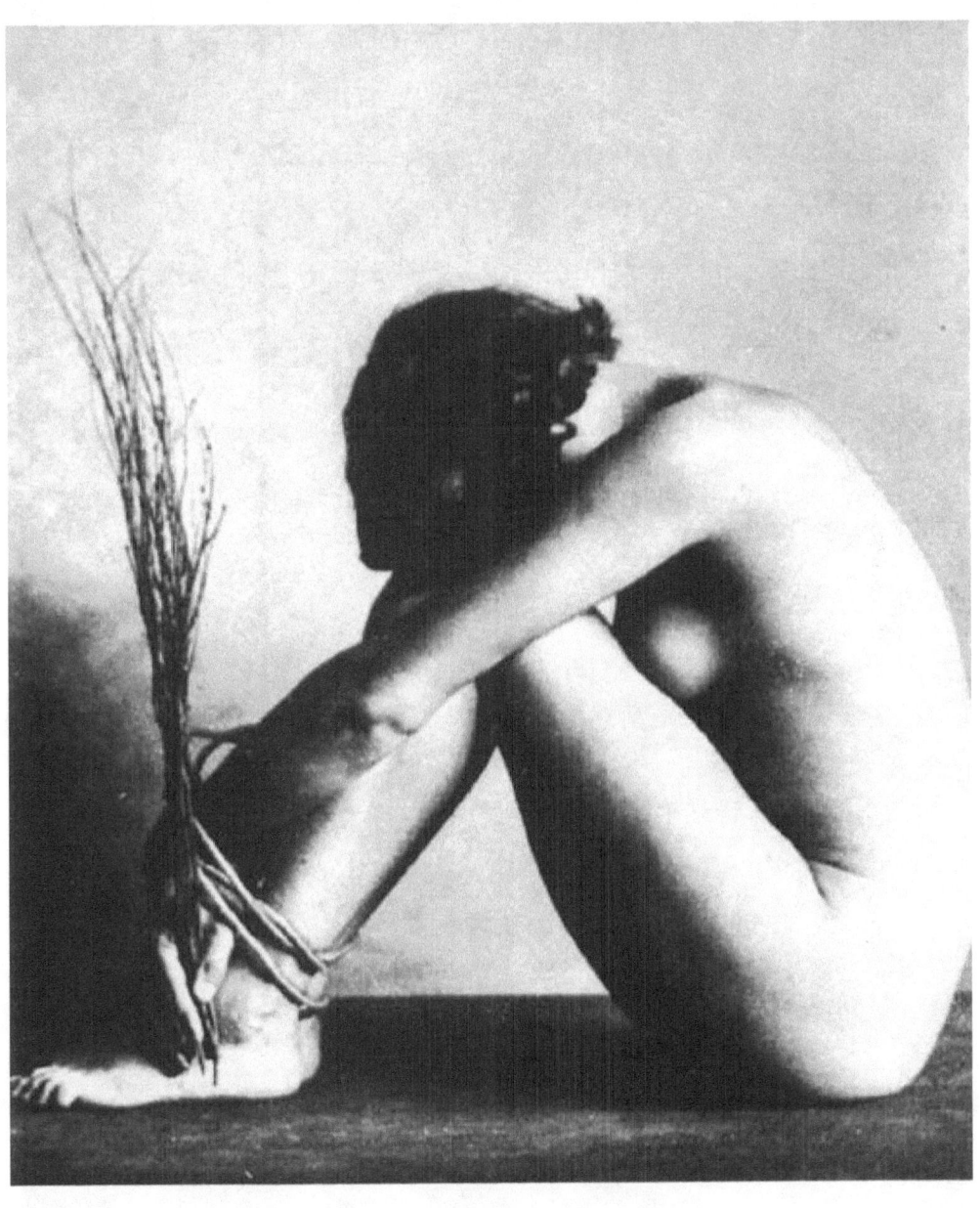

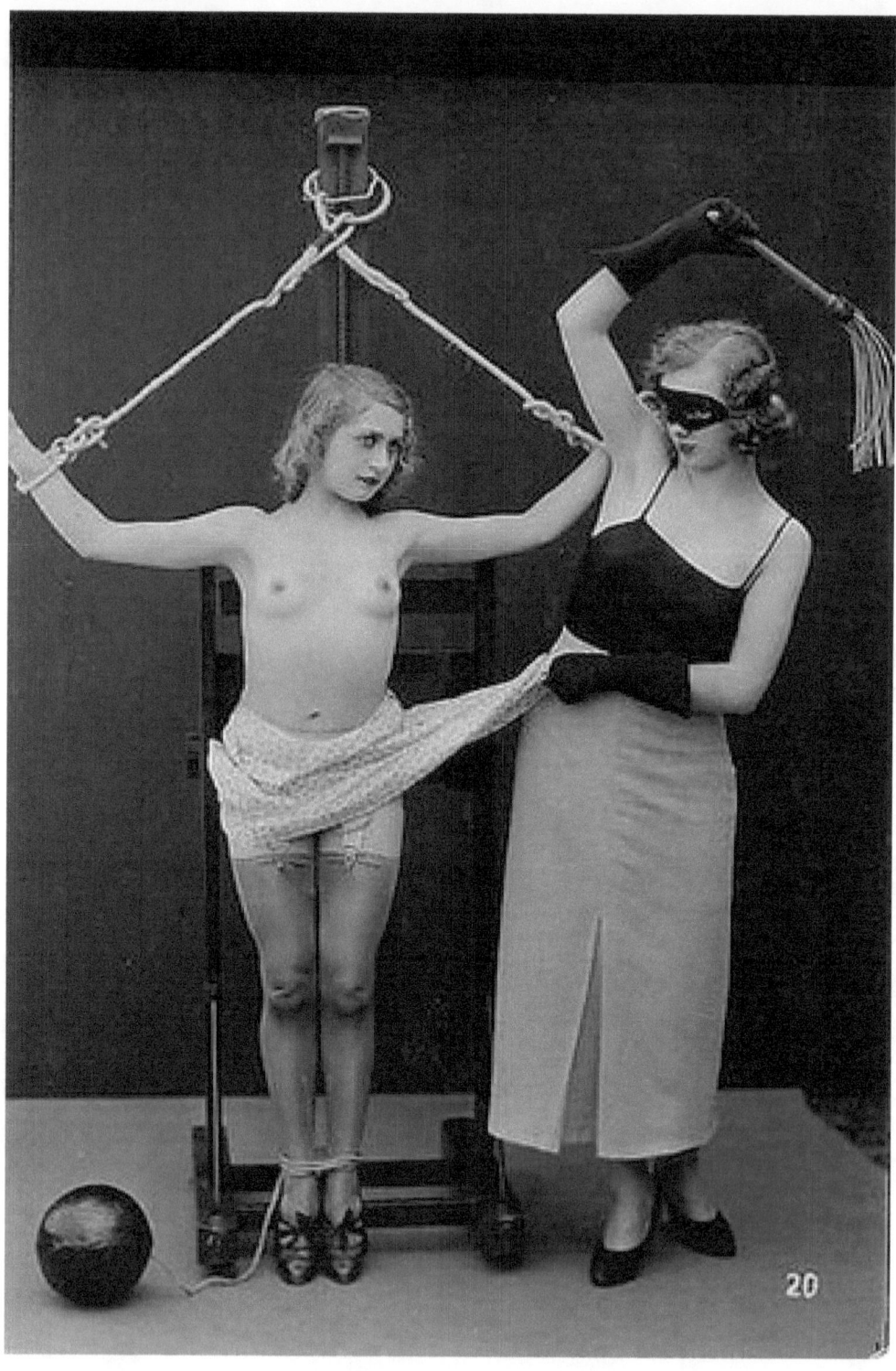

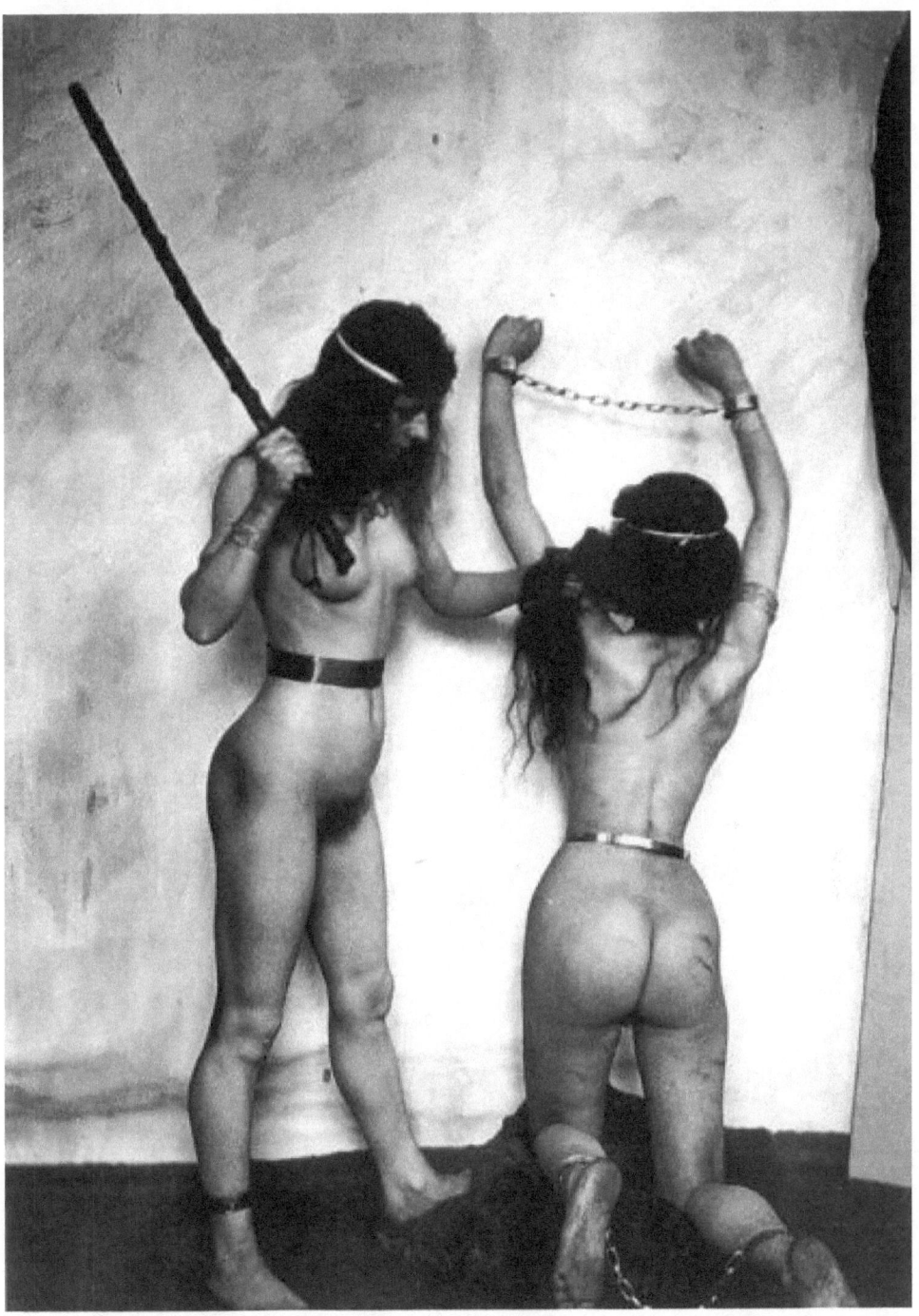

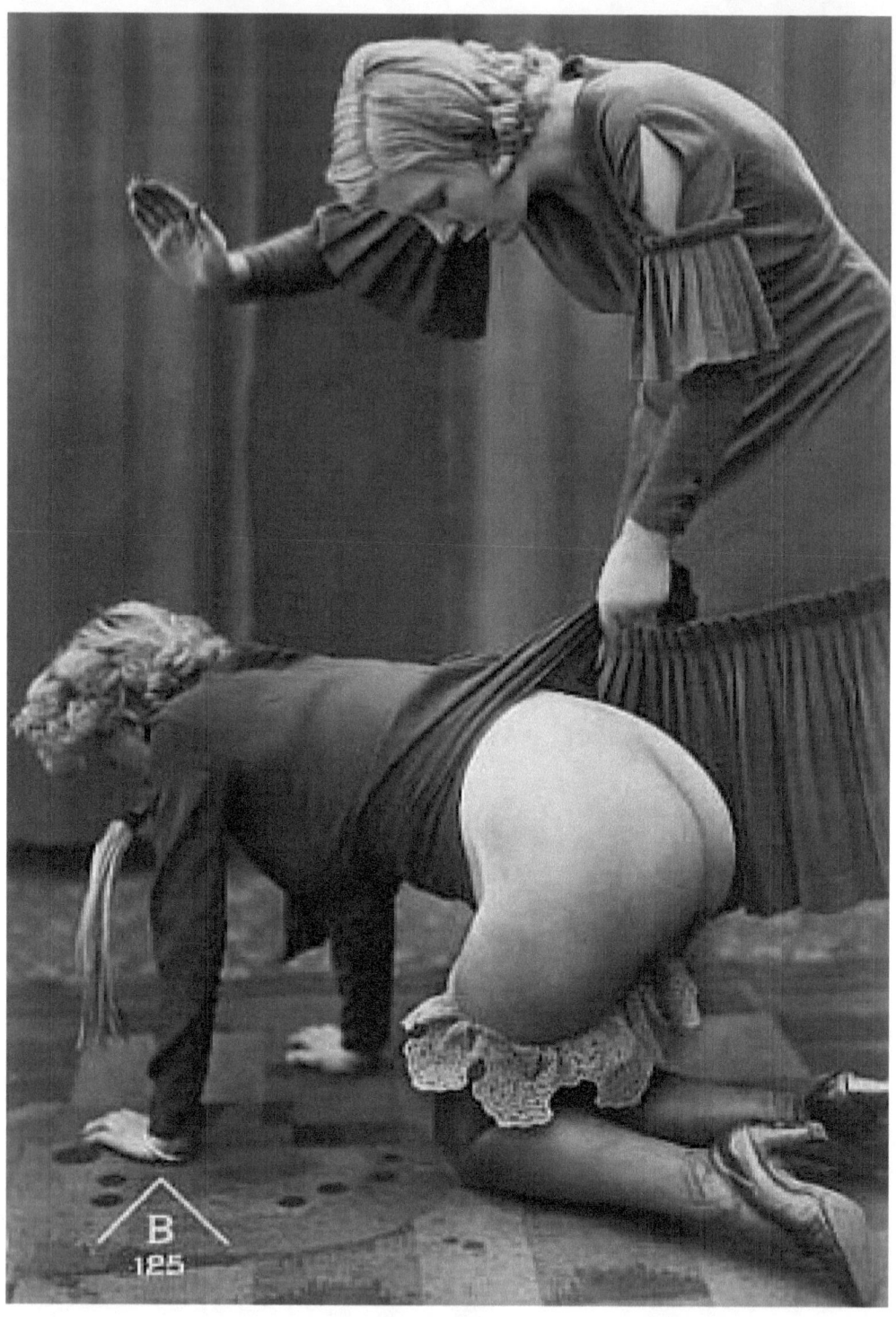

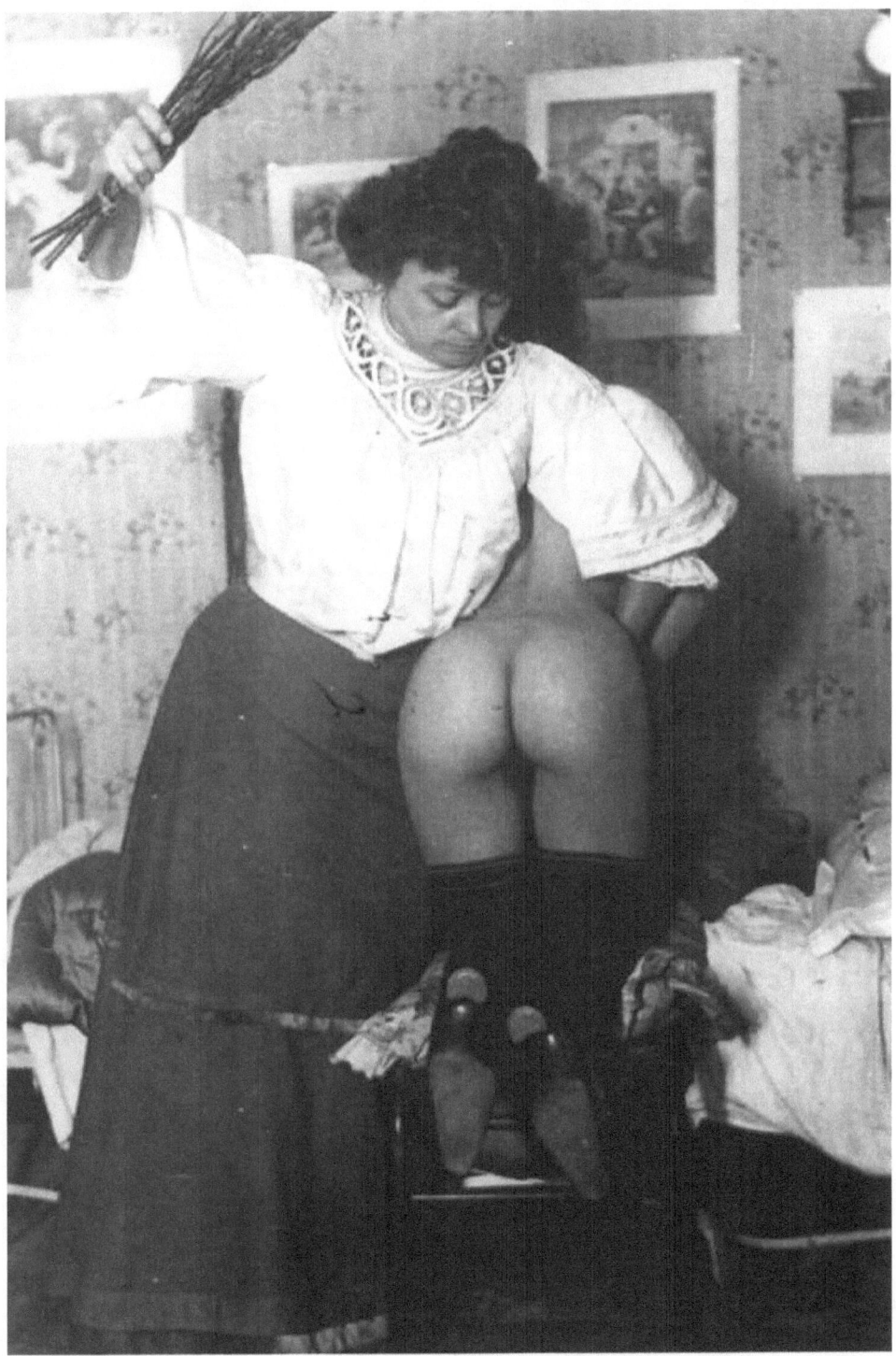

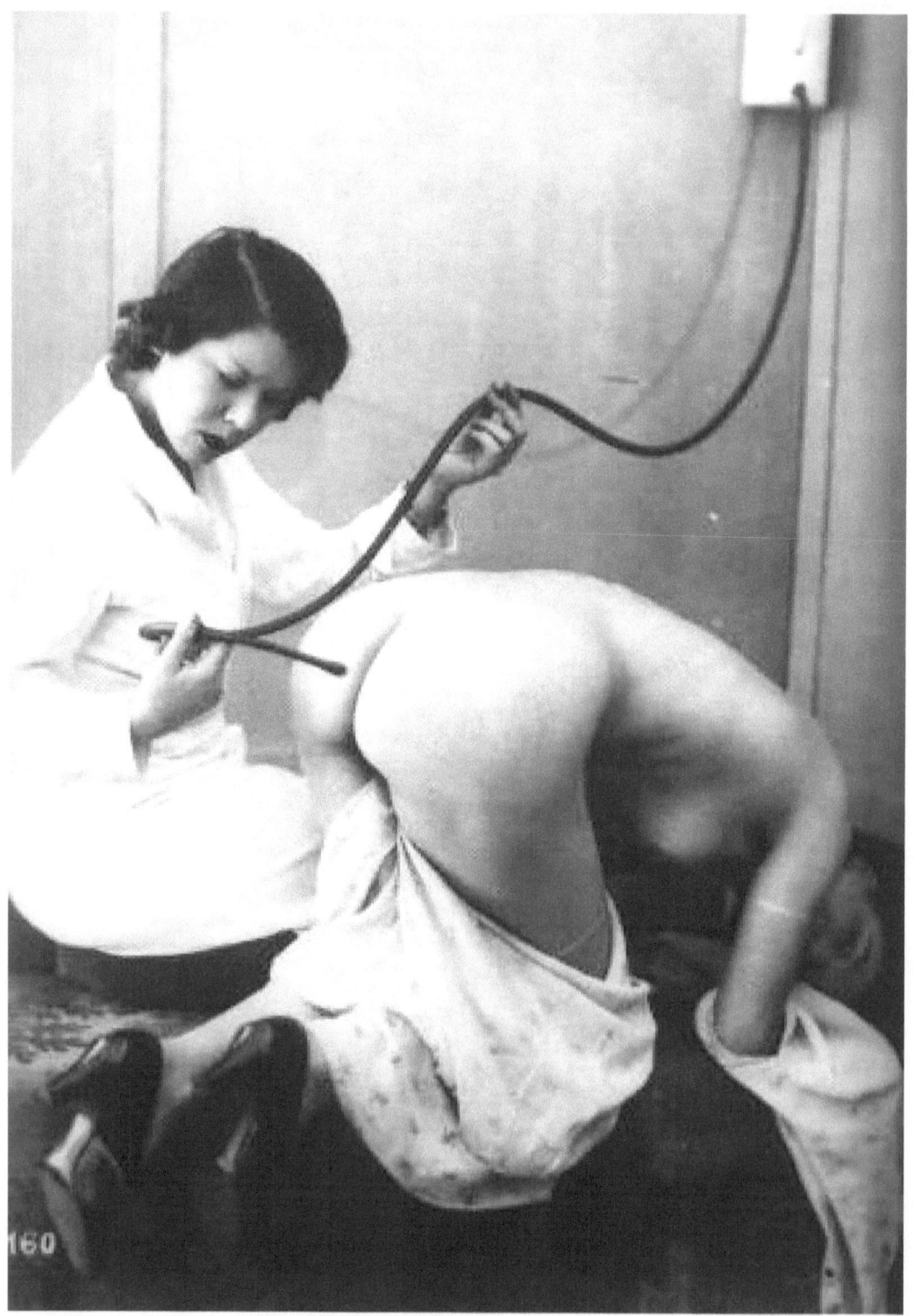

10

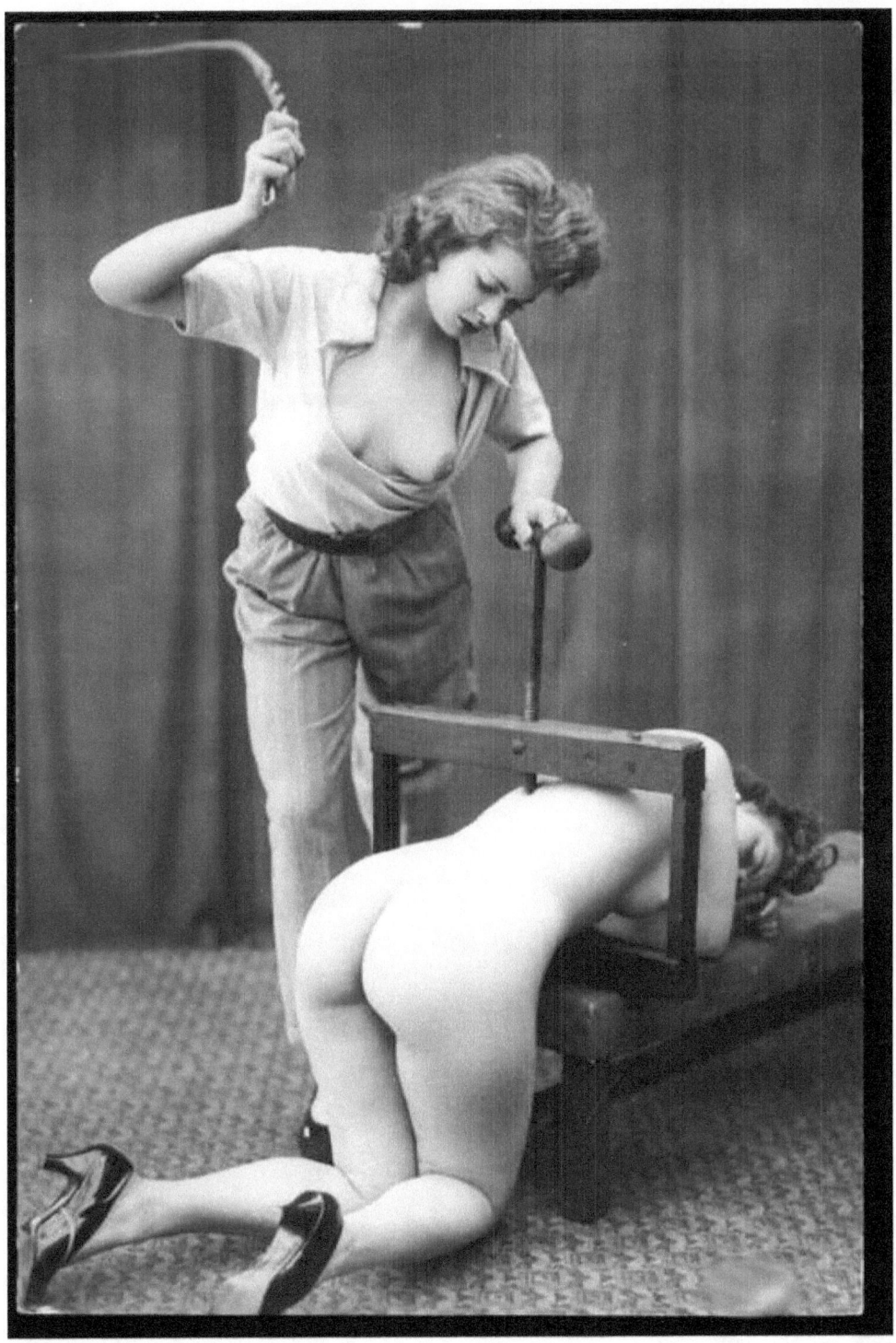

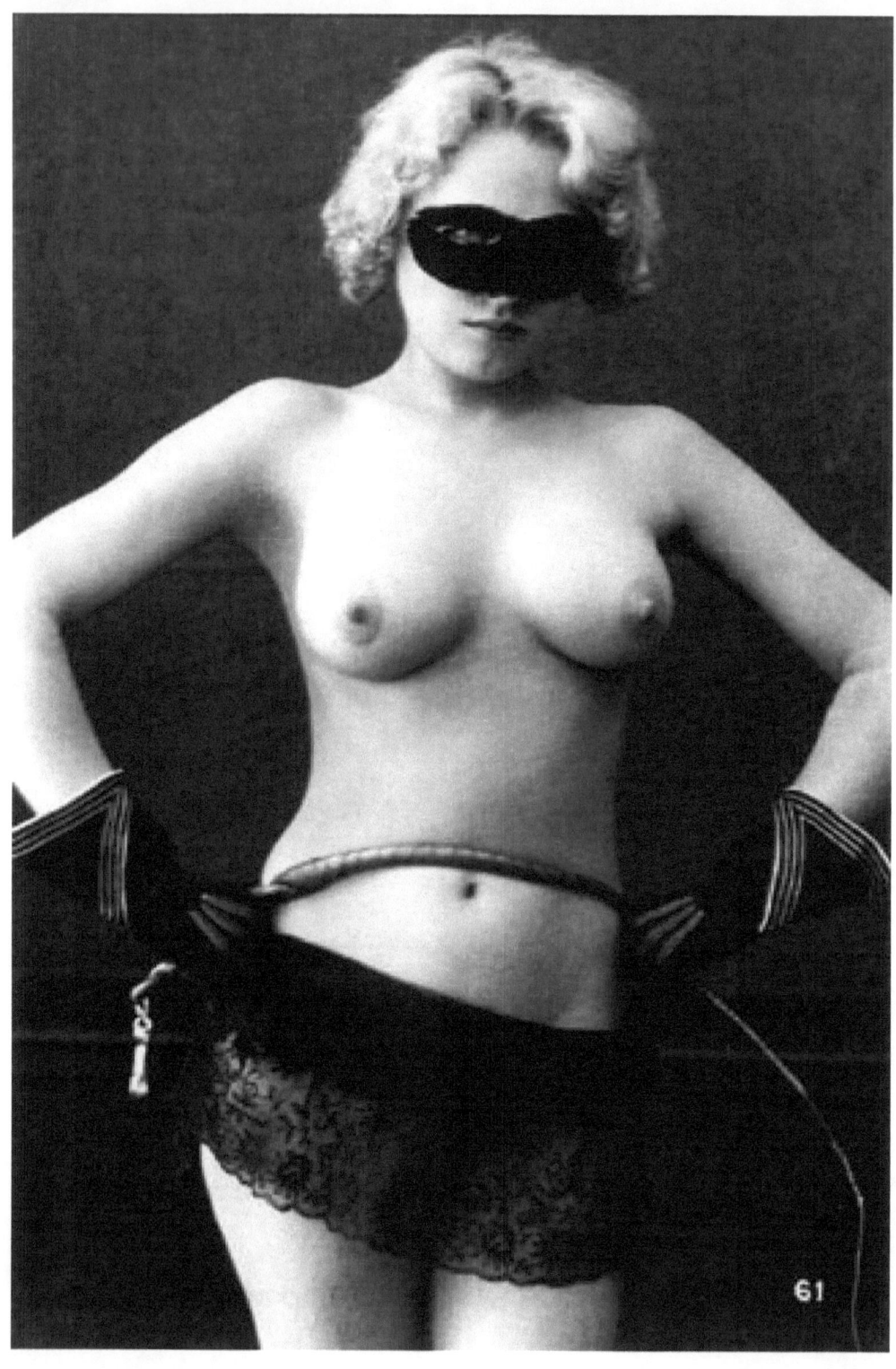

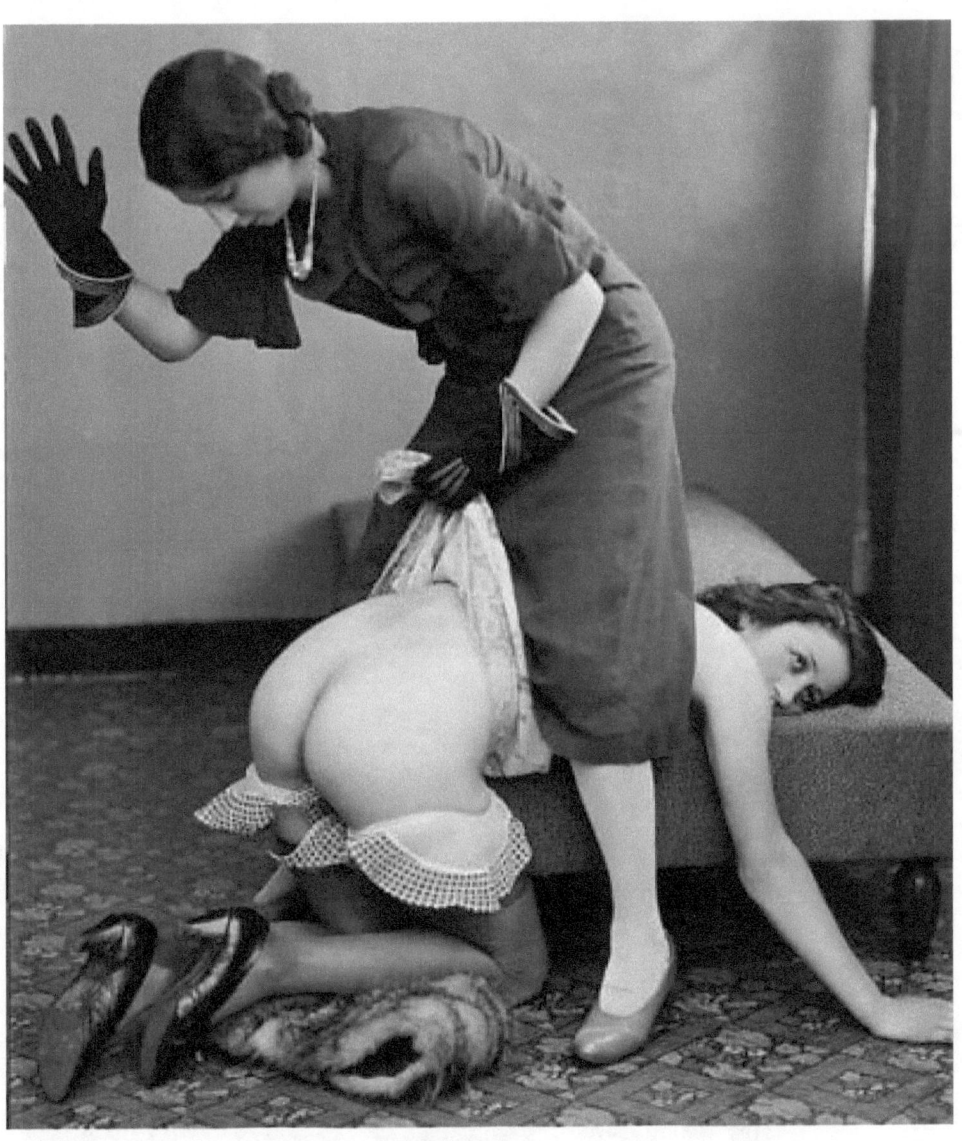

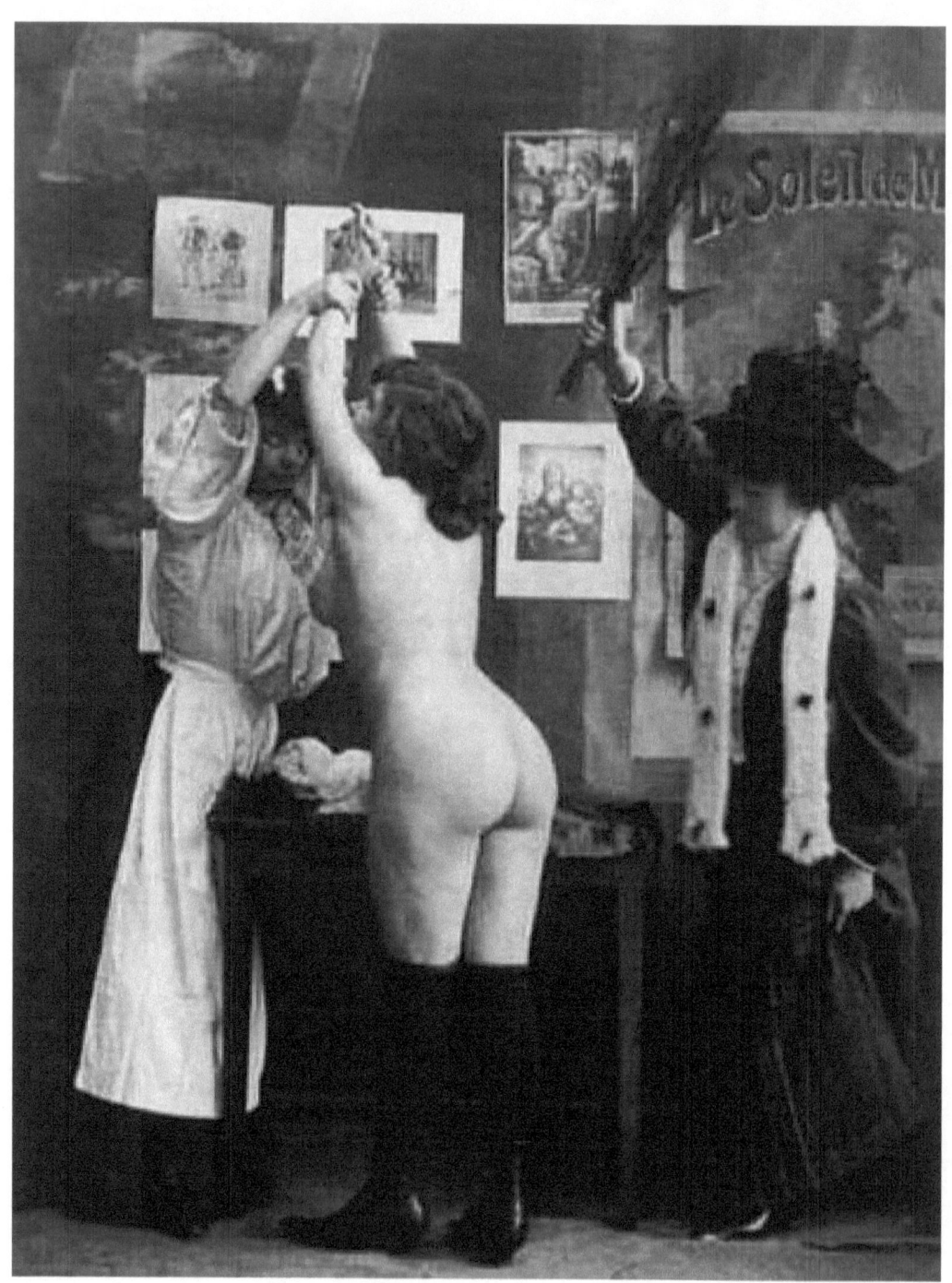

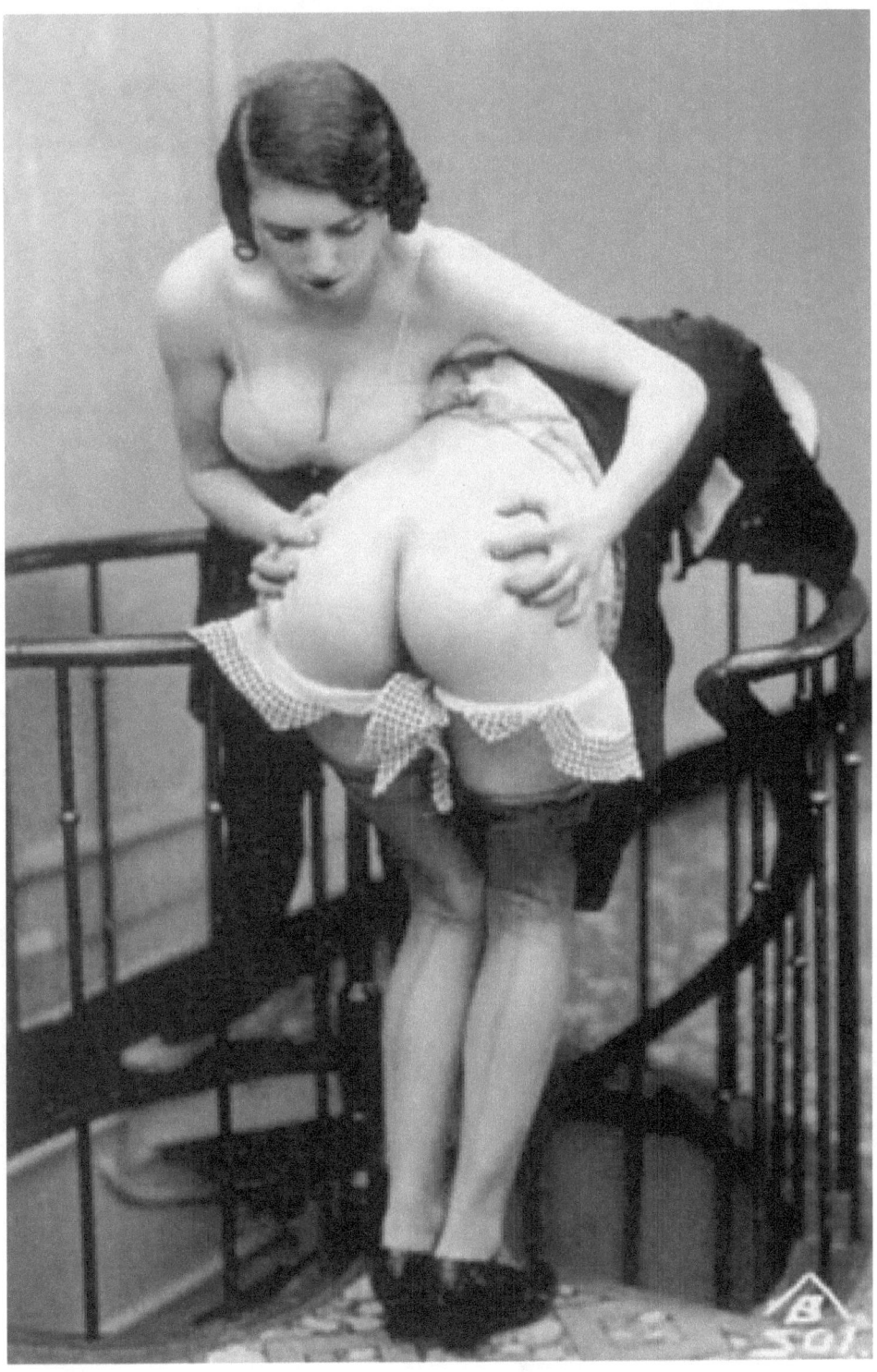

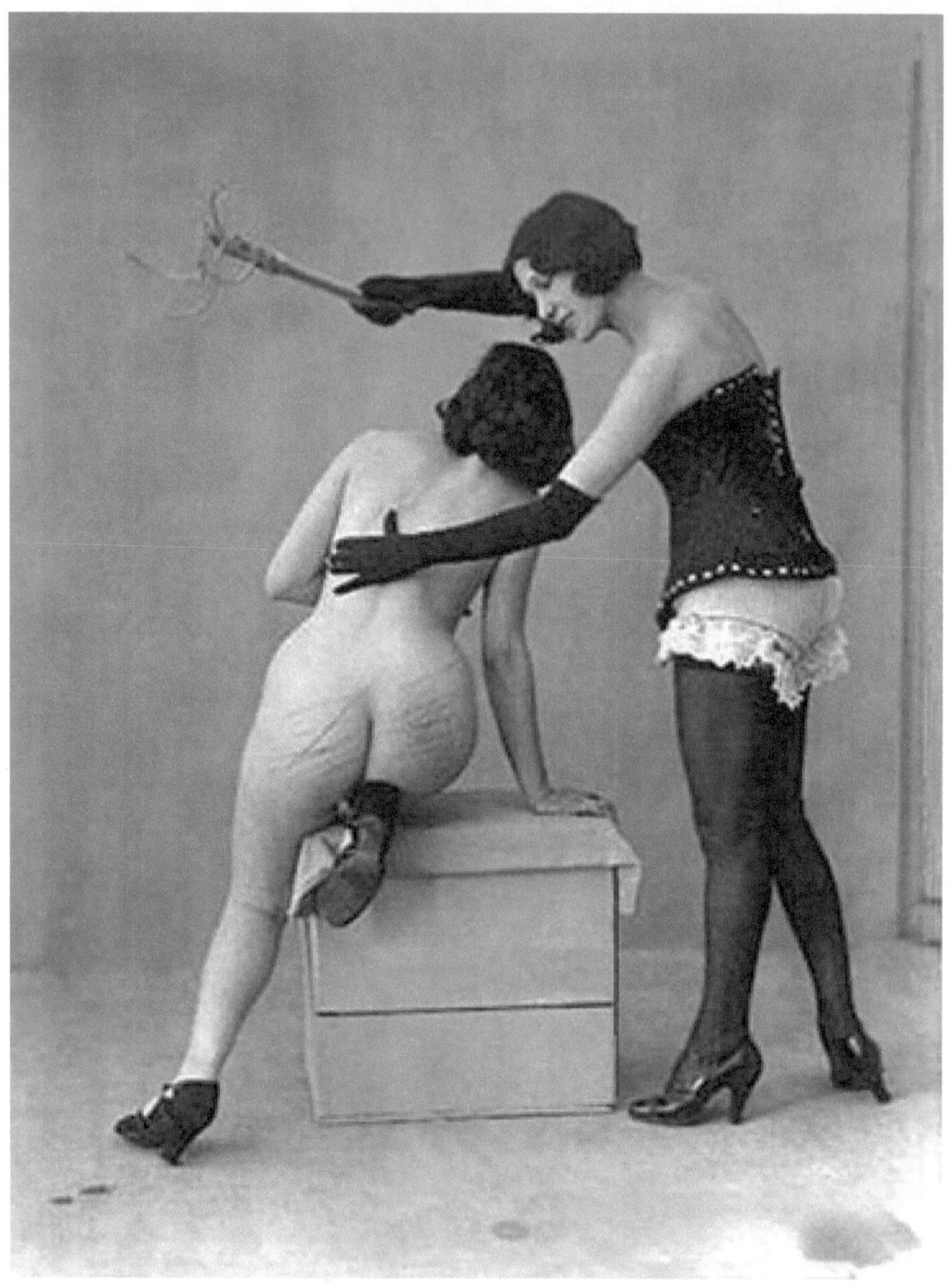

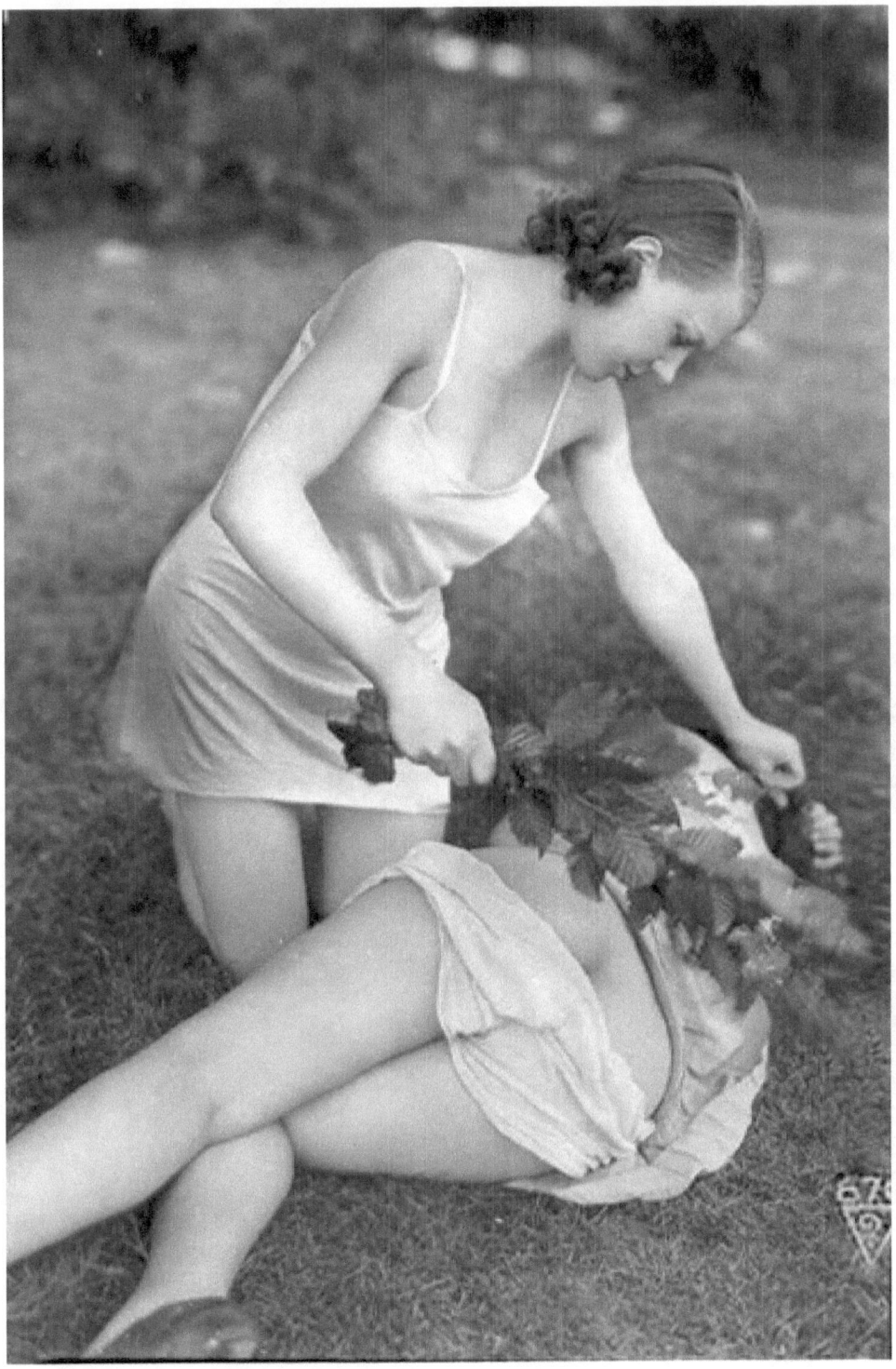

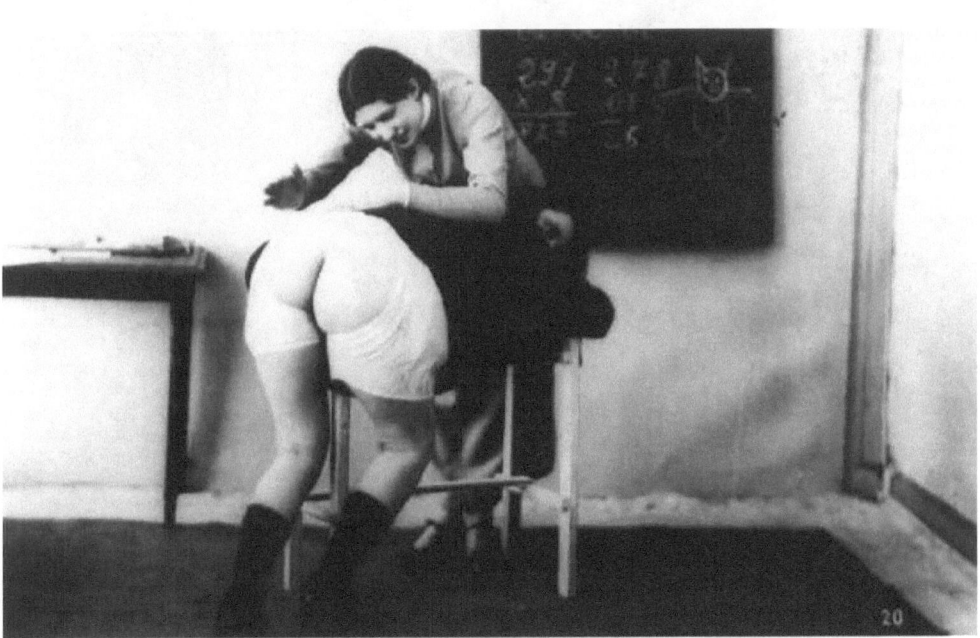

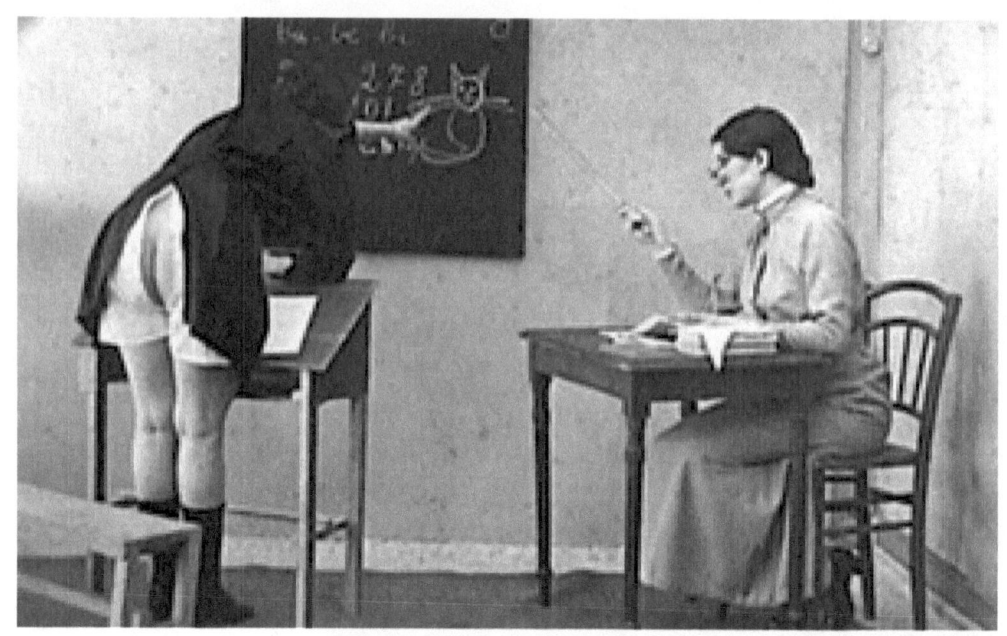

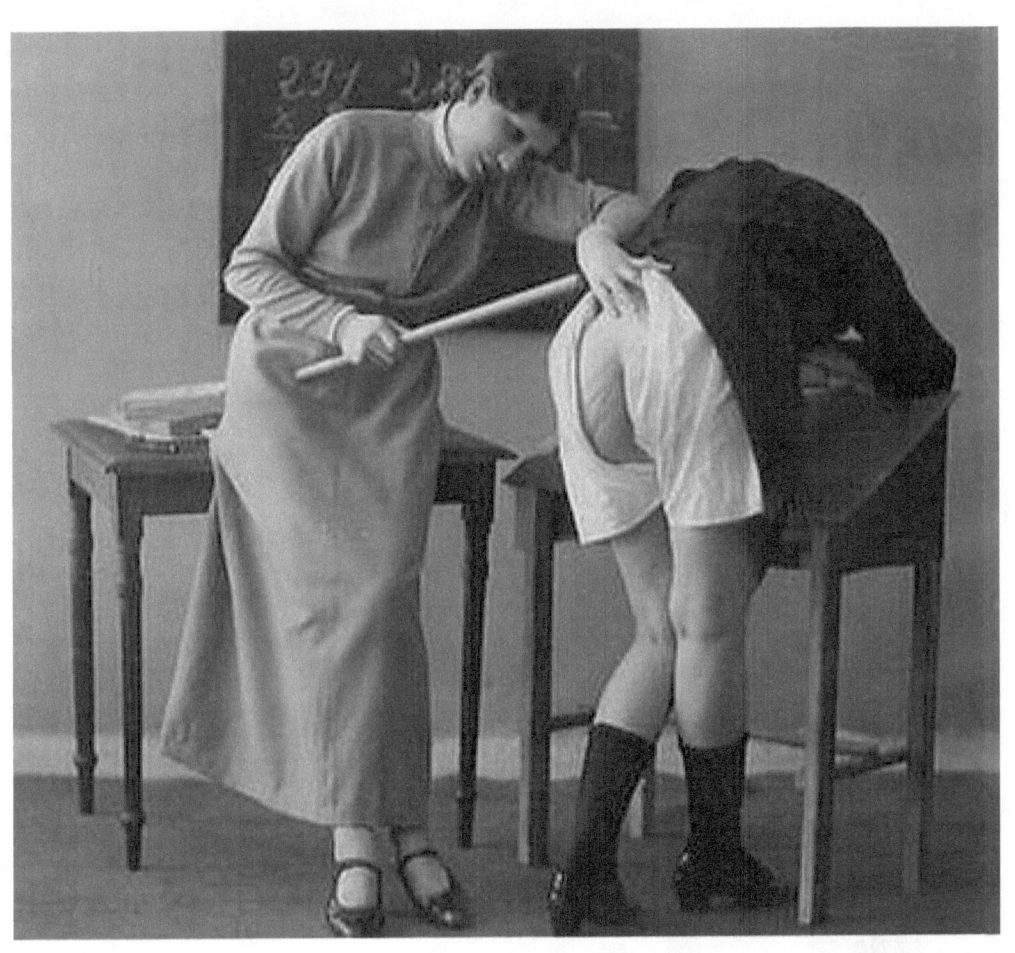

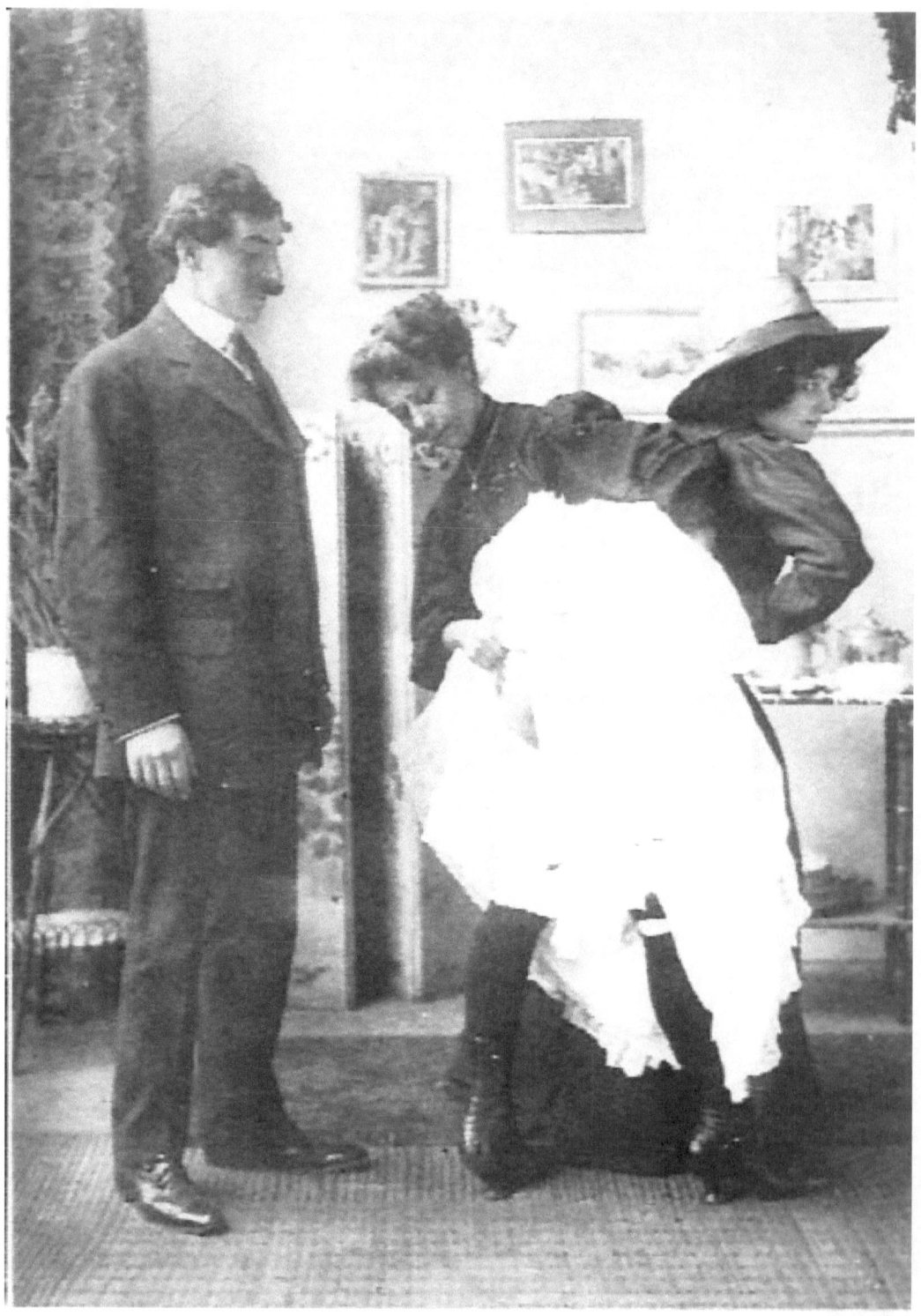

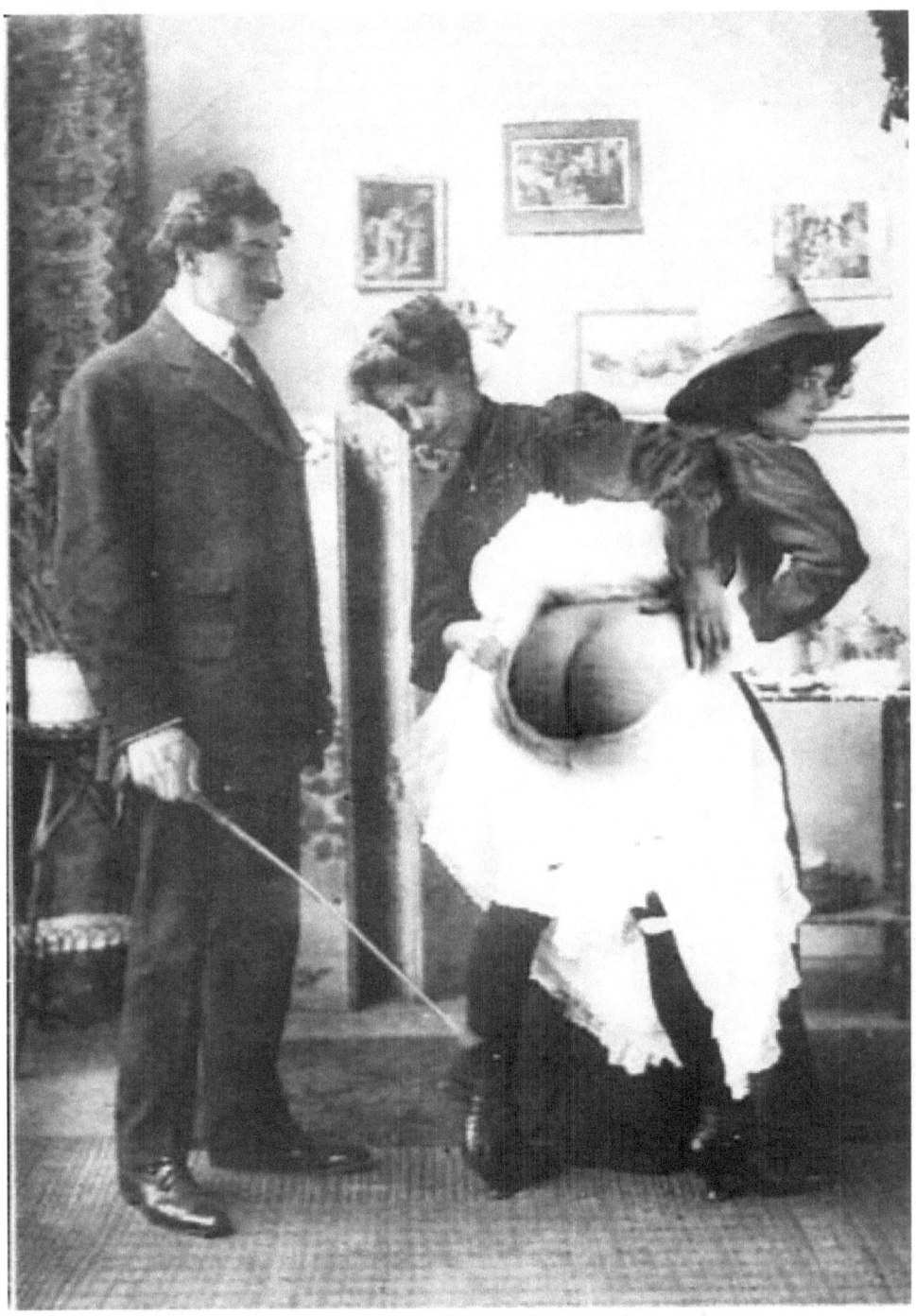

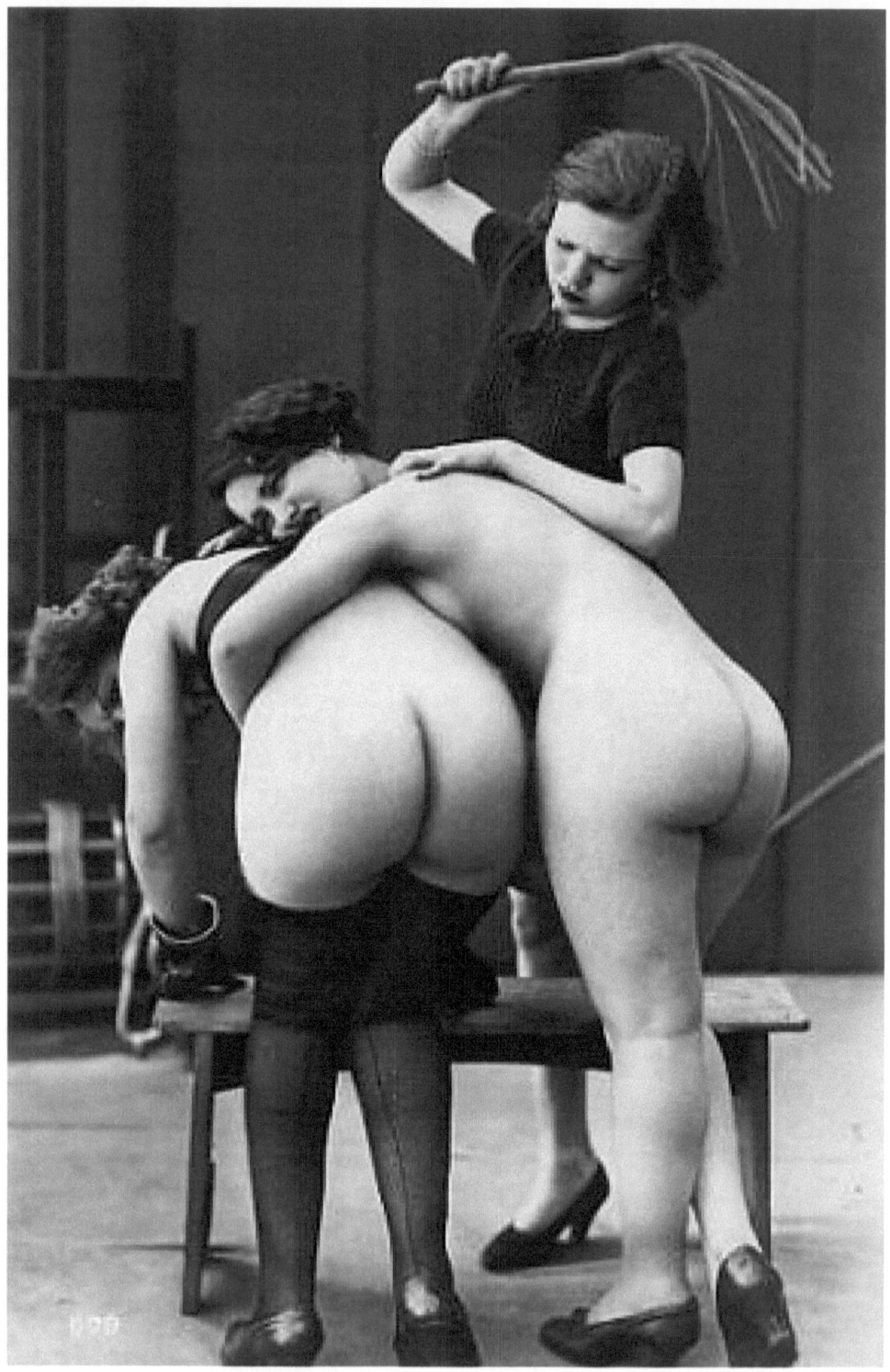

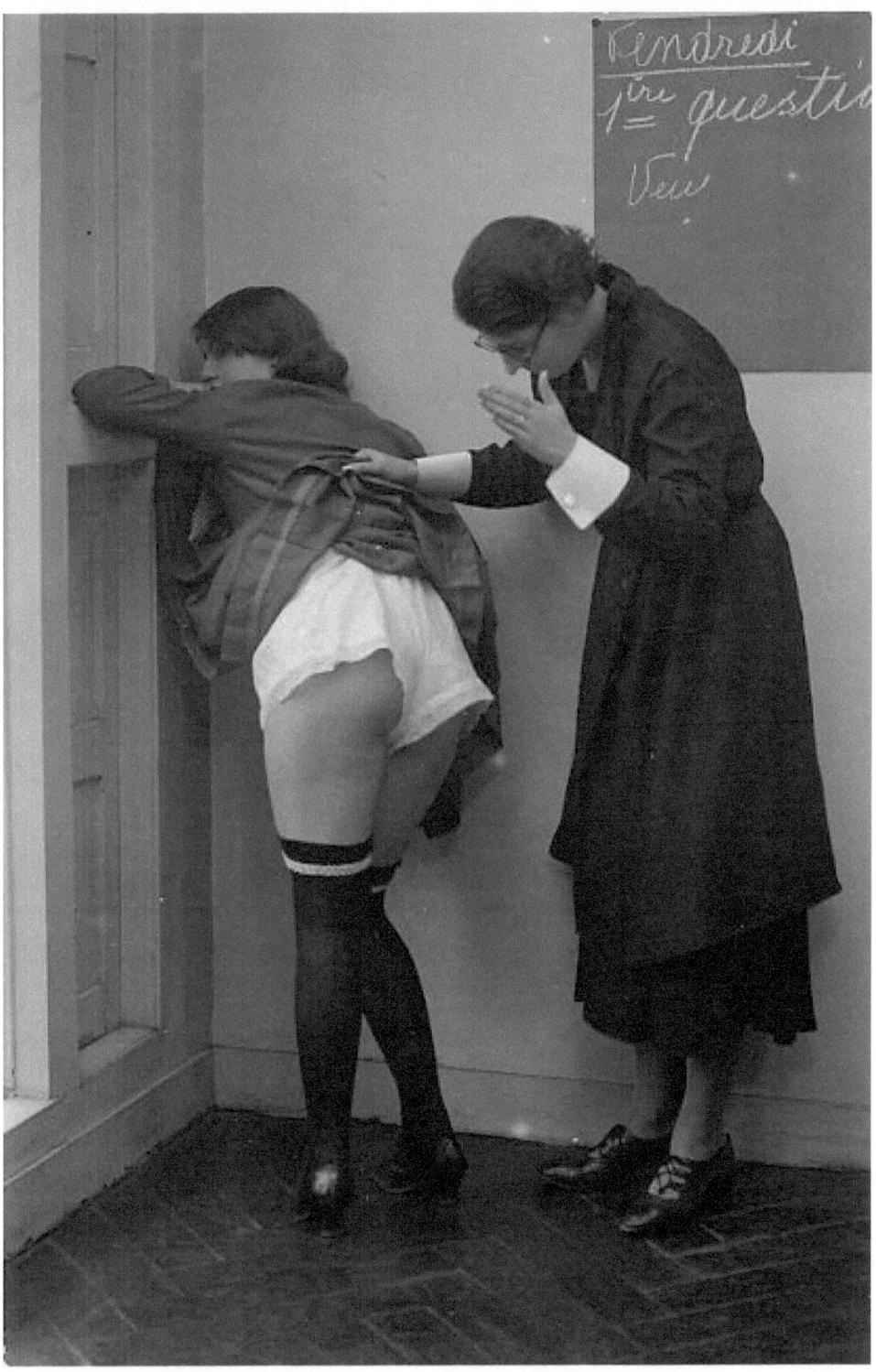

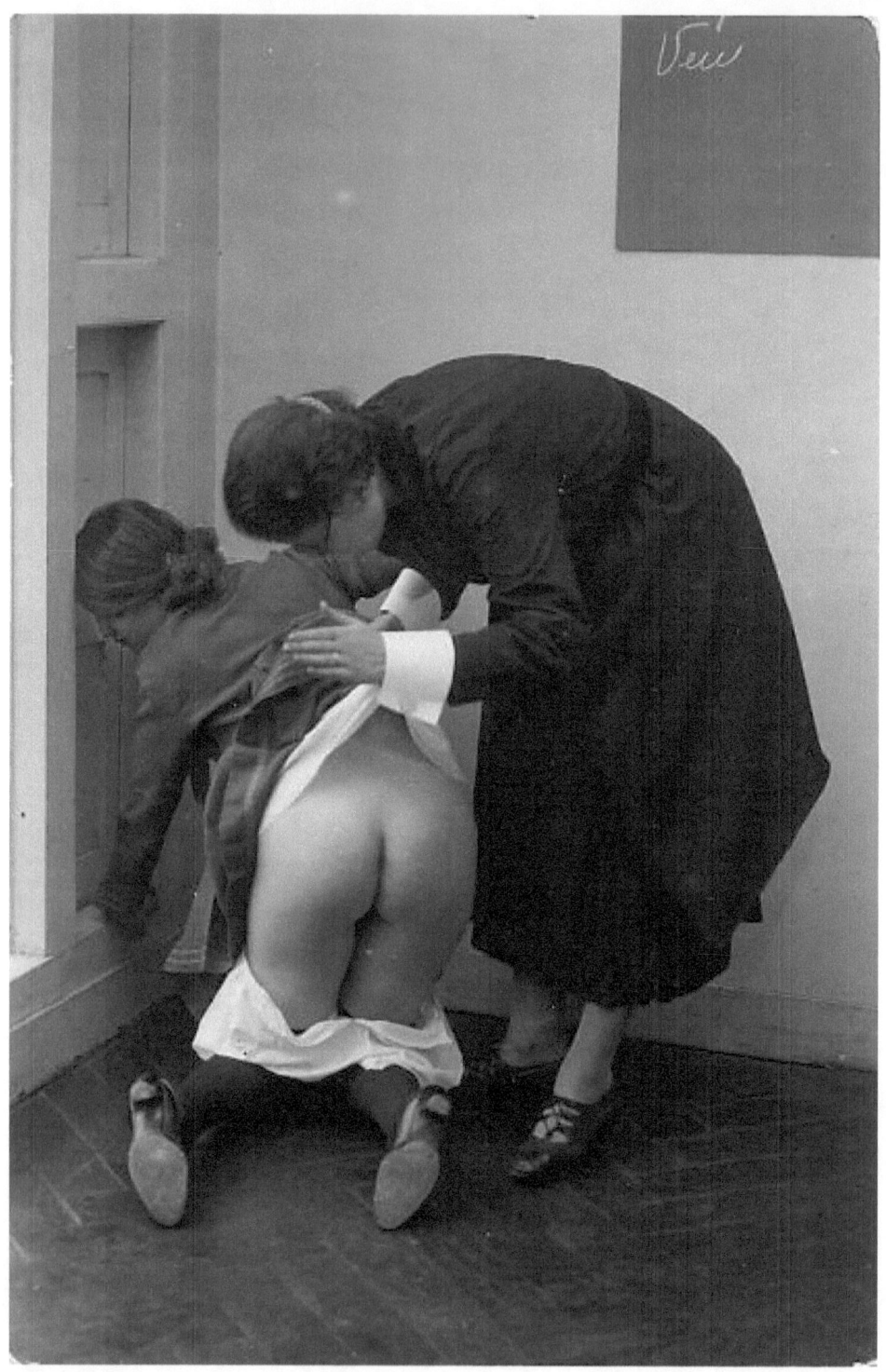

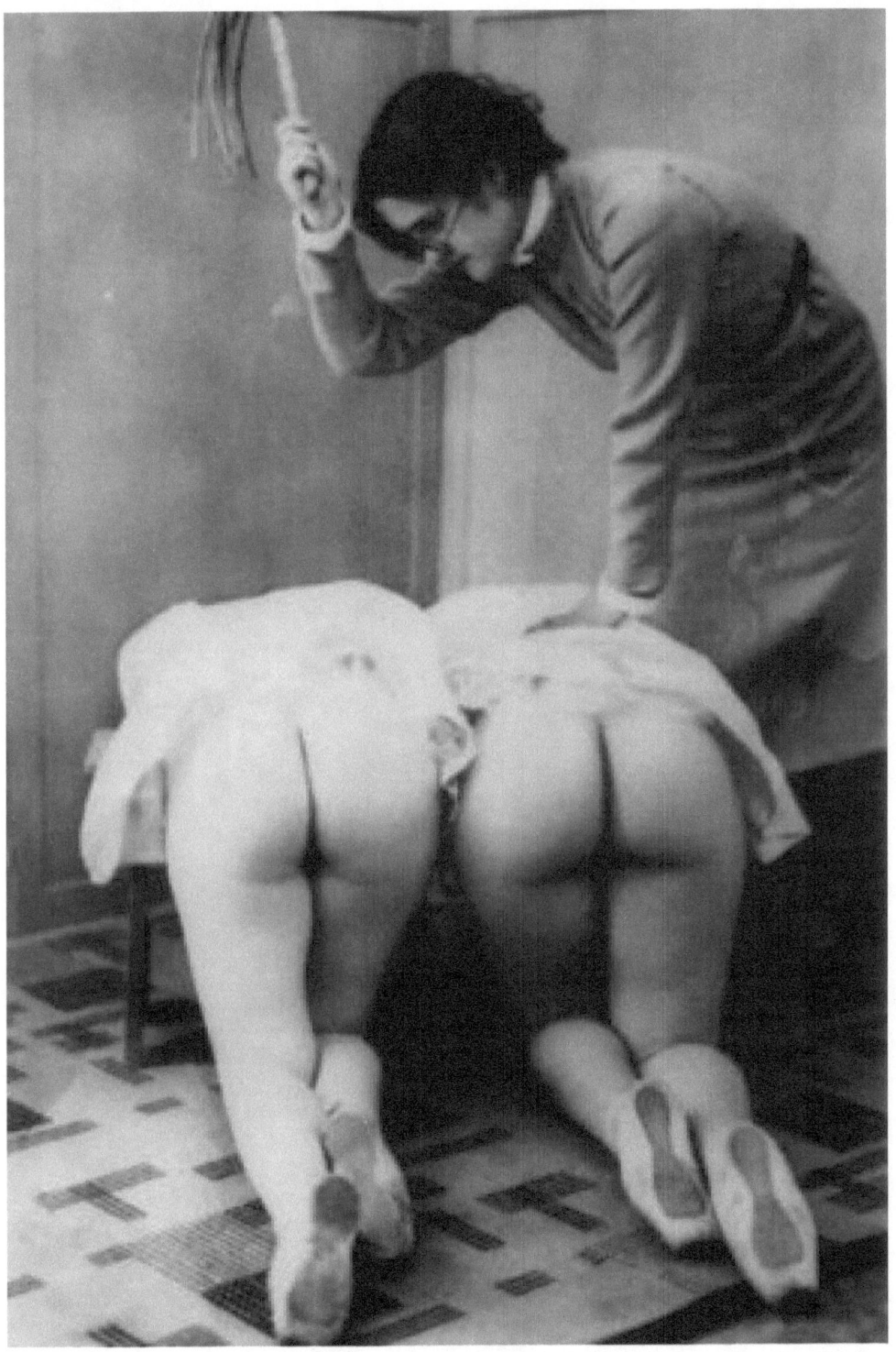

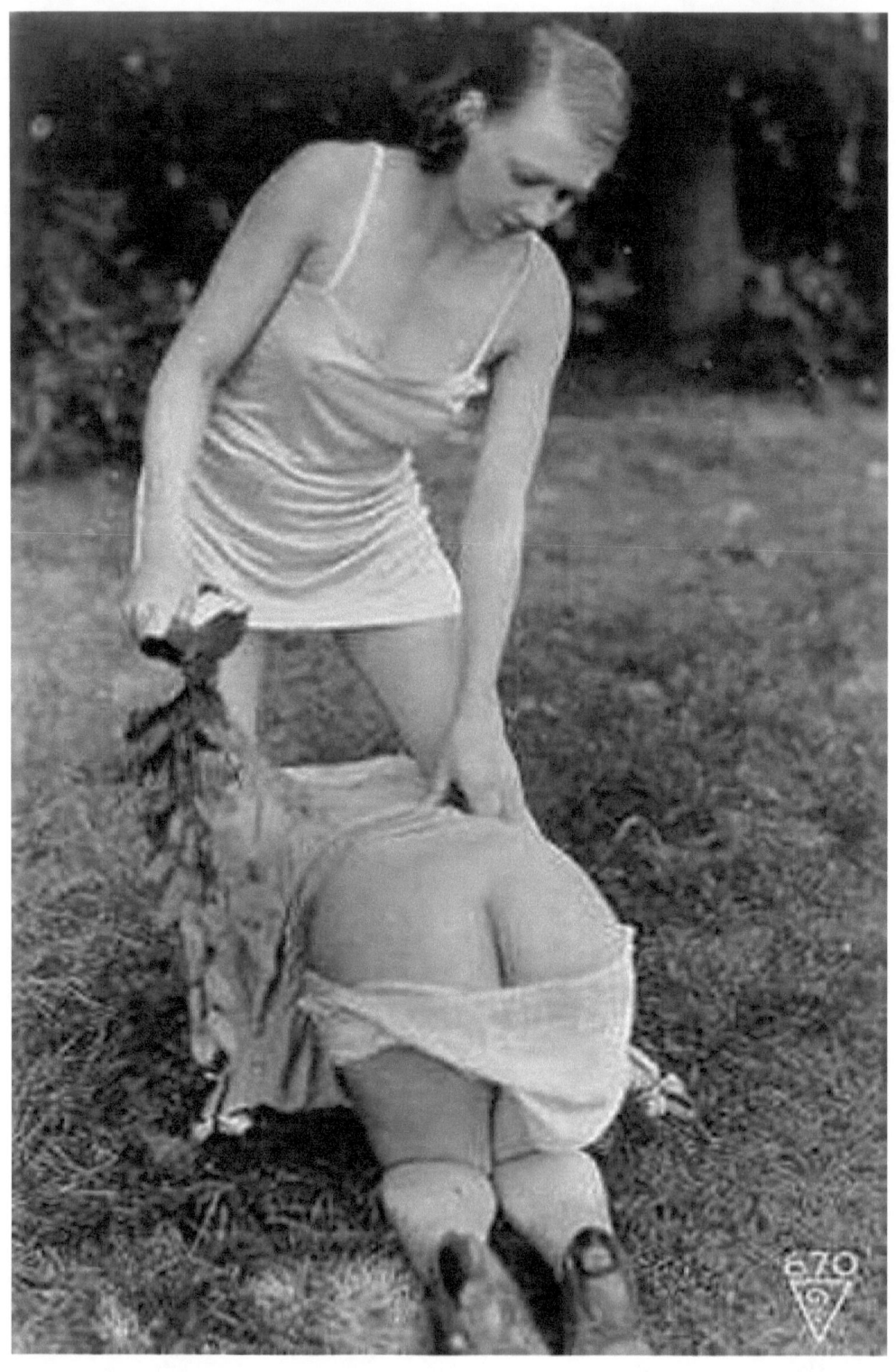

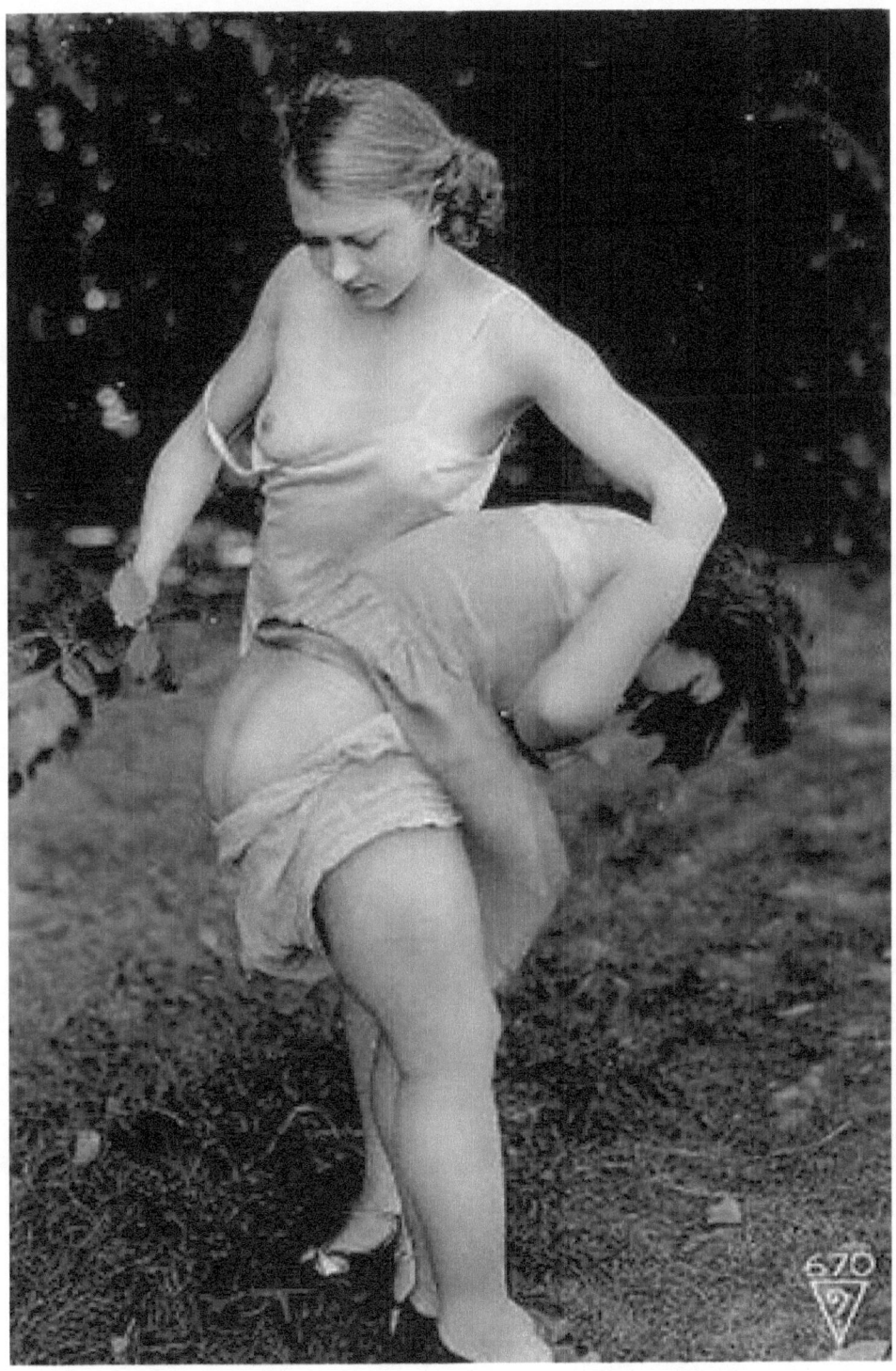

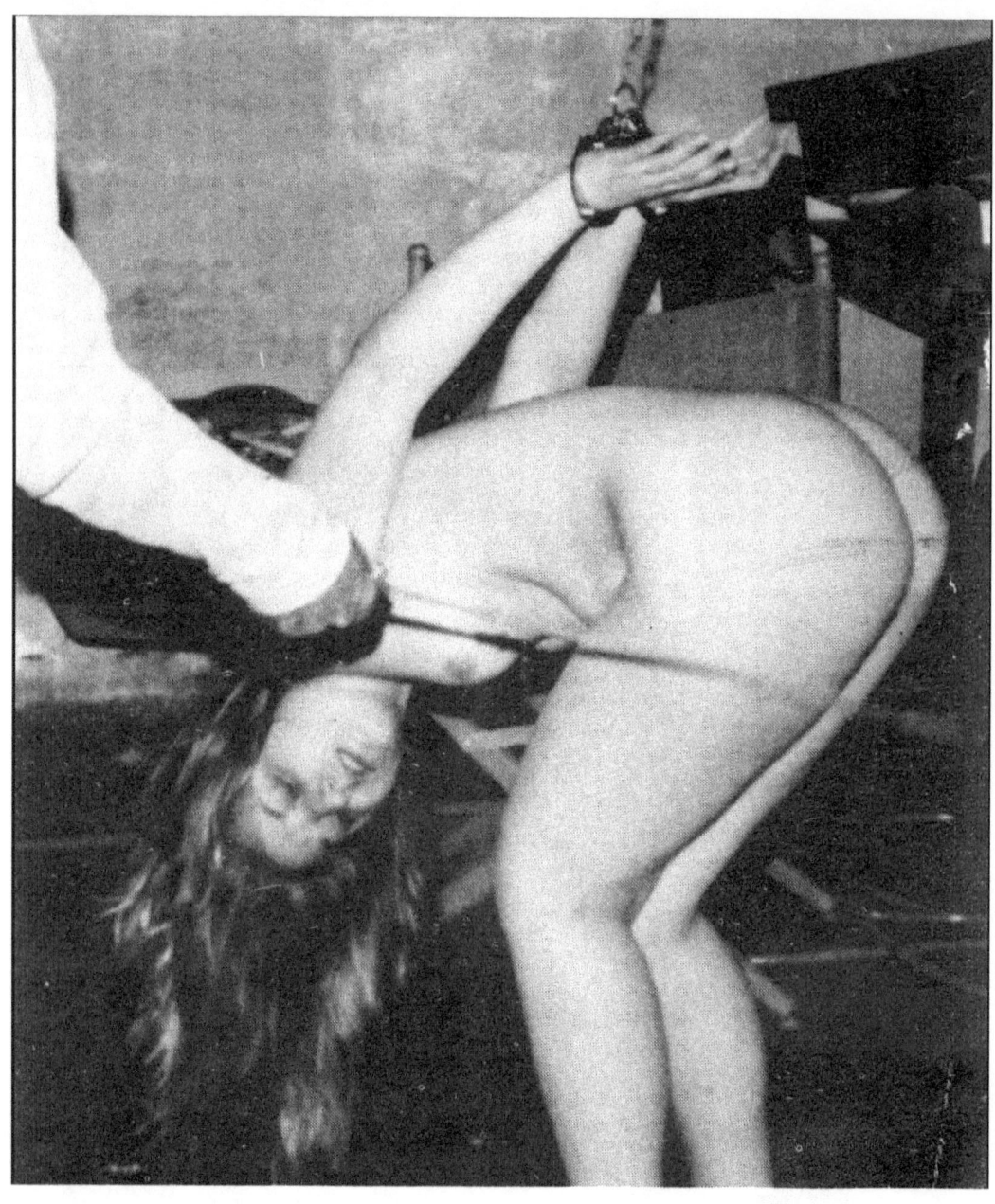

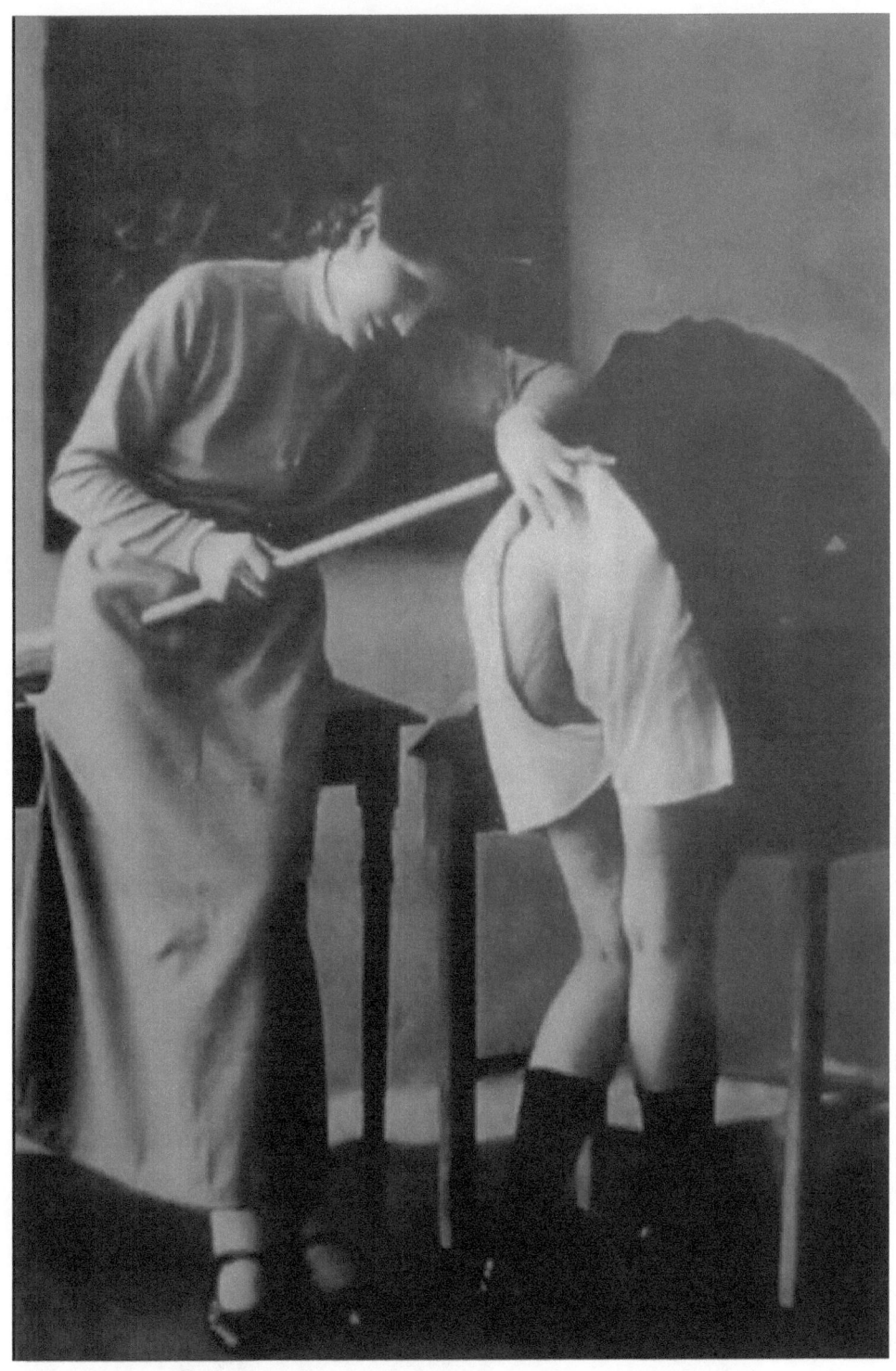

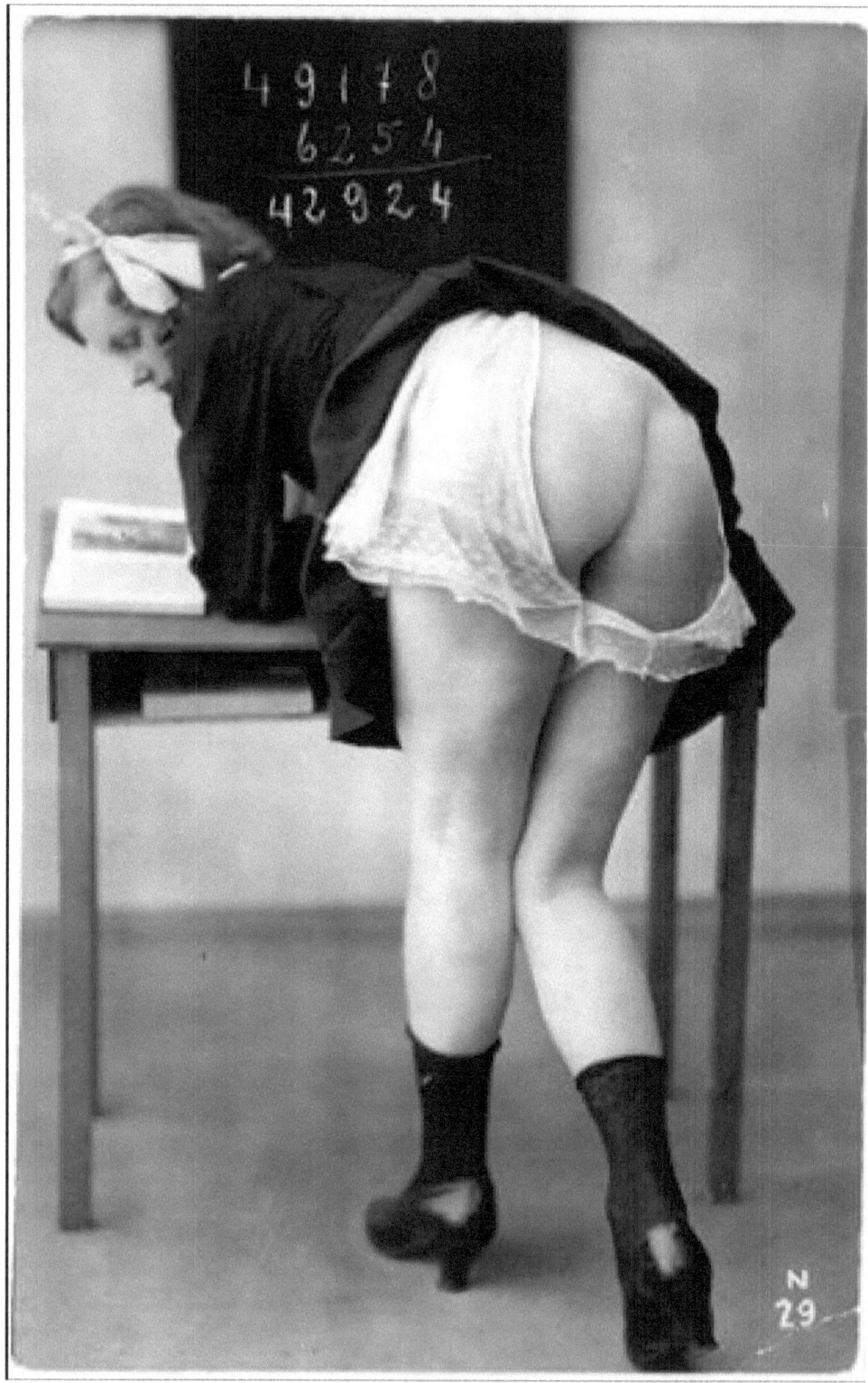

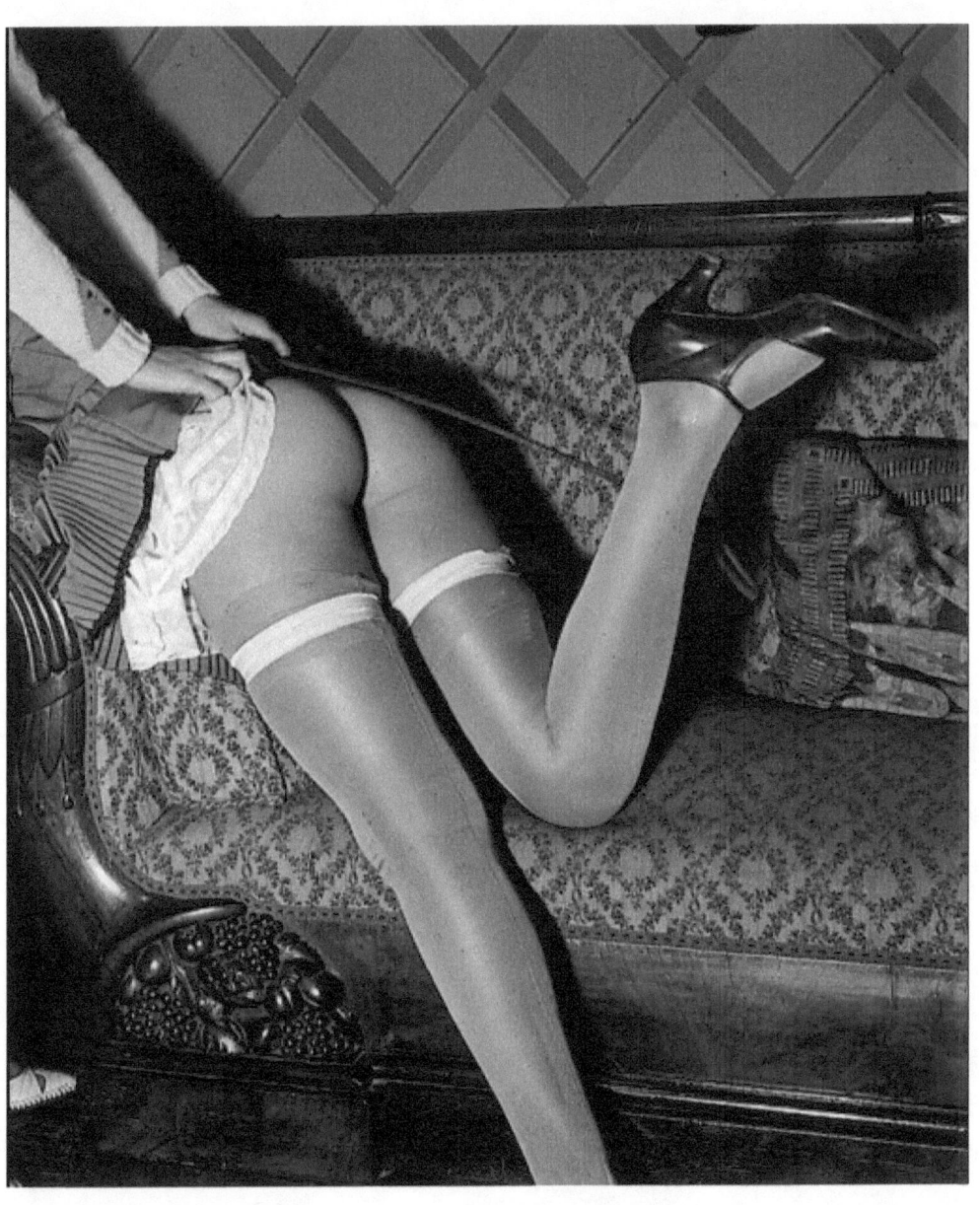

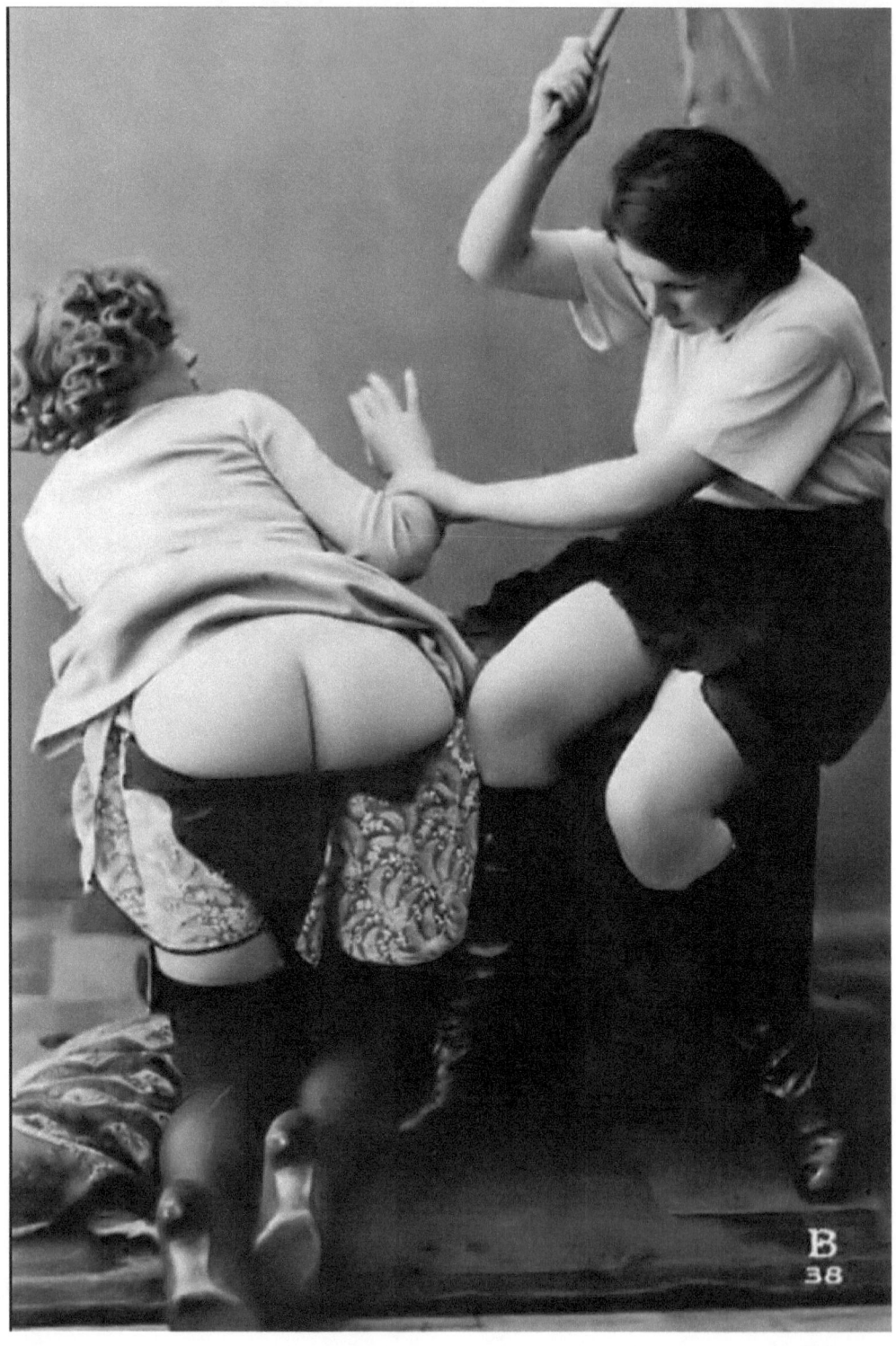

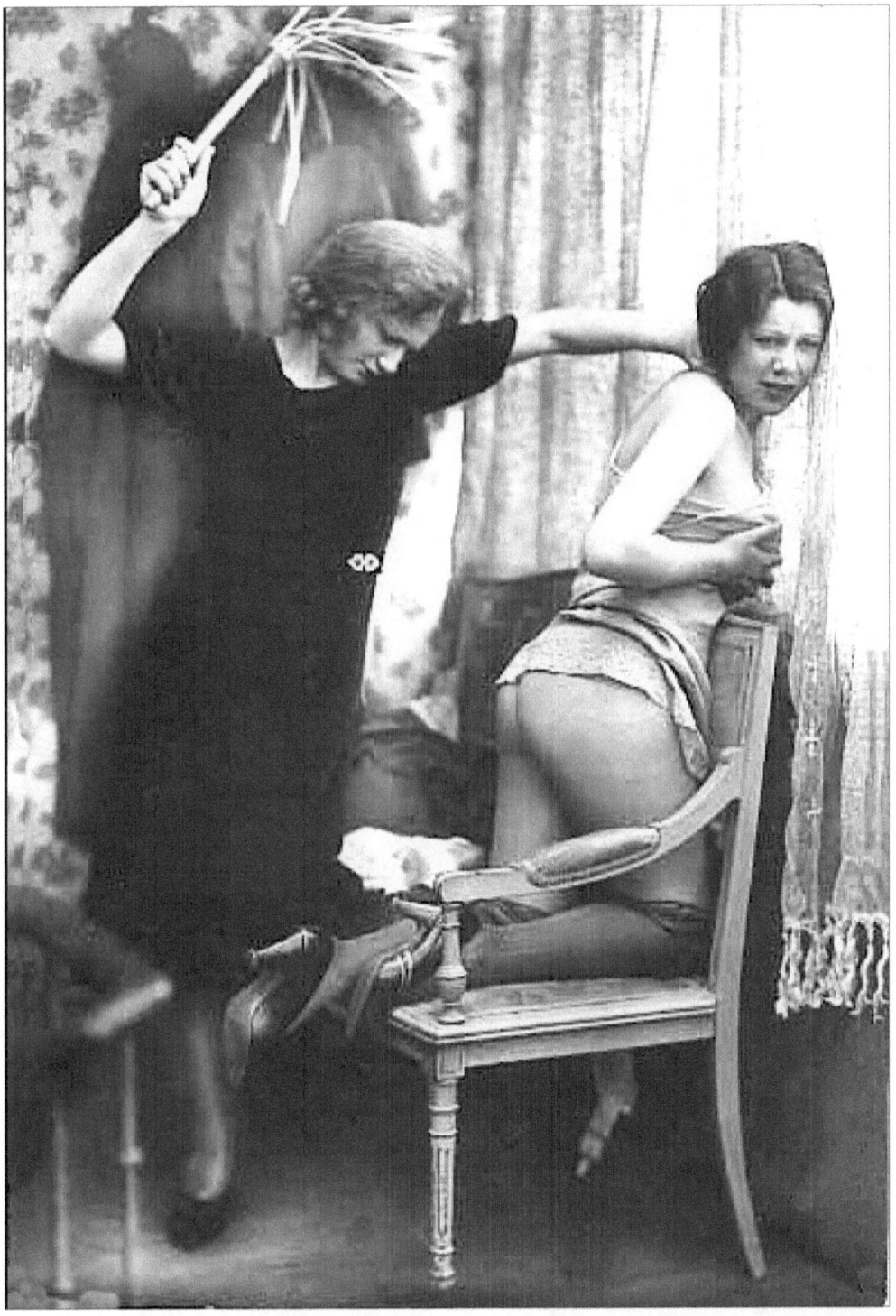

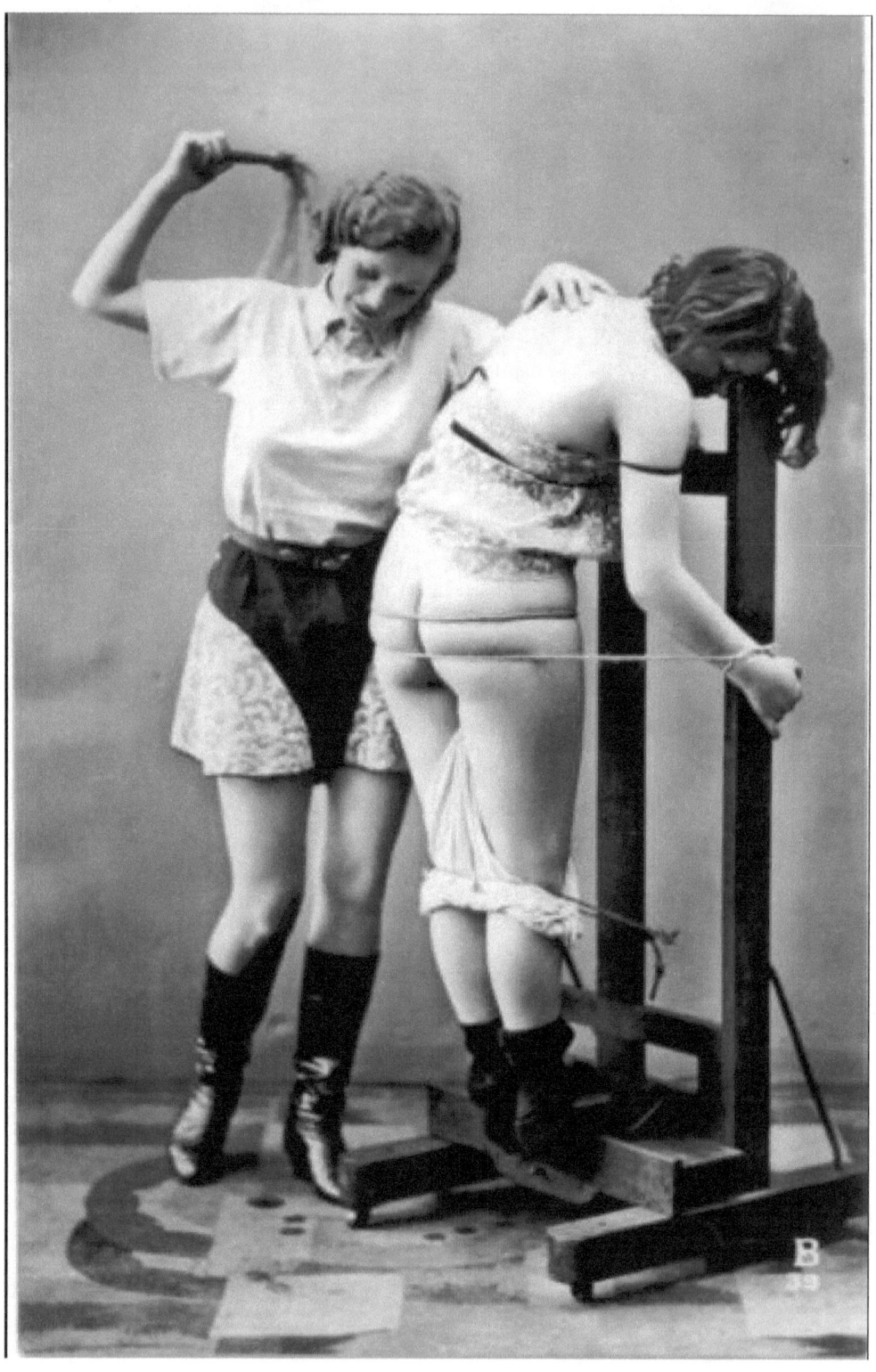

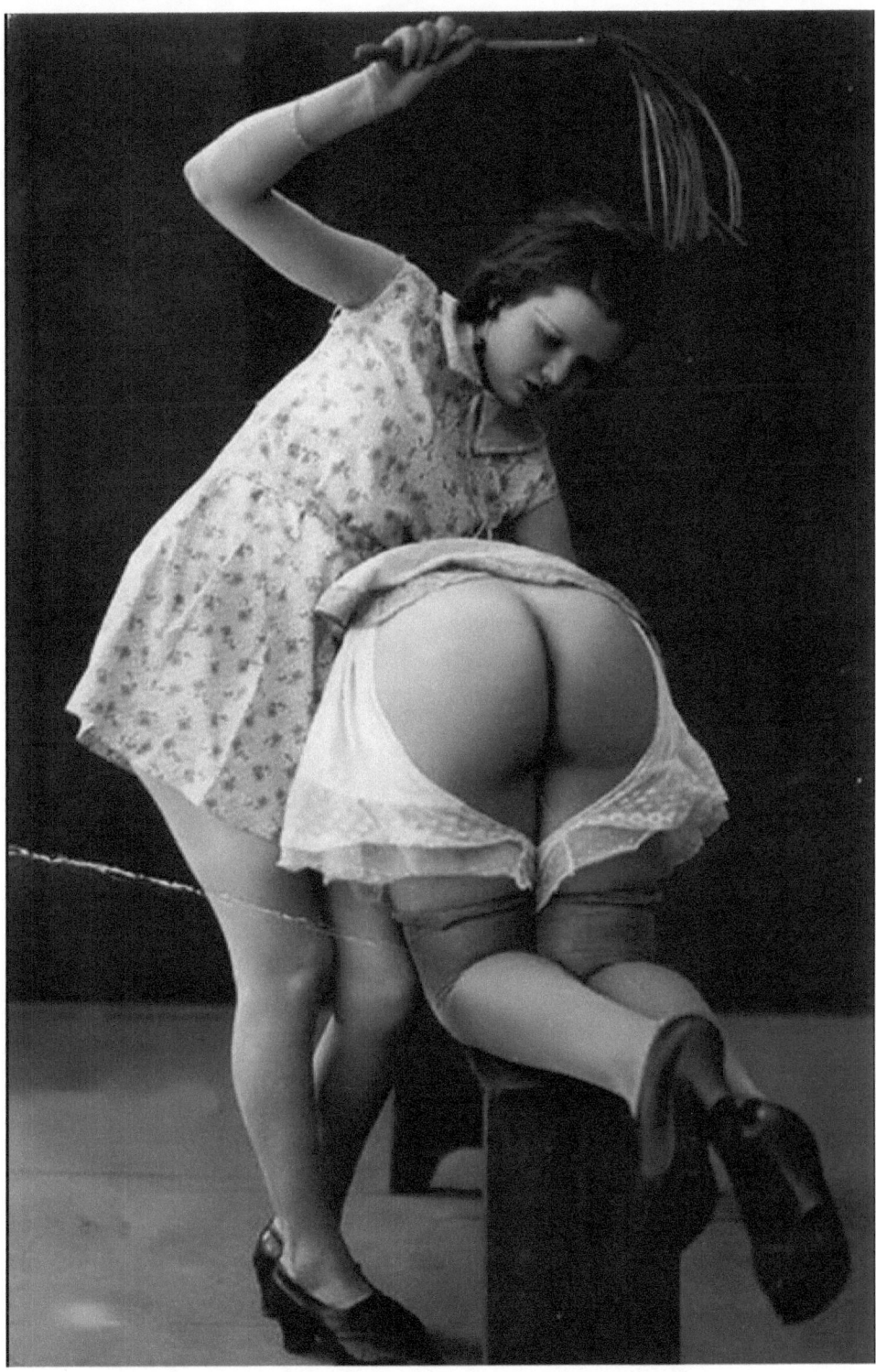

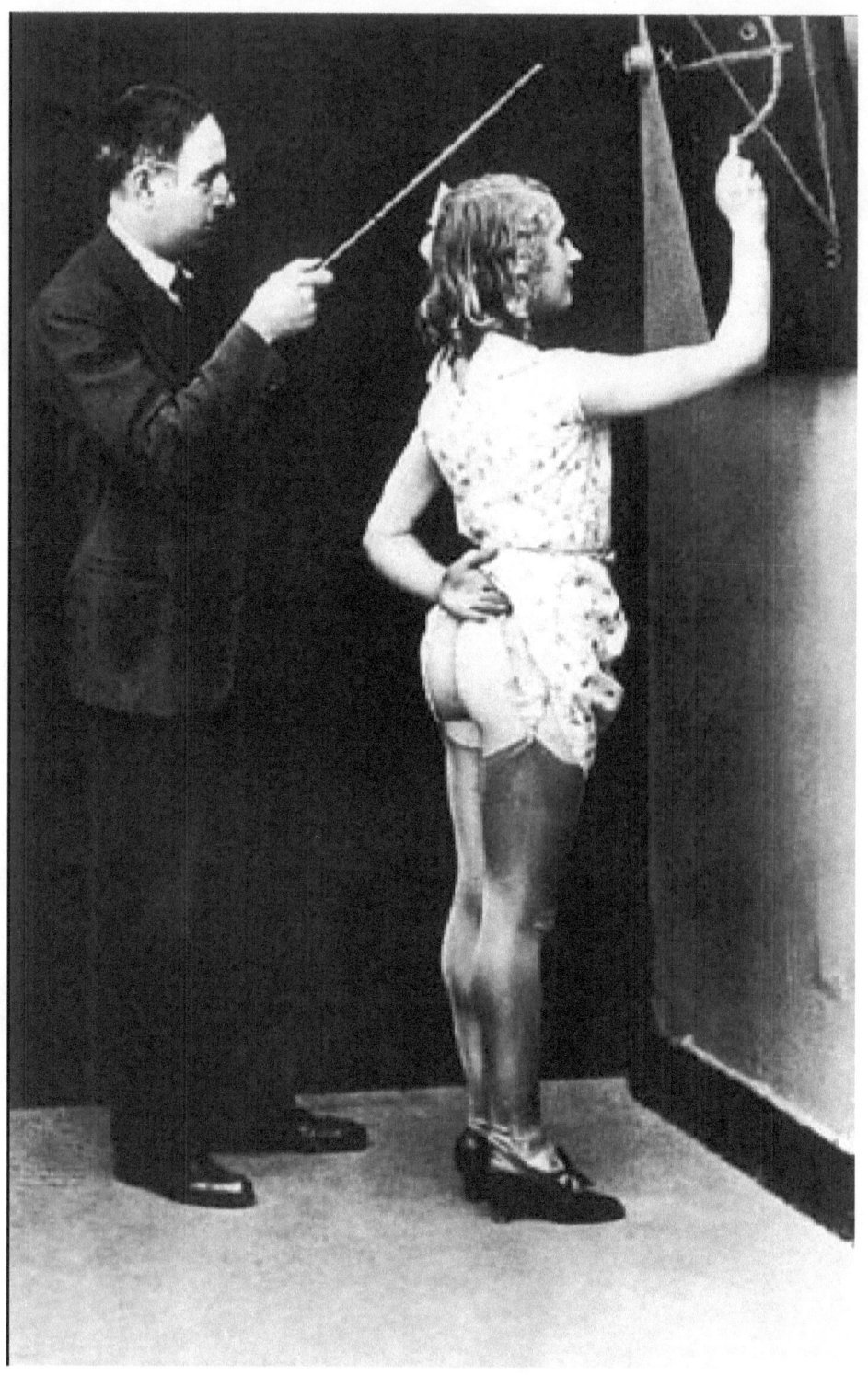

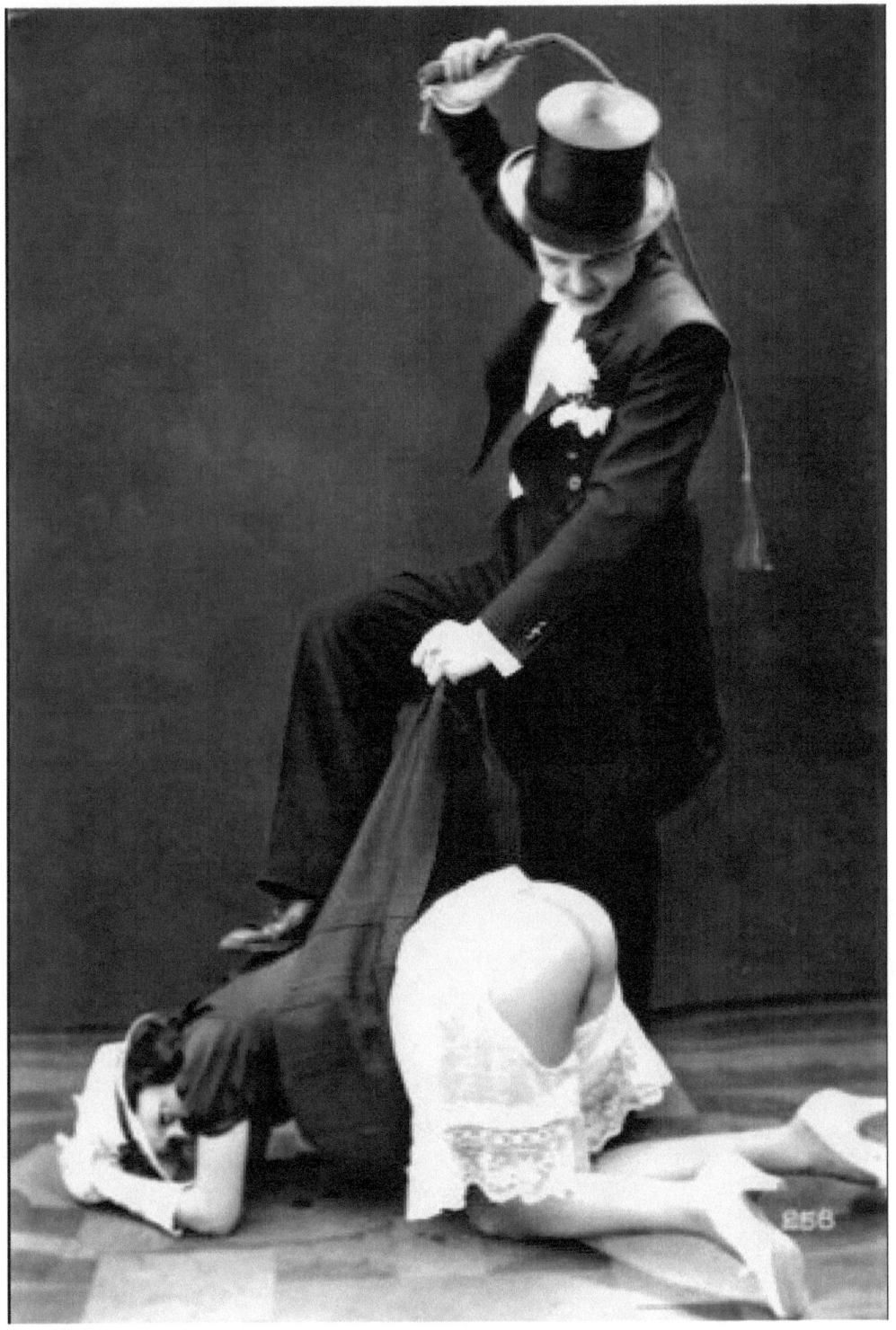

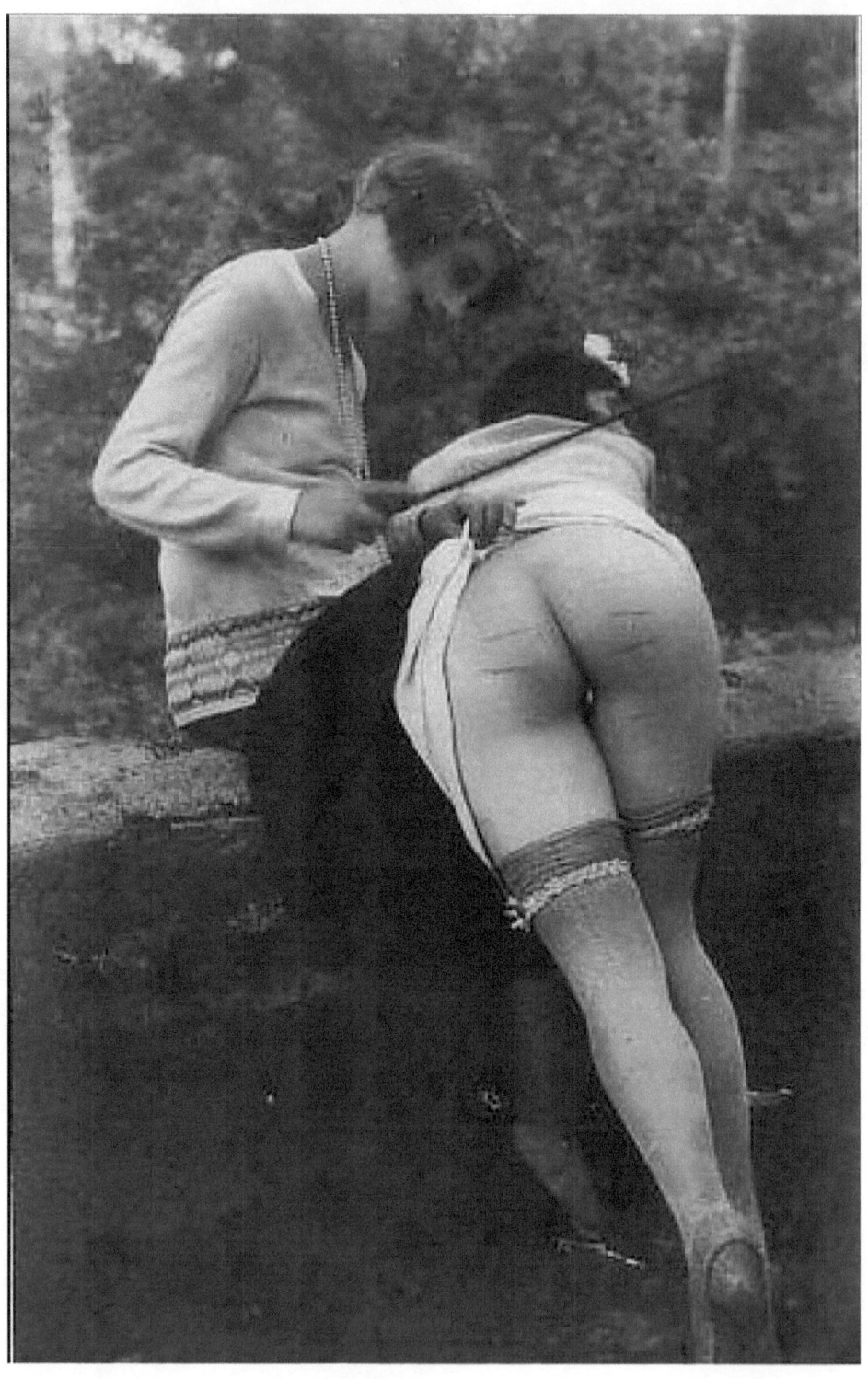

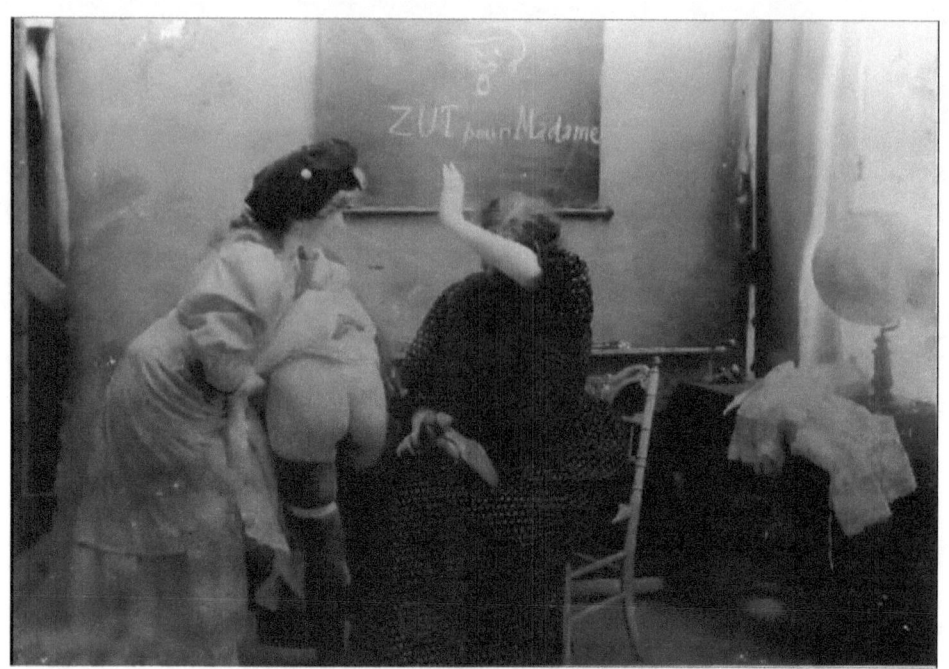
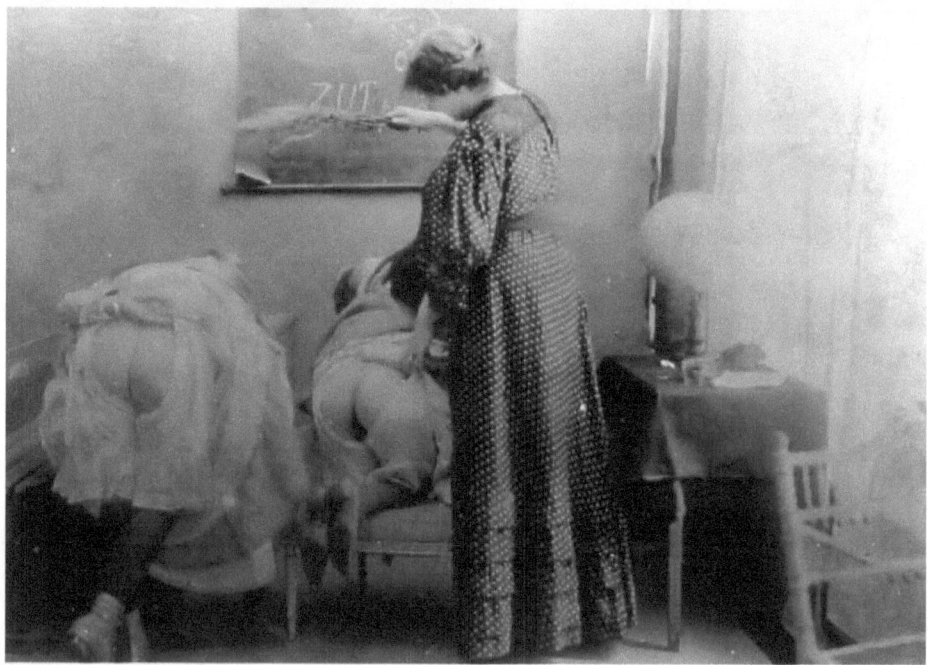

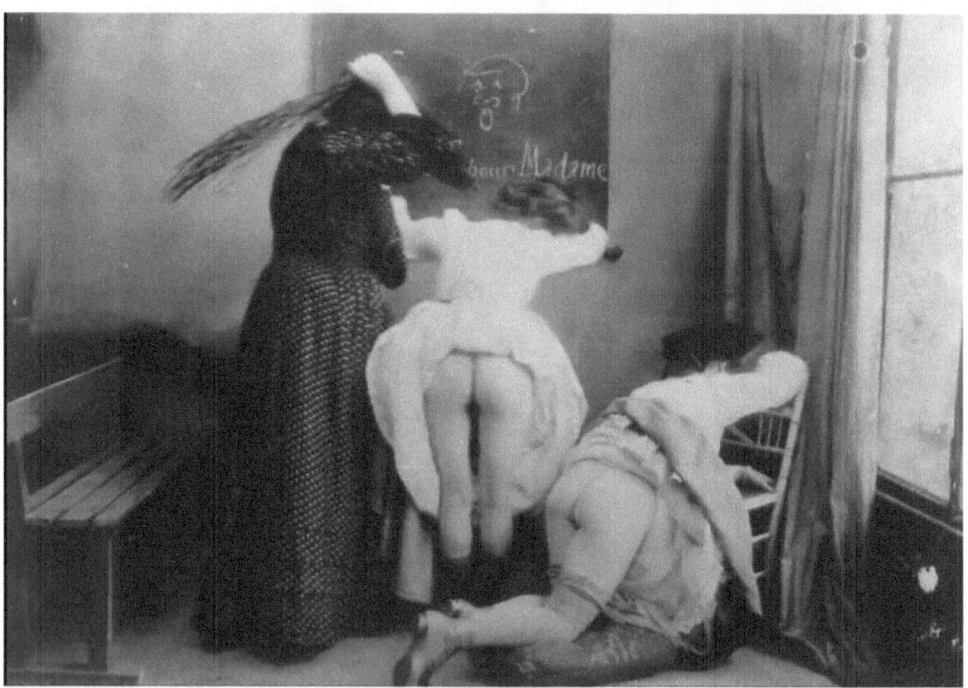

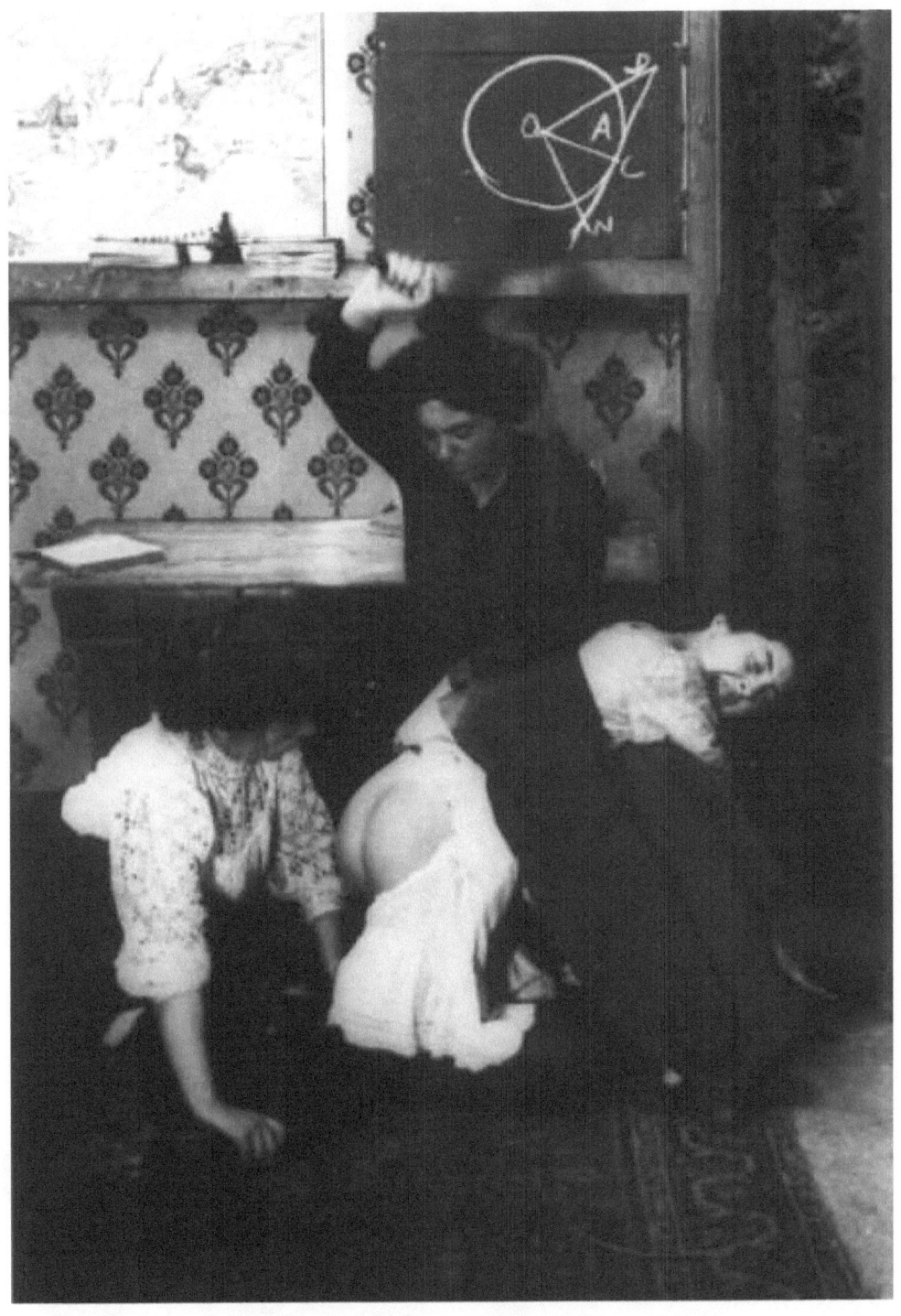

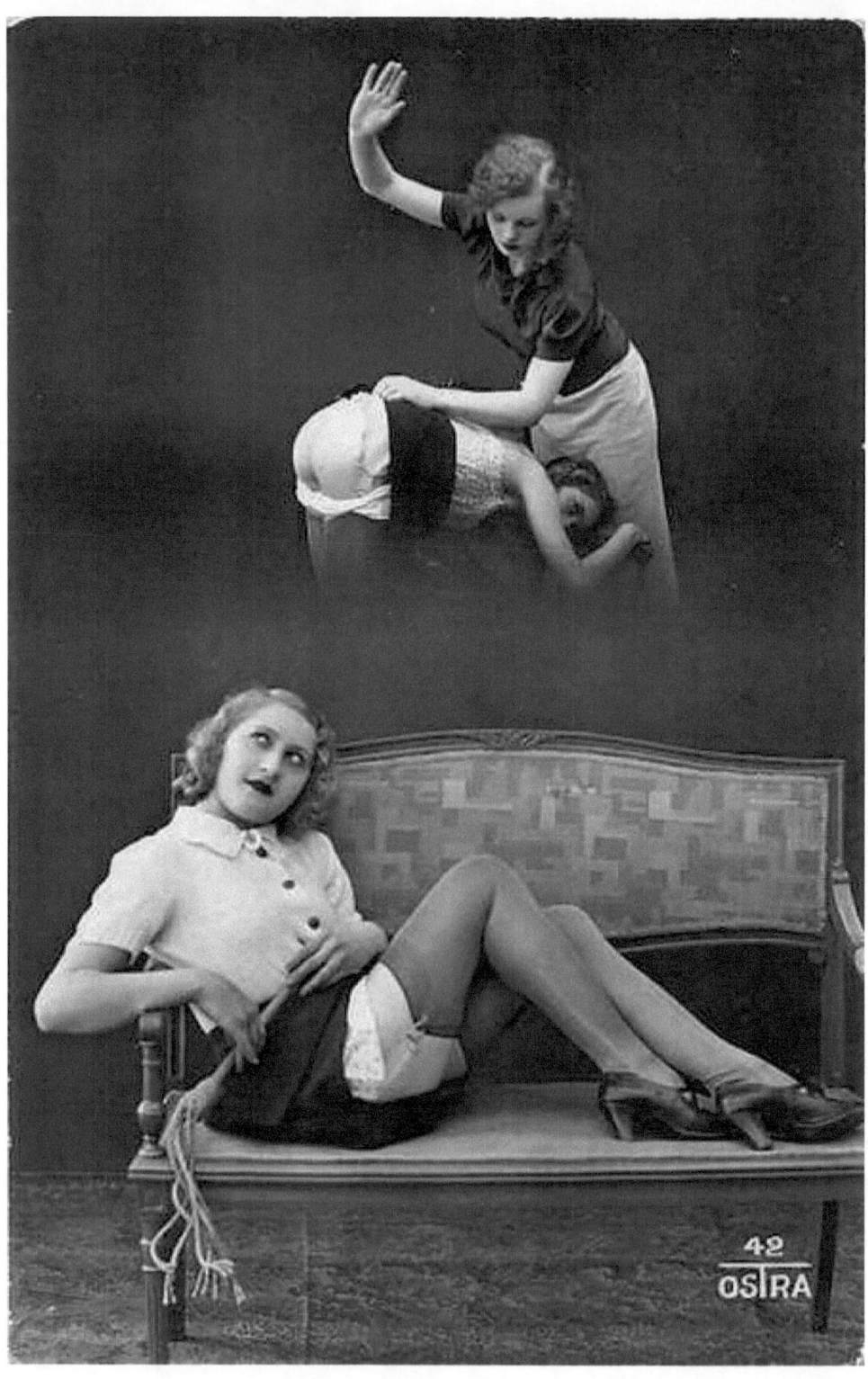

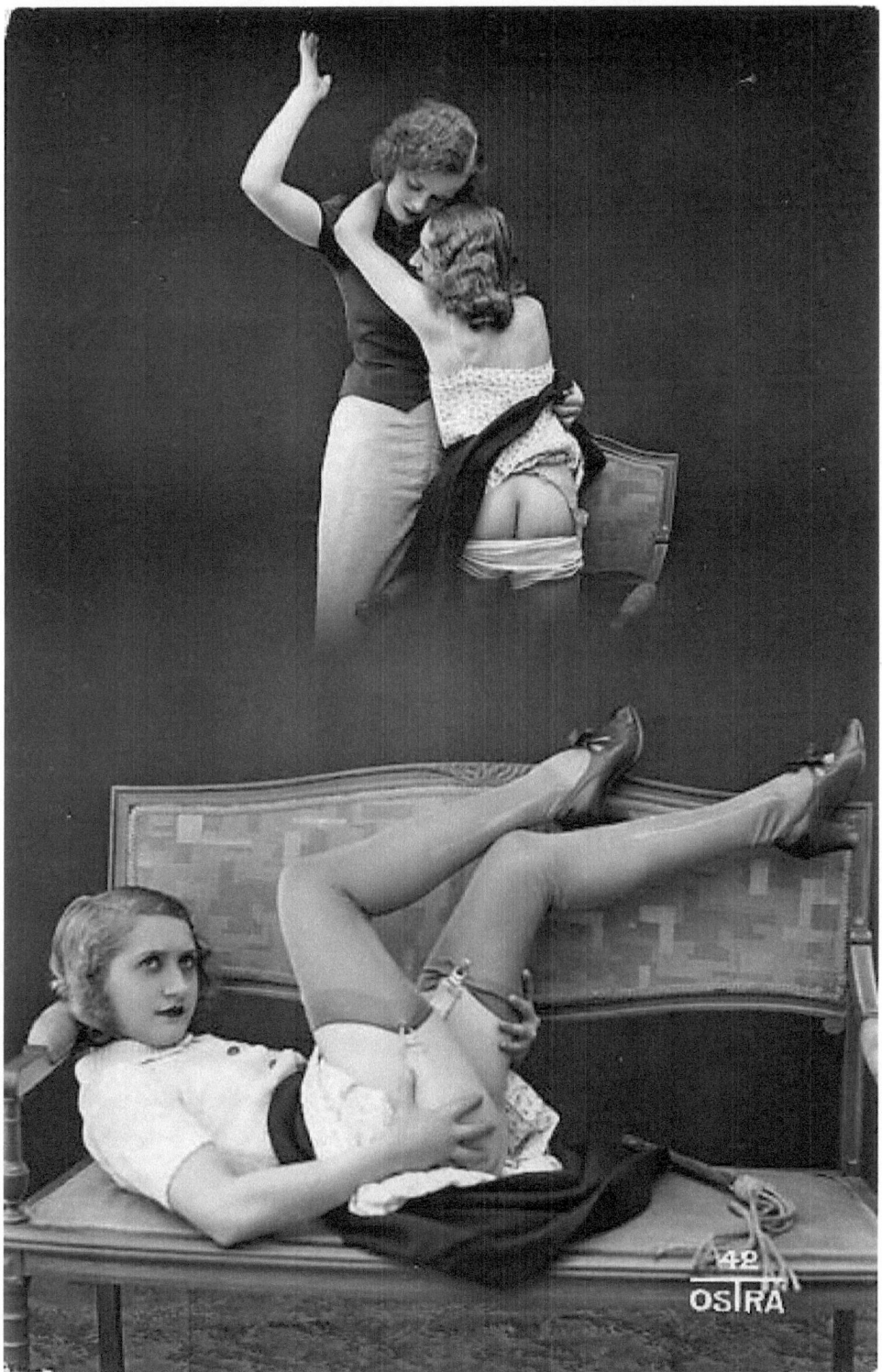

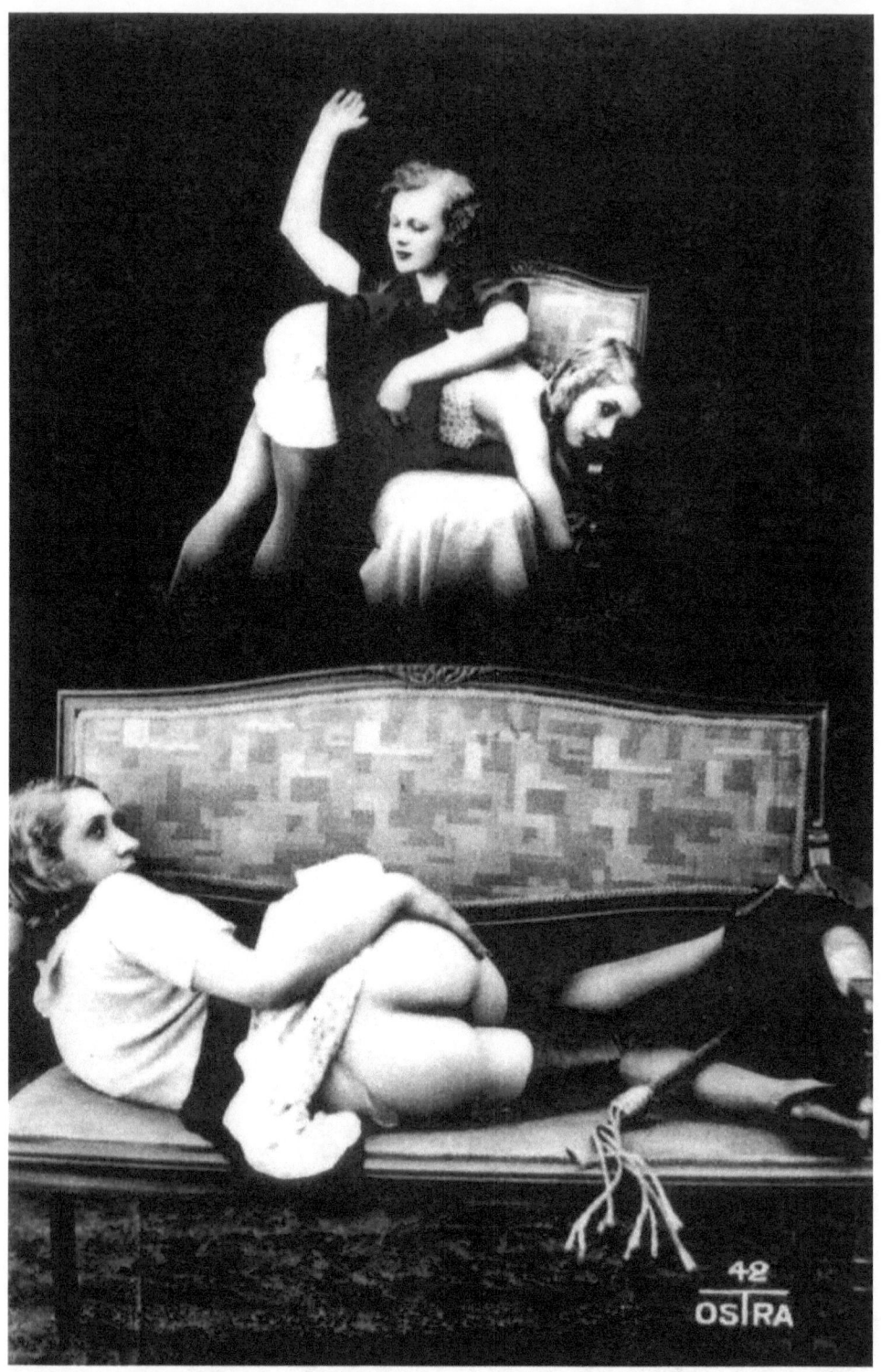

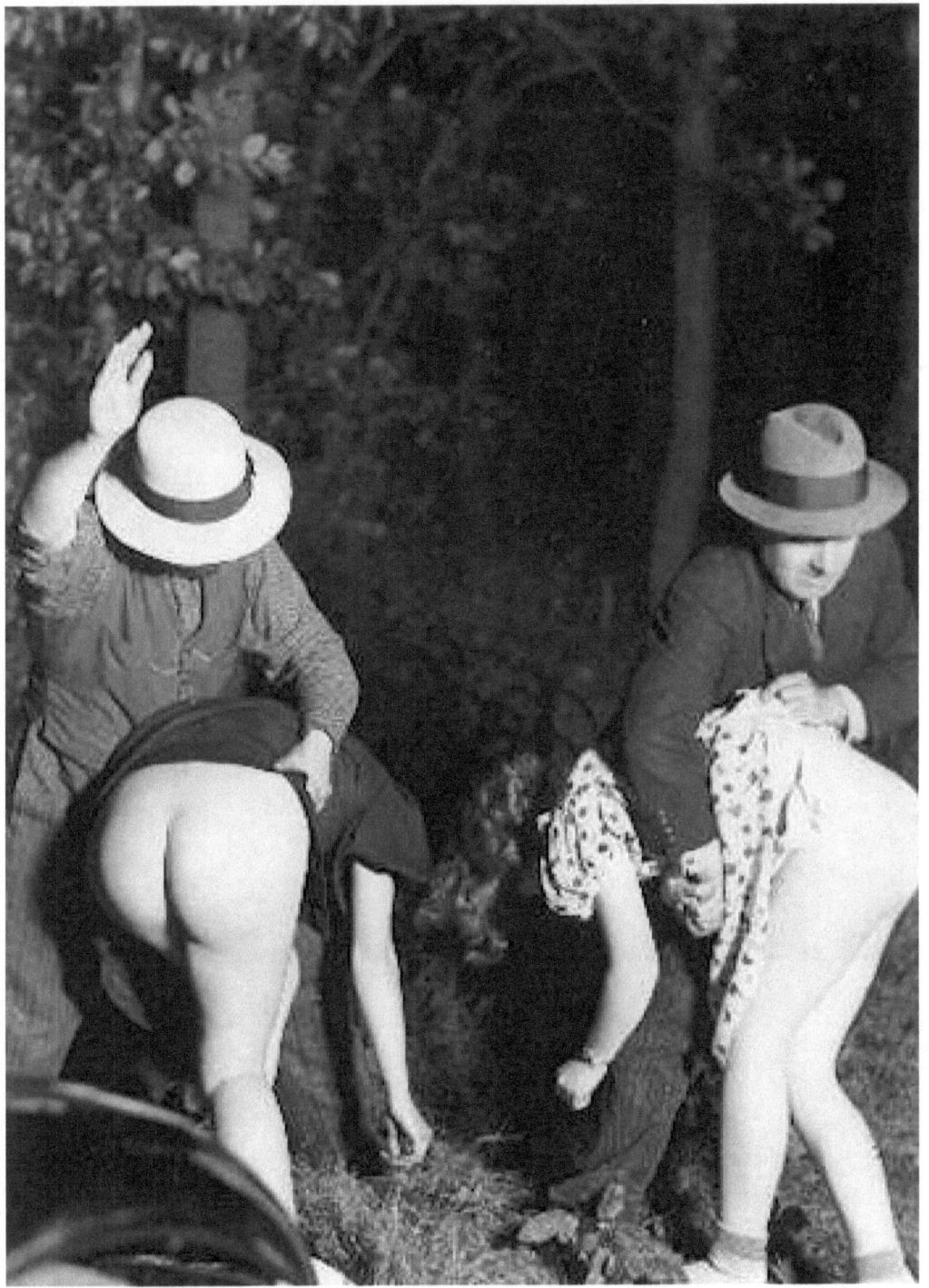

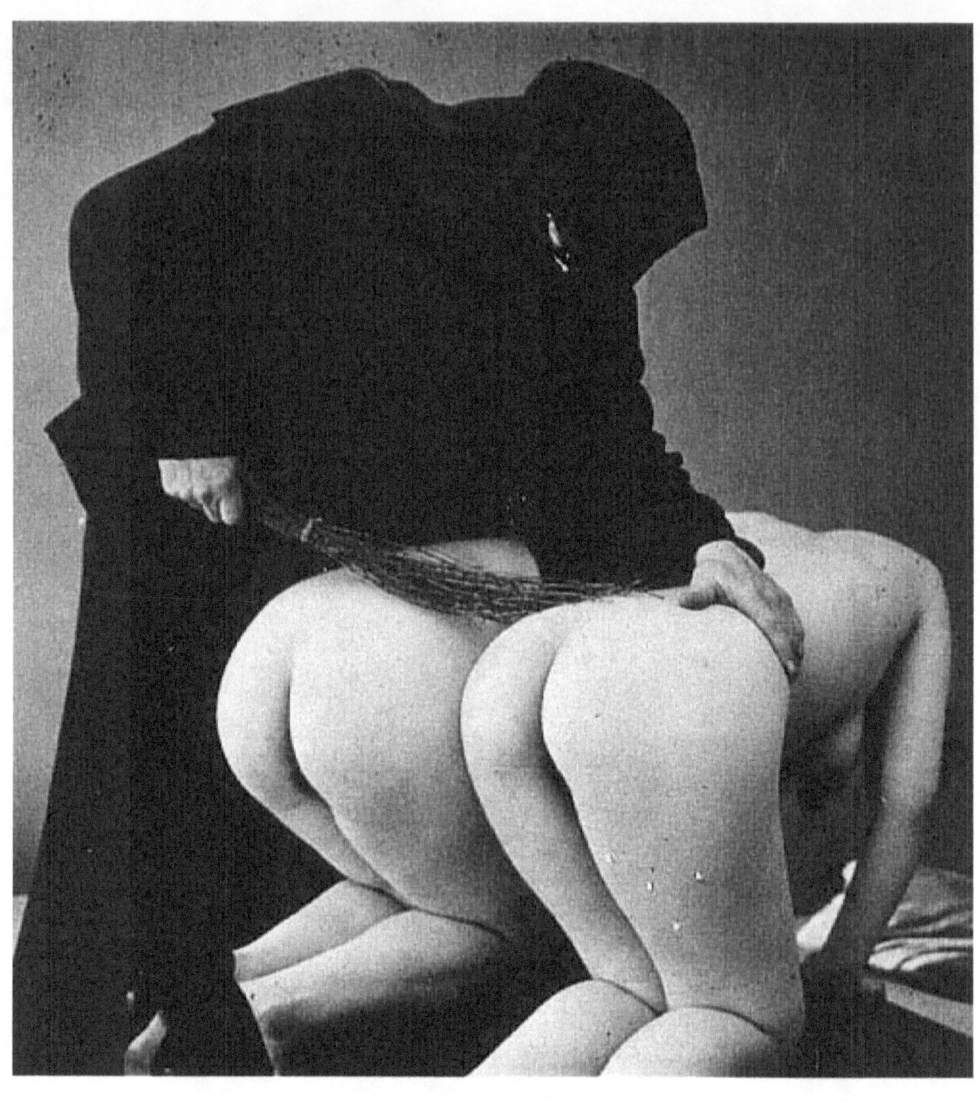

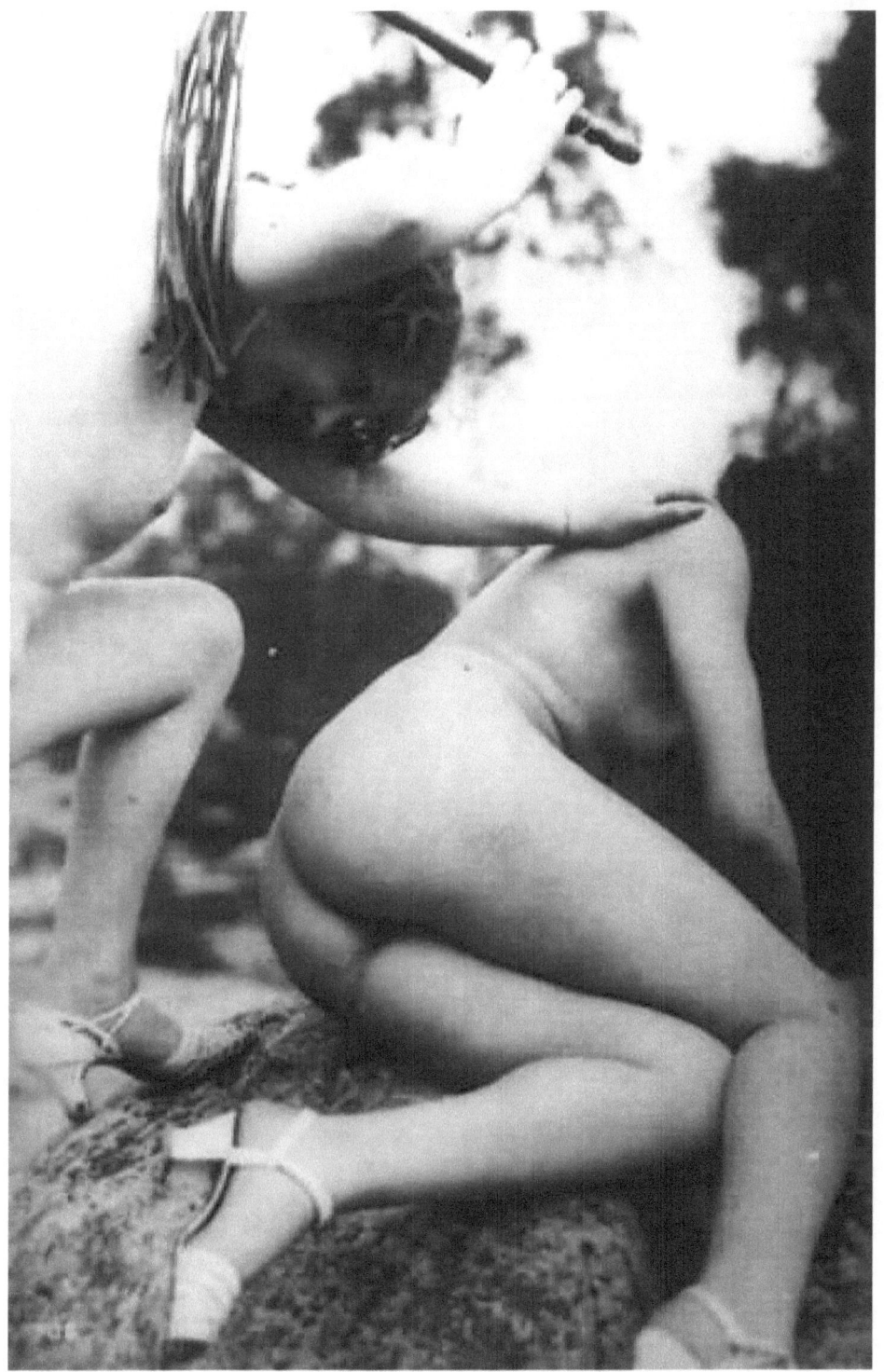

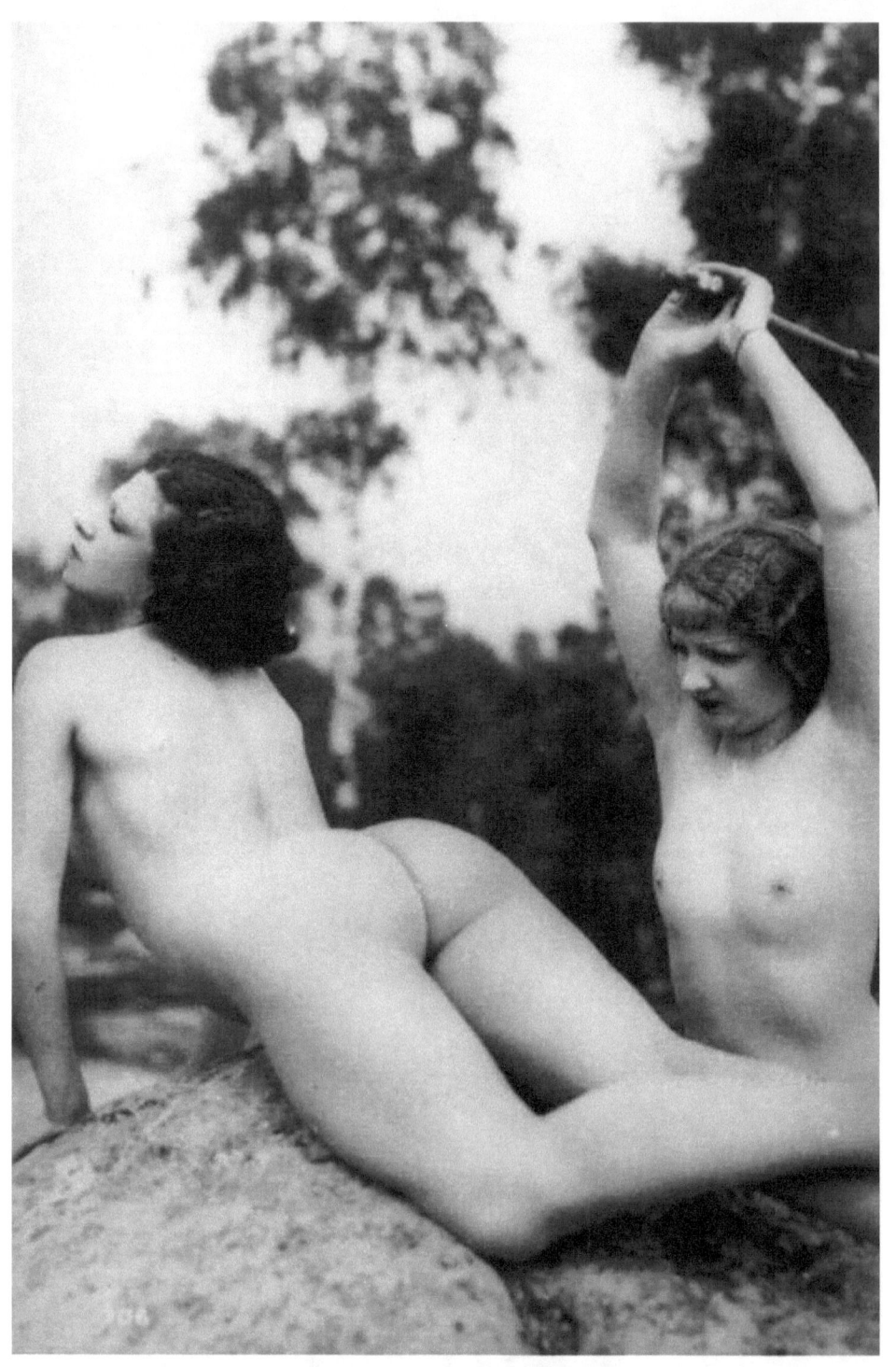

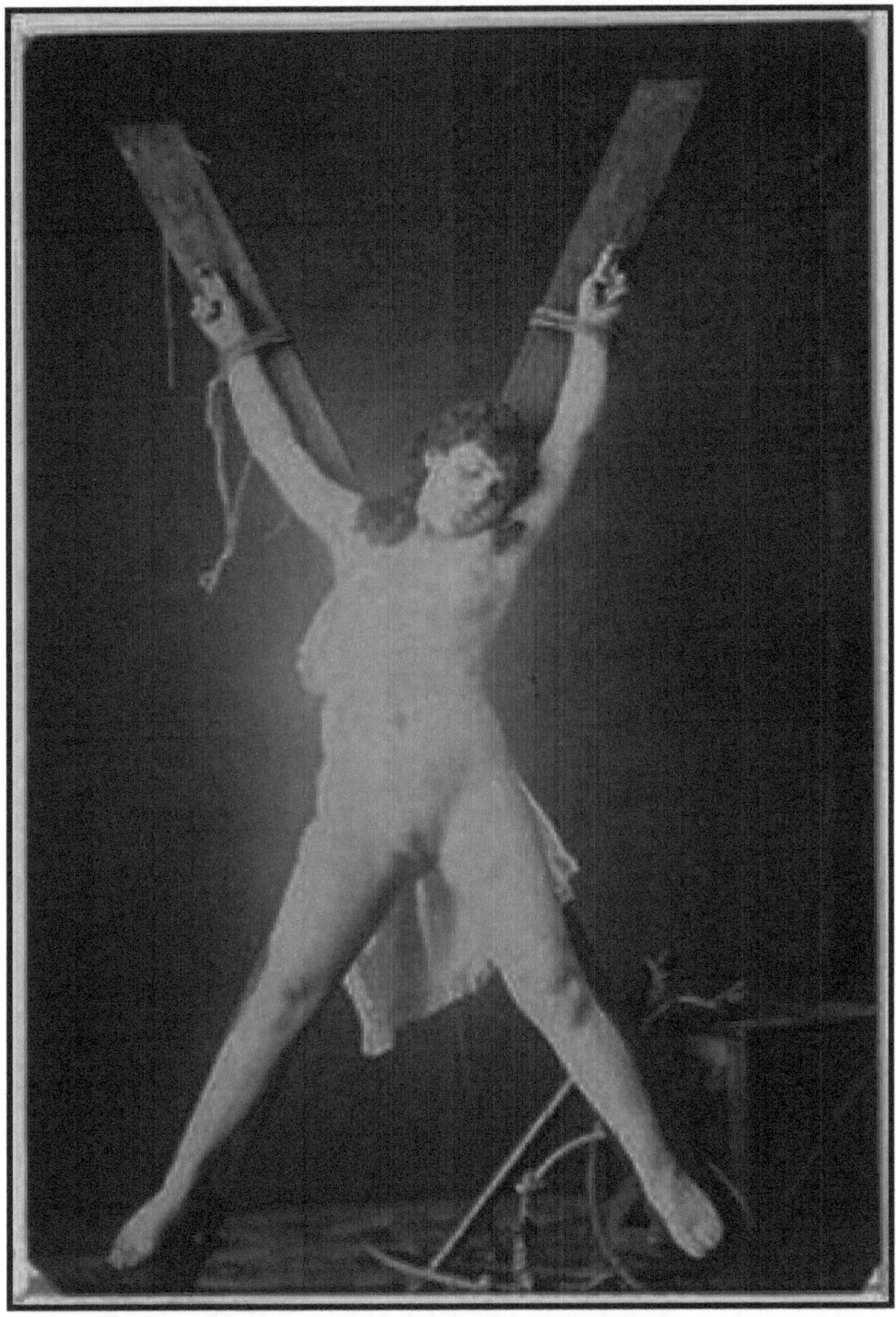

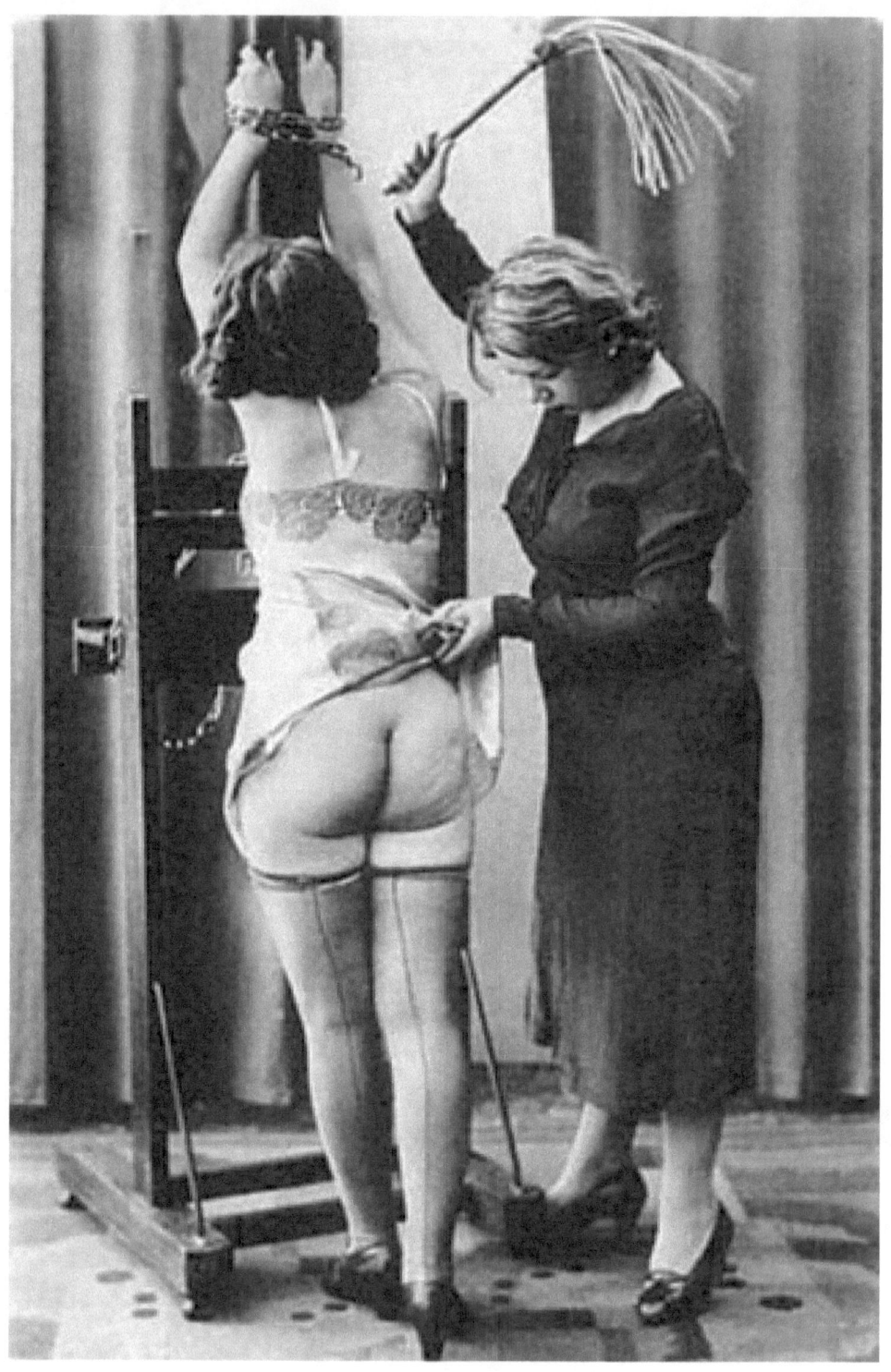

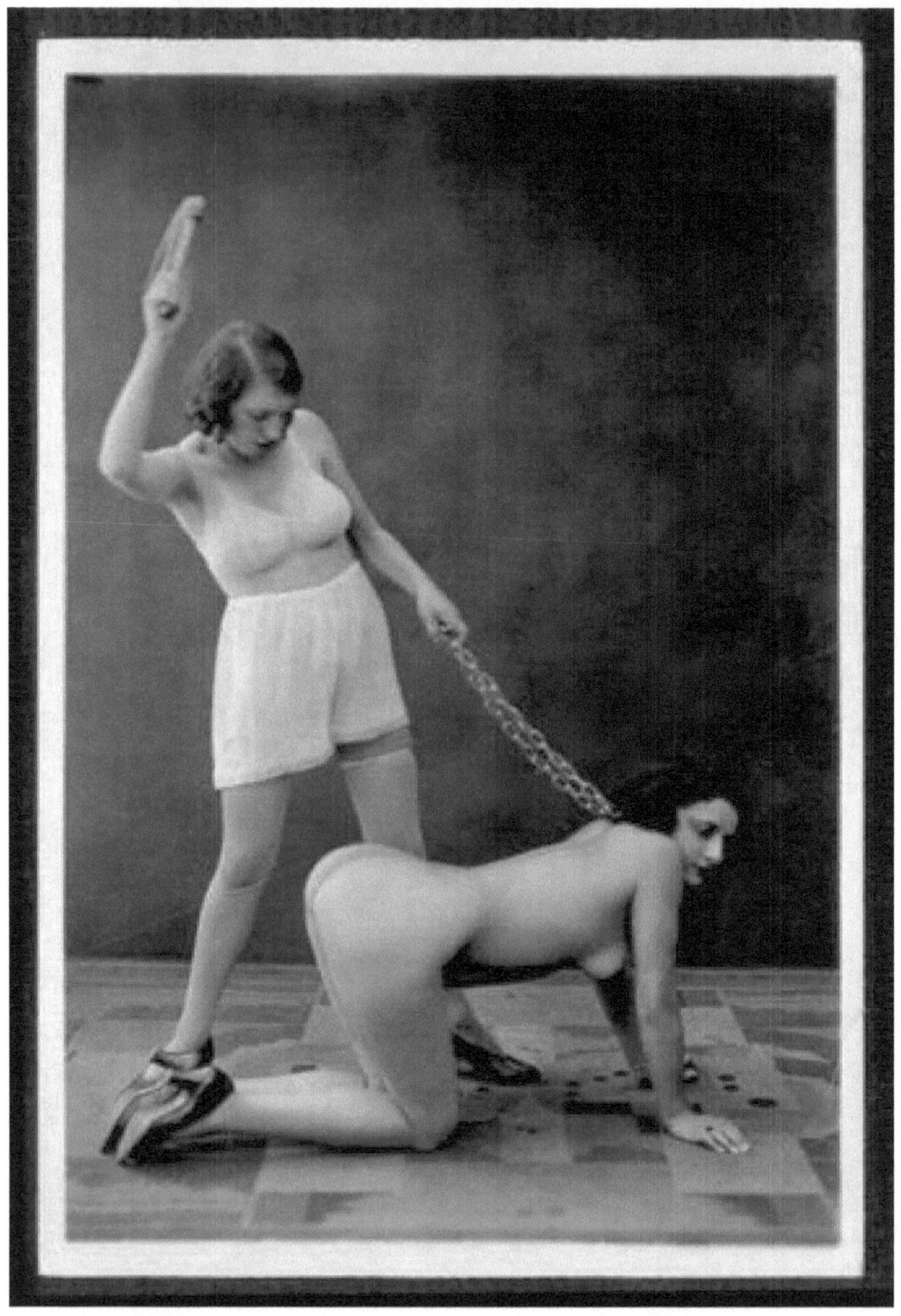

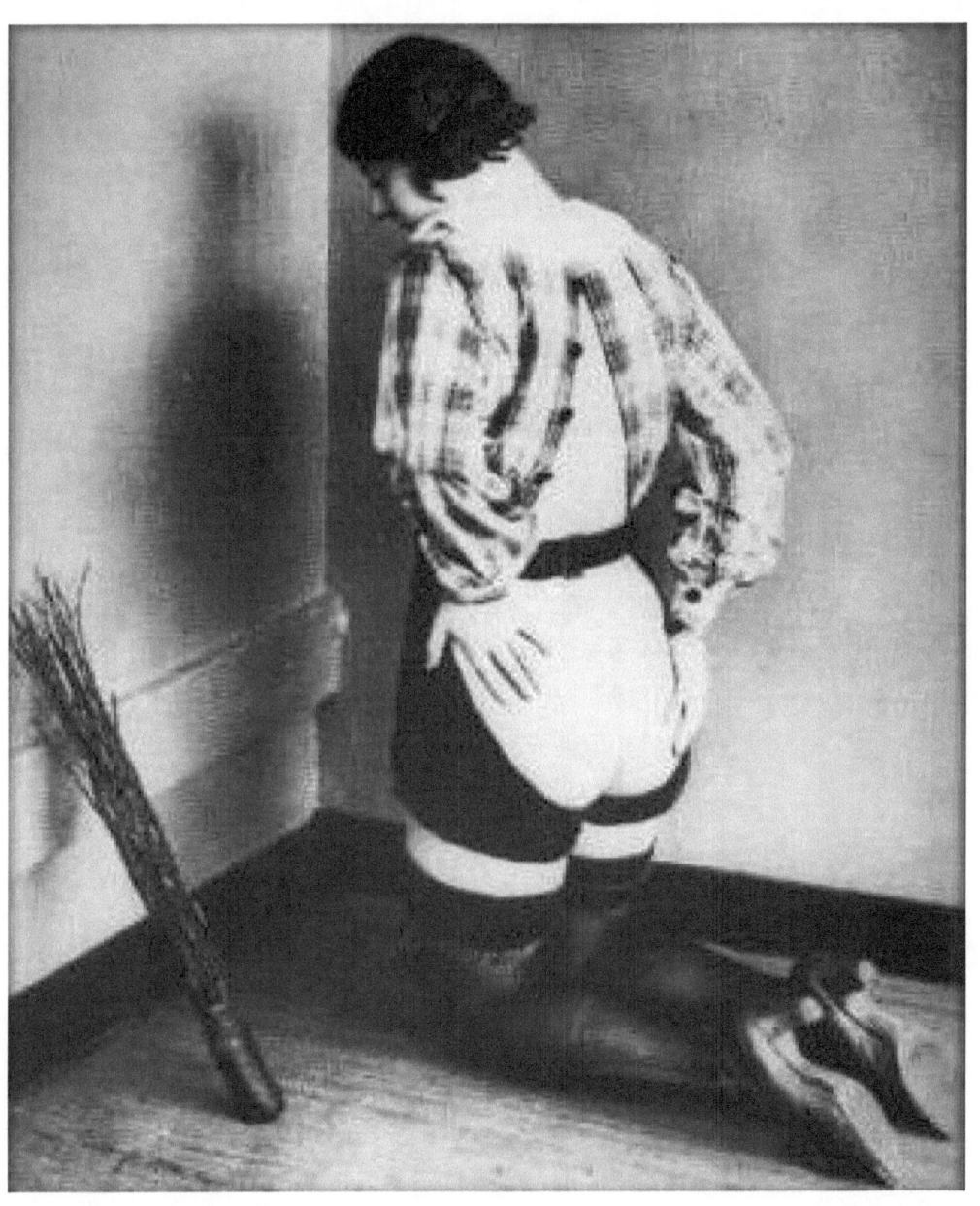

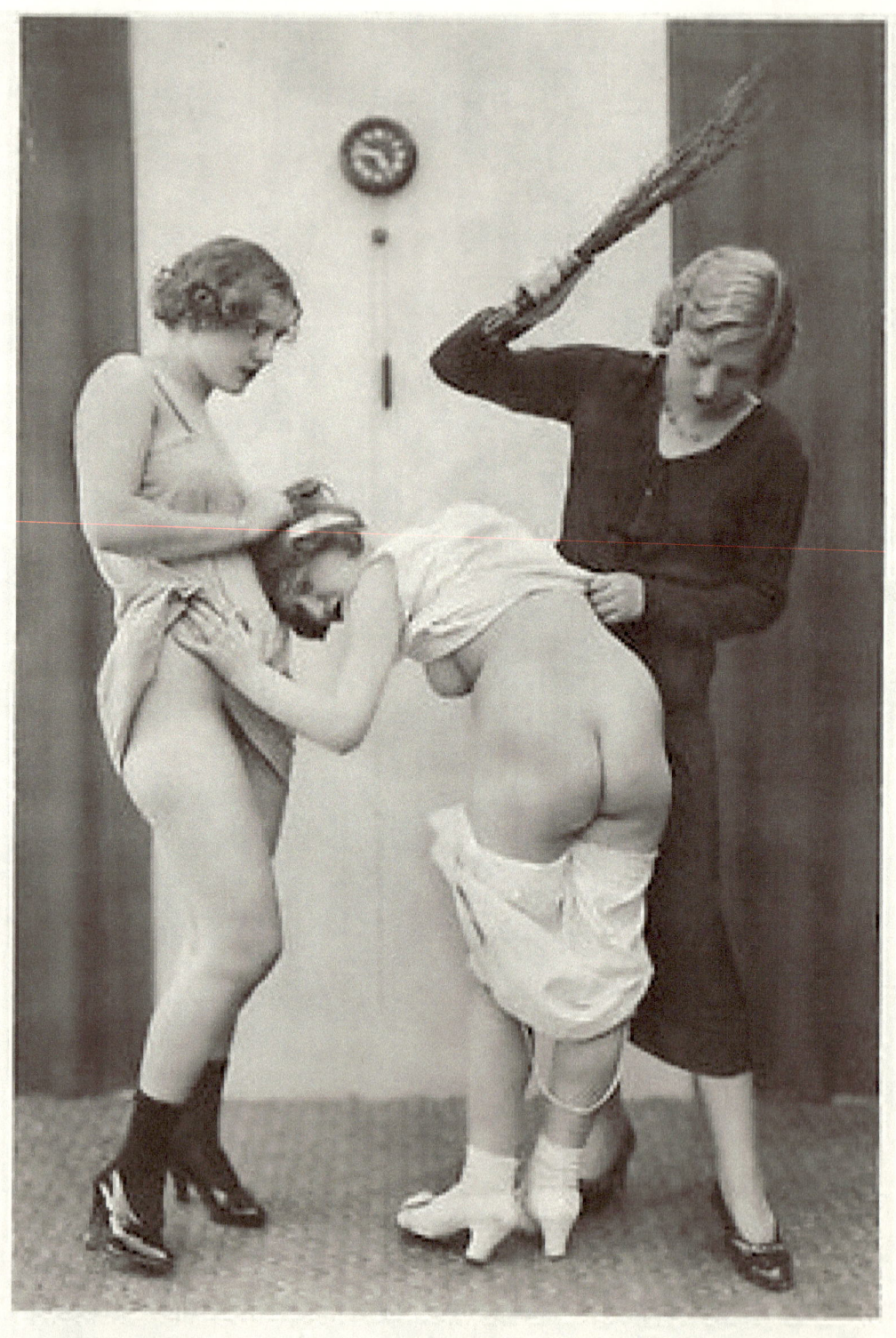

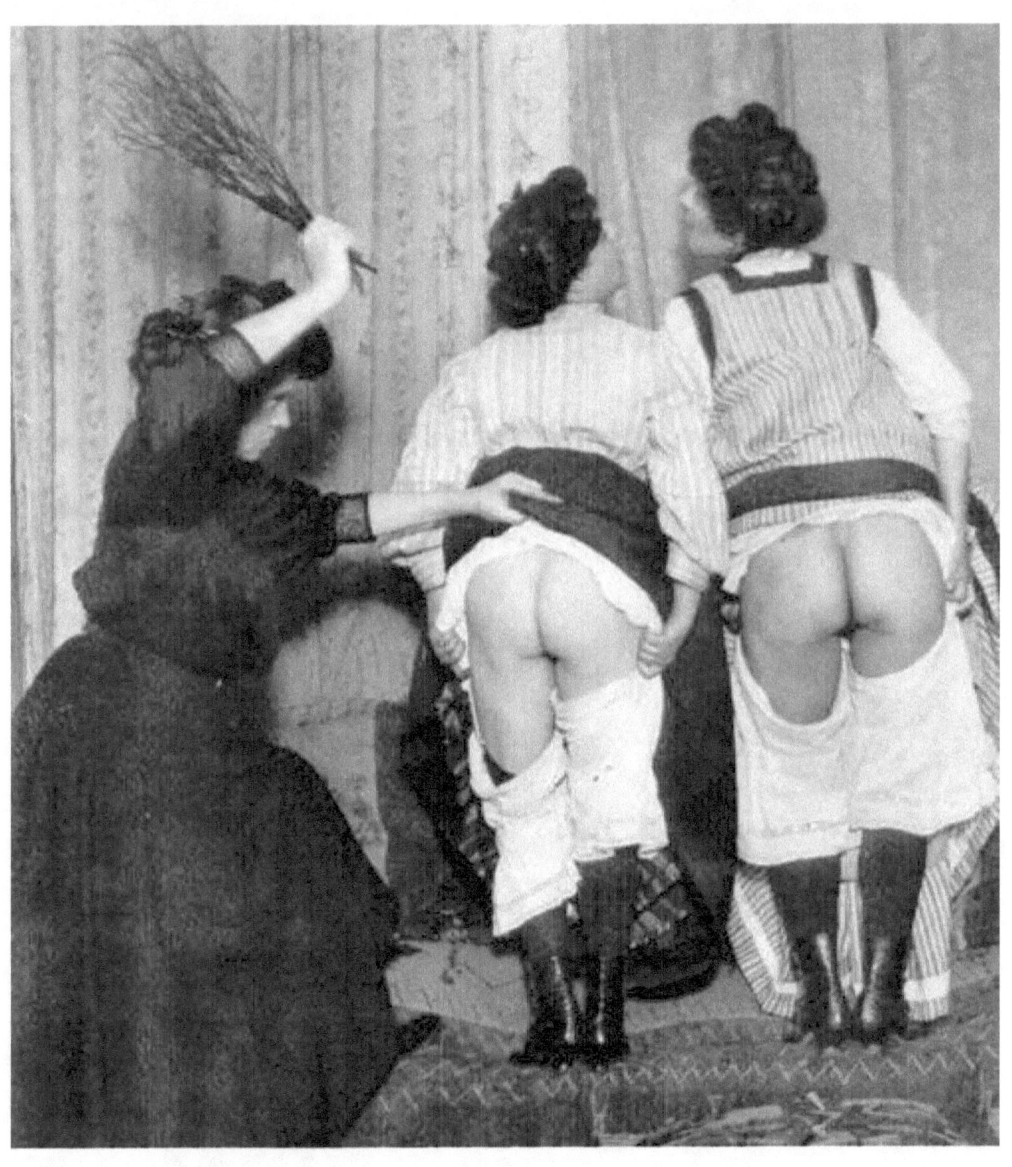

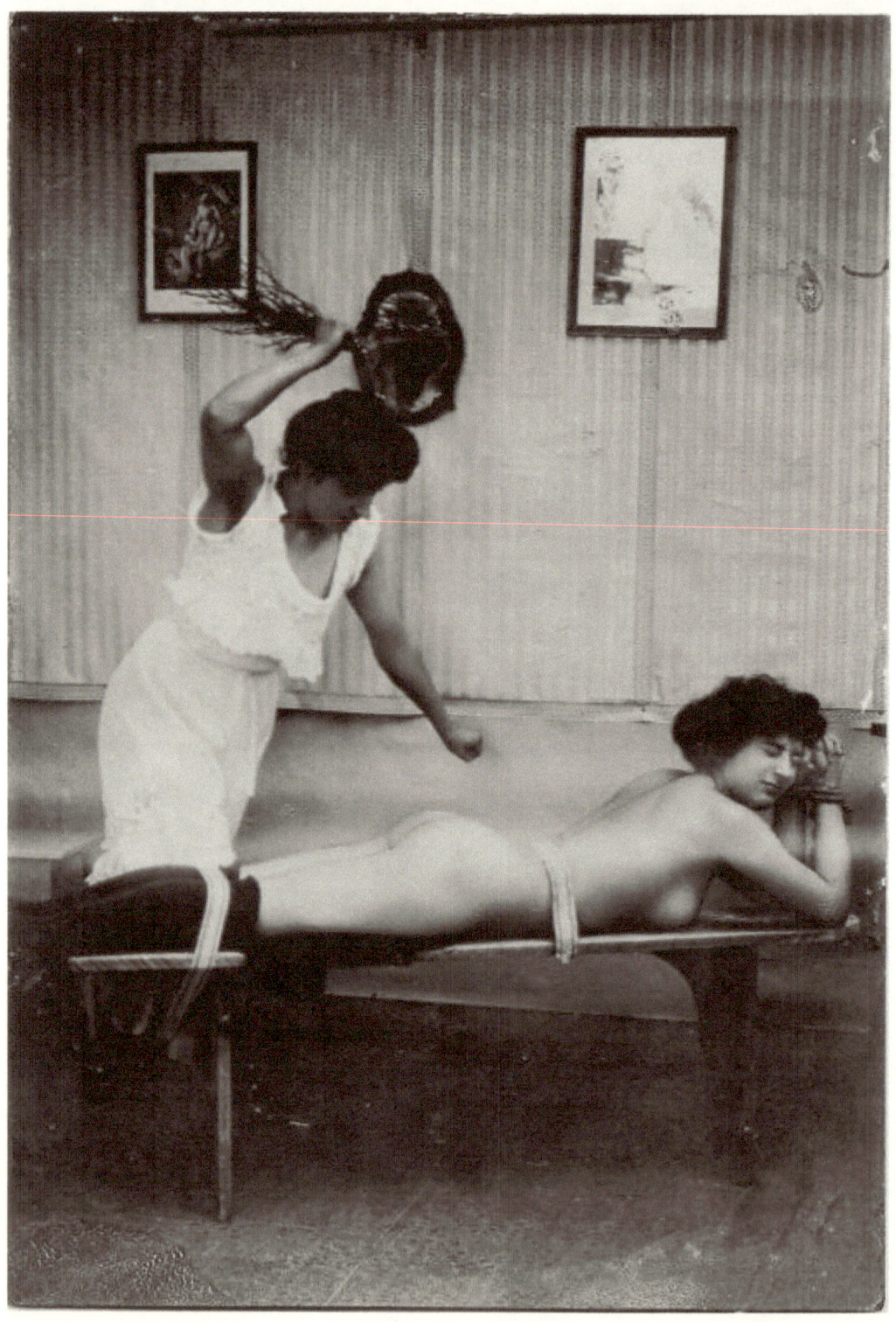

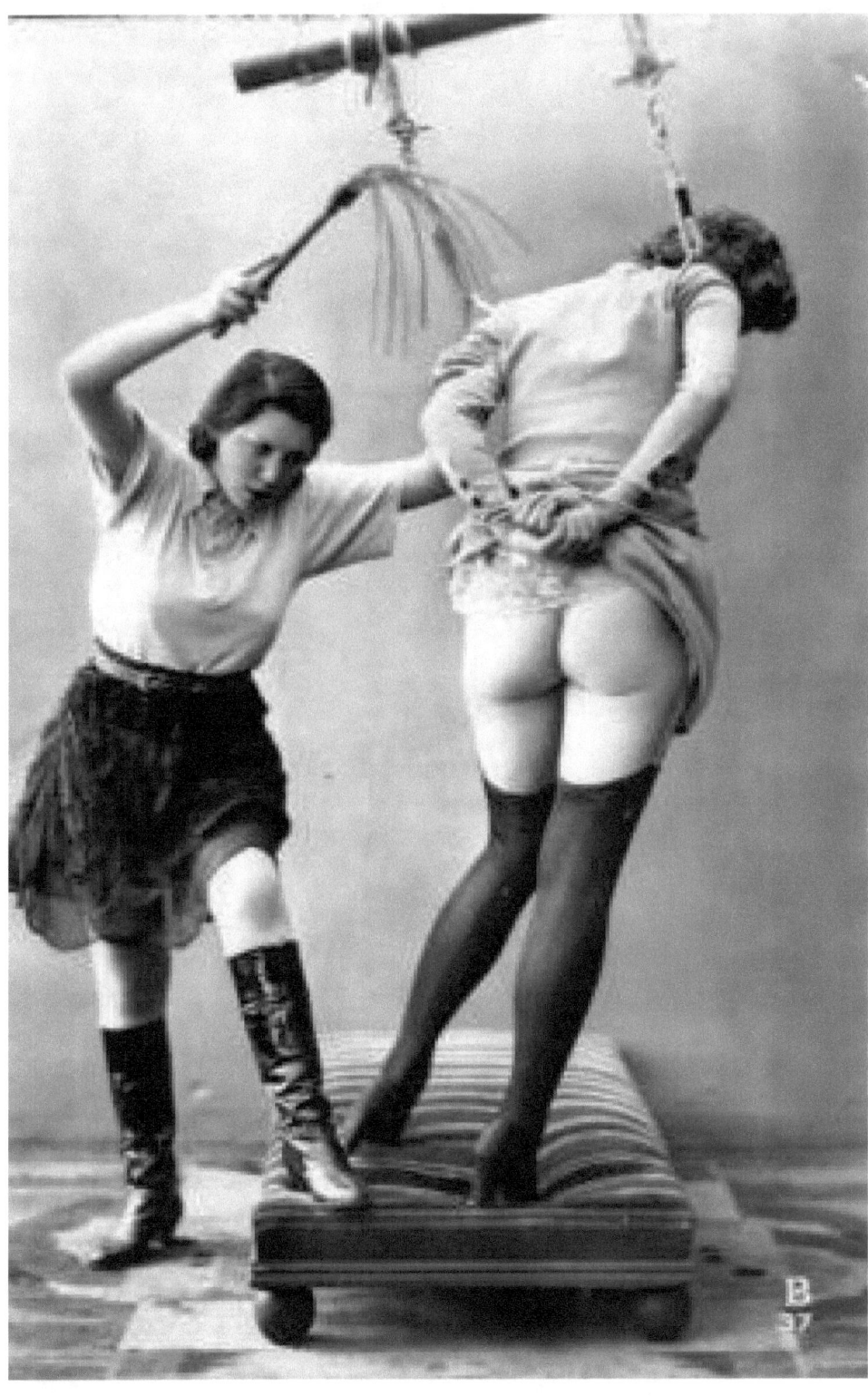

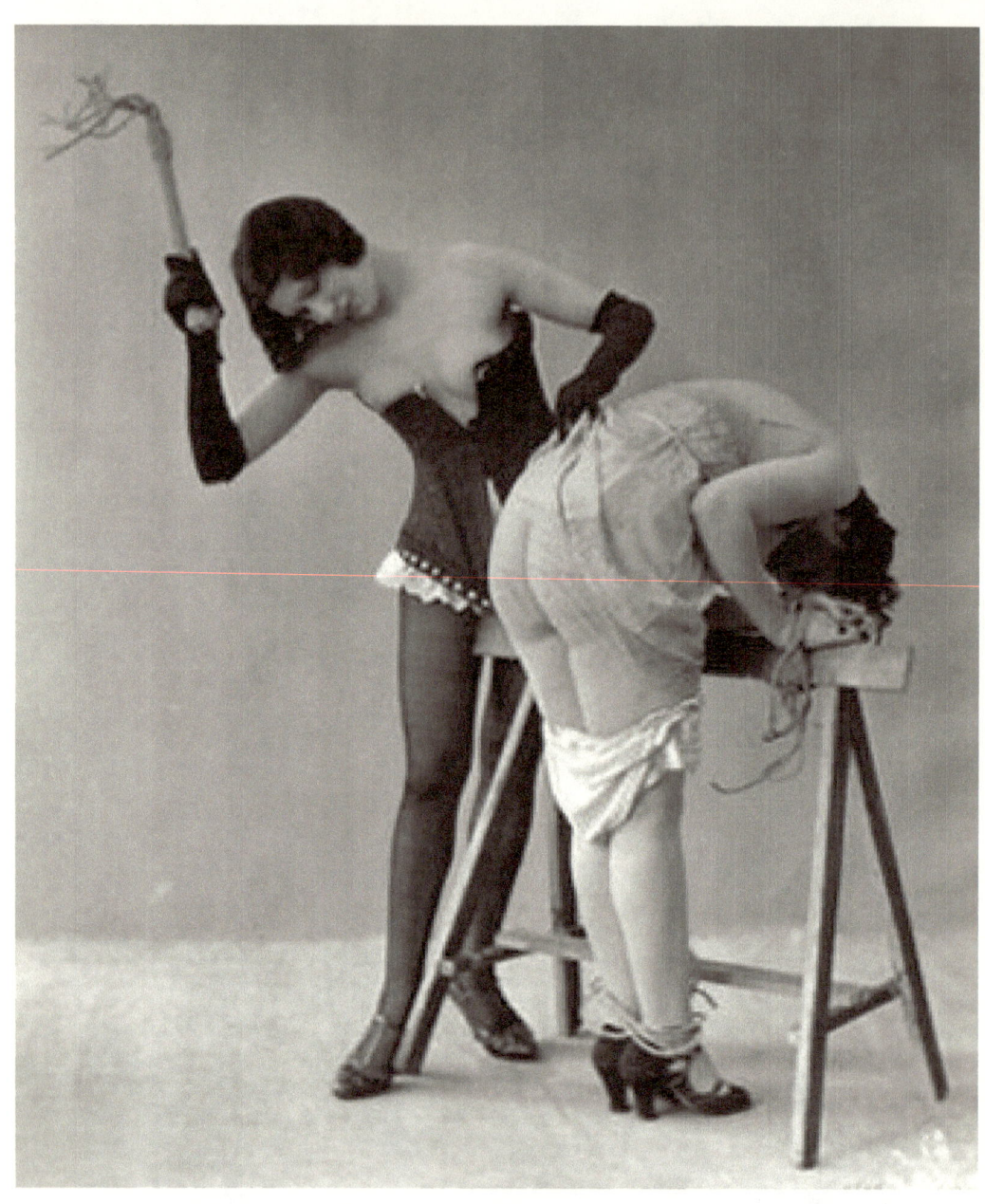

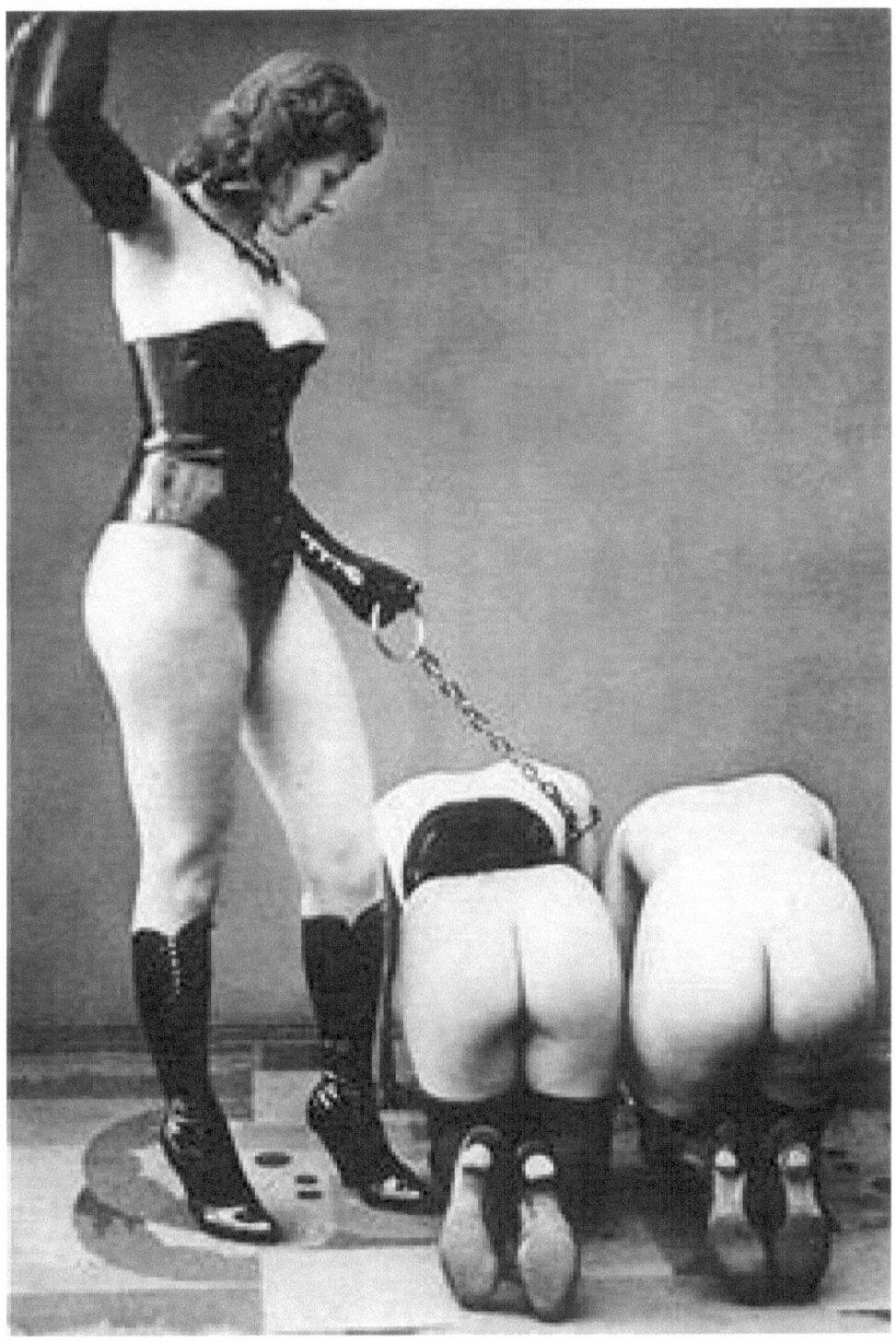

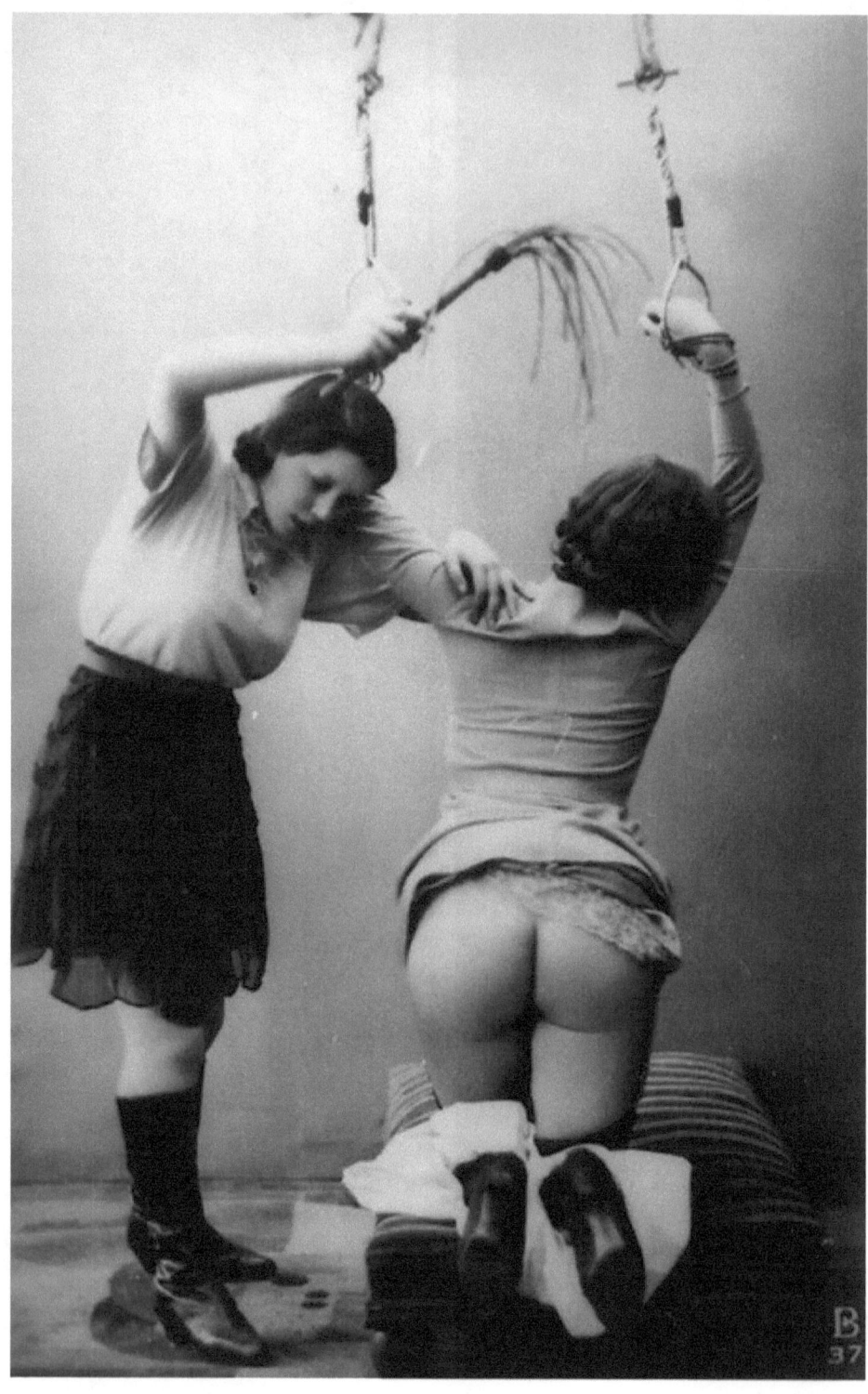

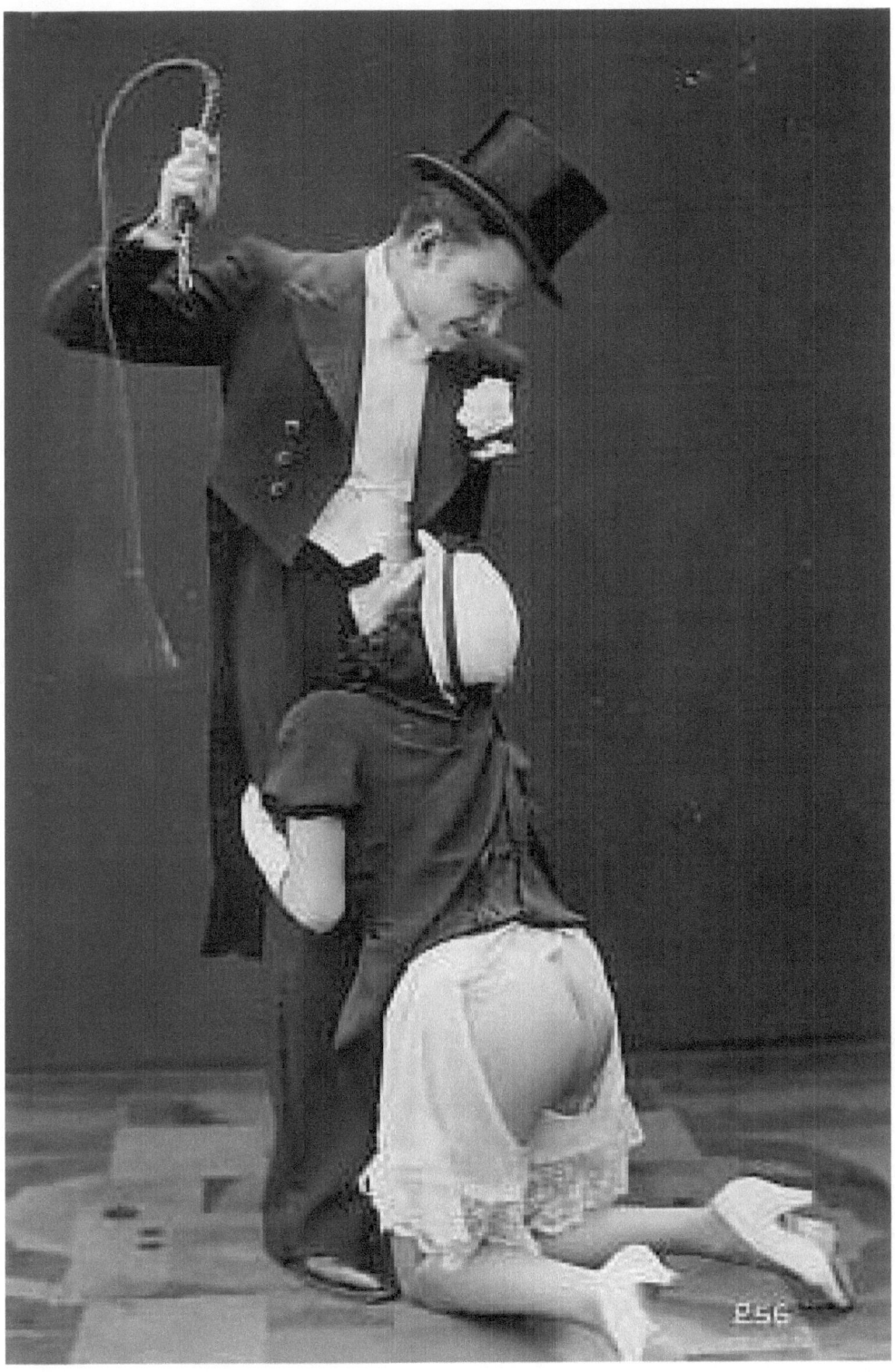

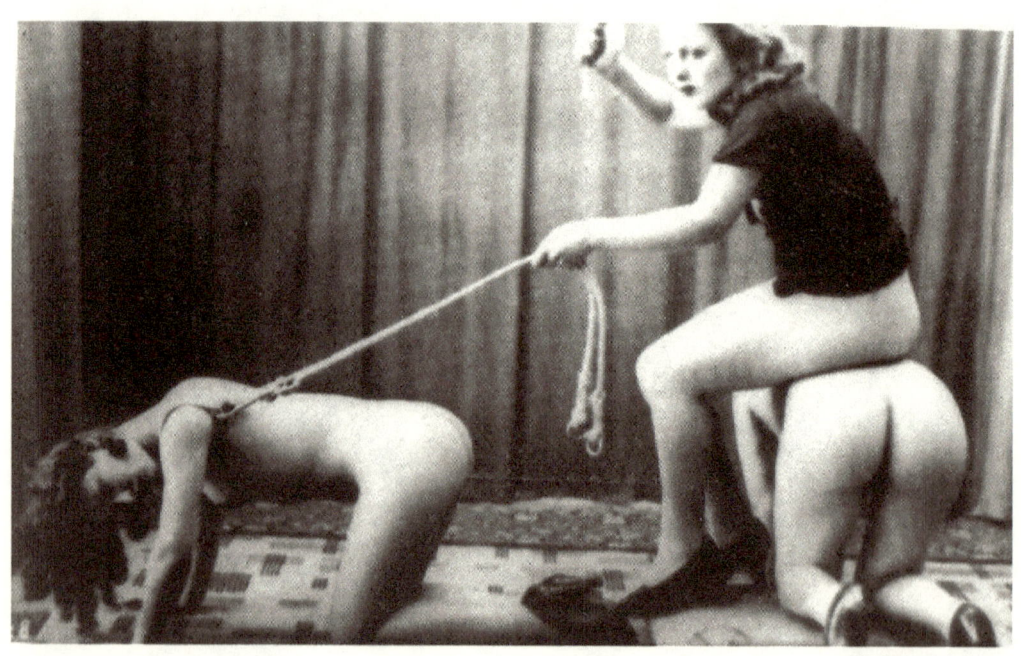

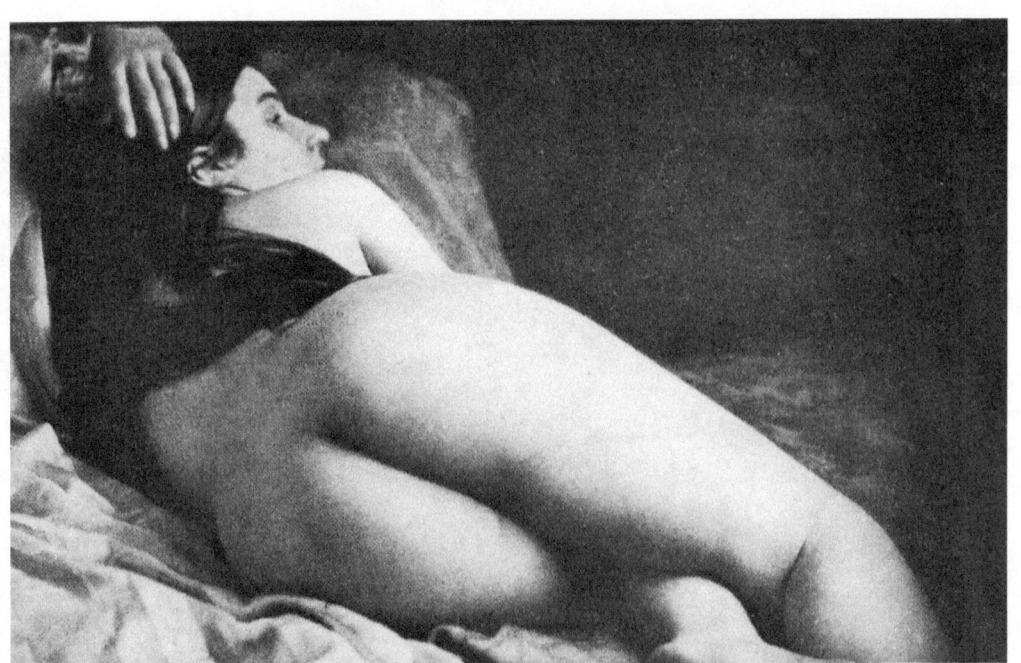

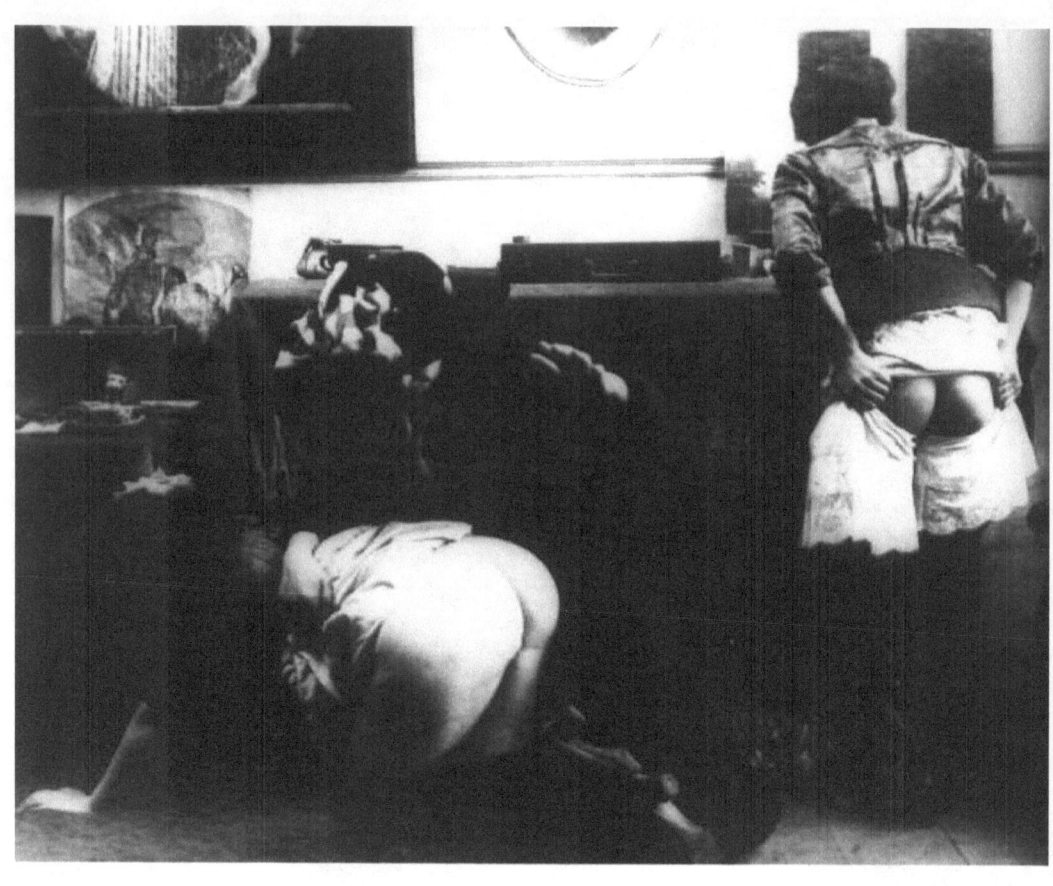

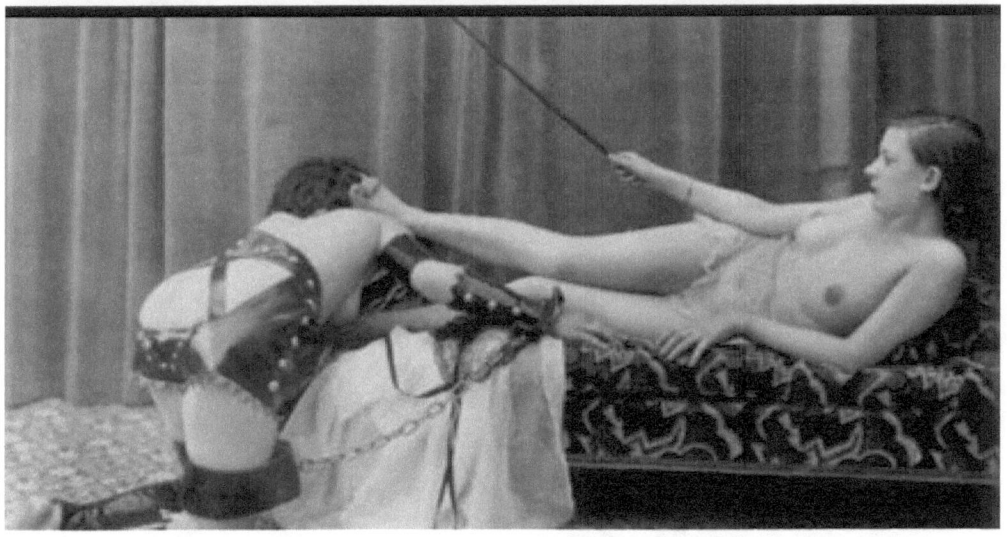

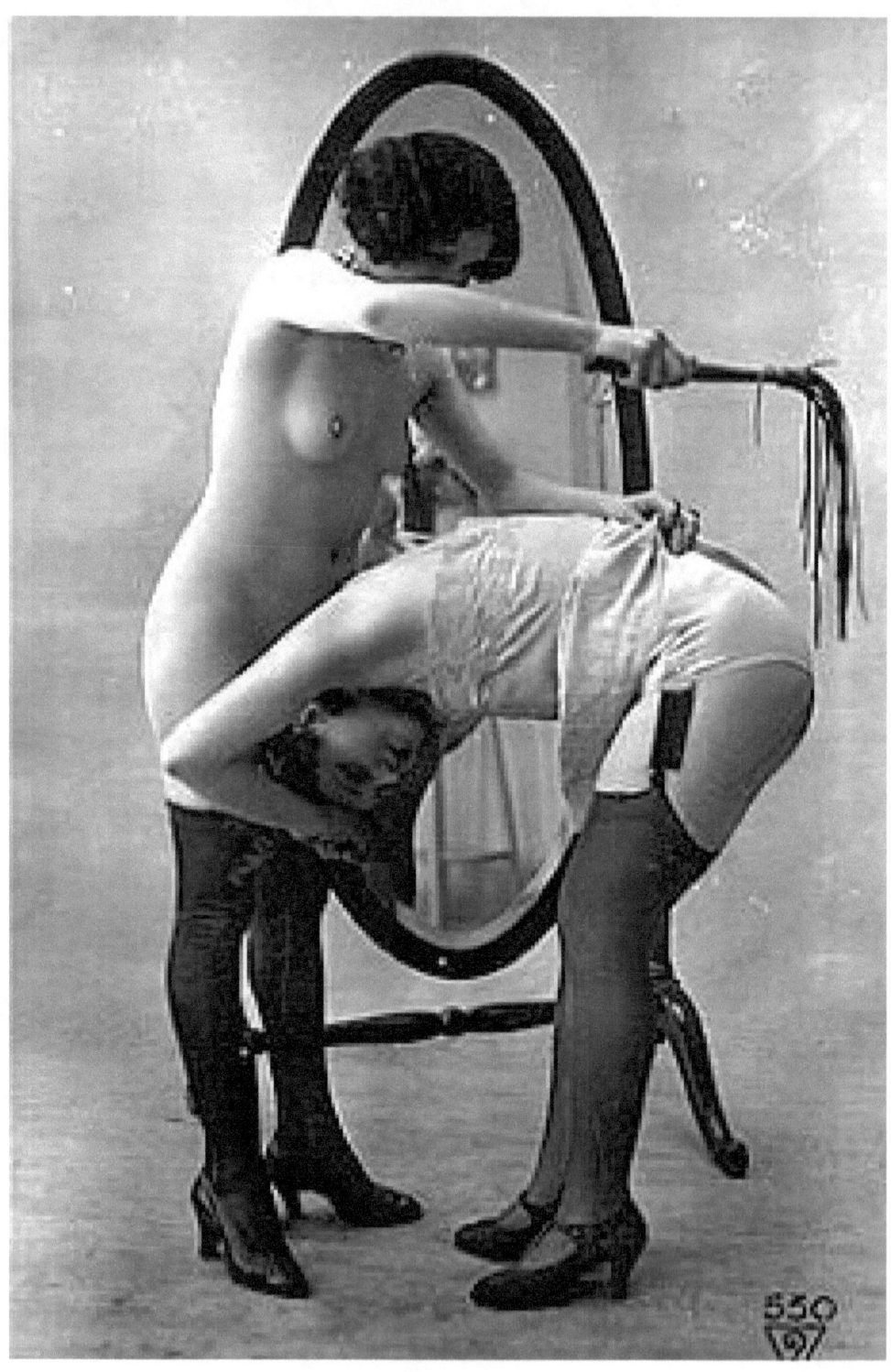

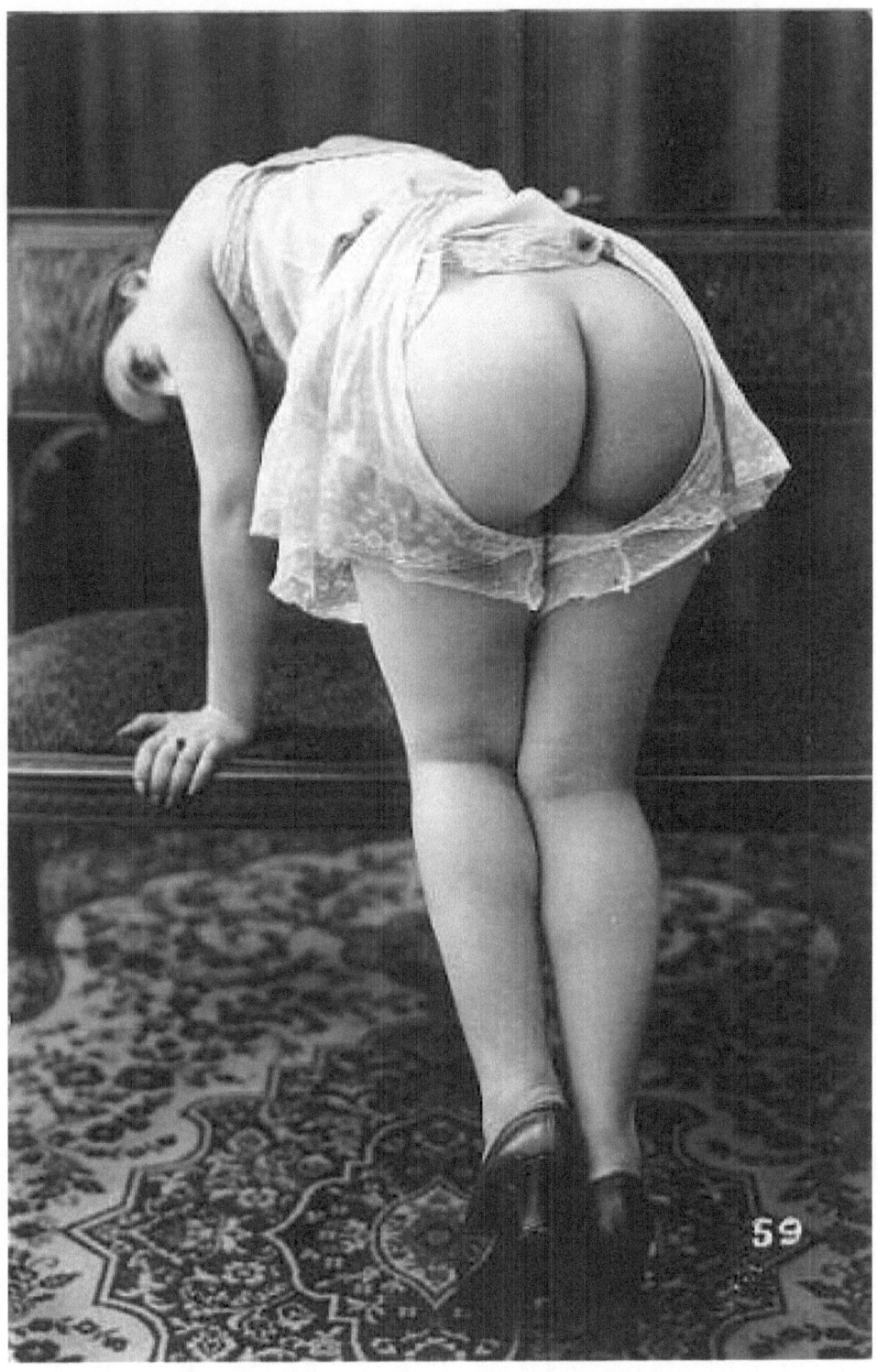

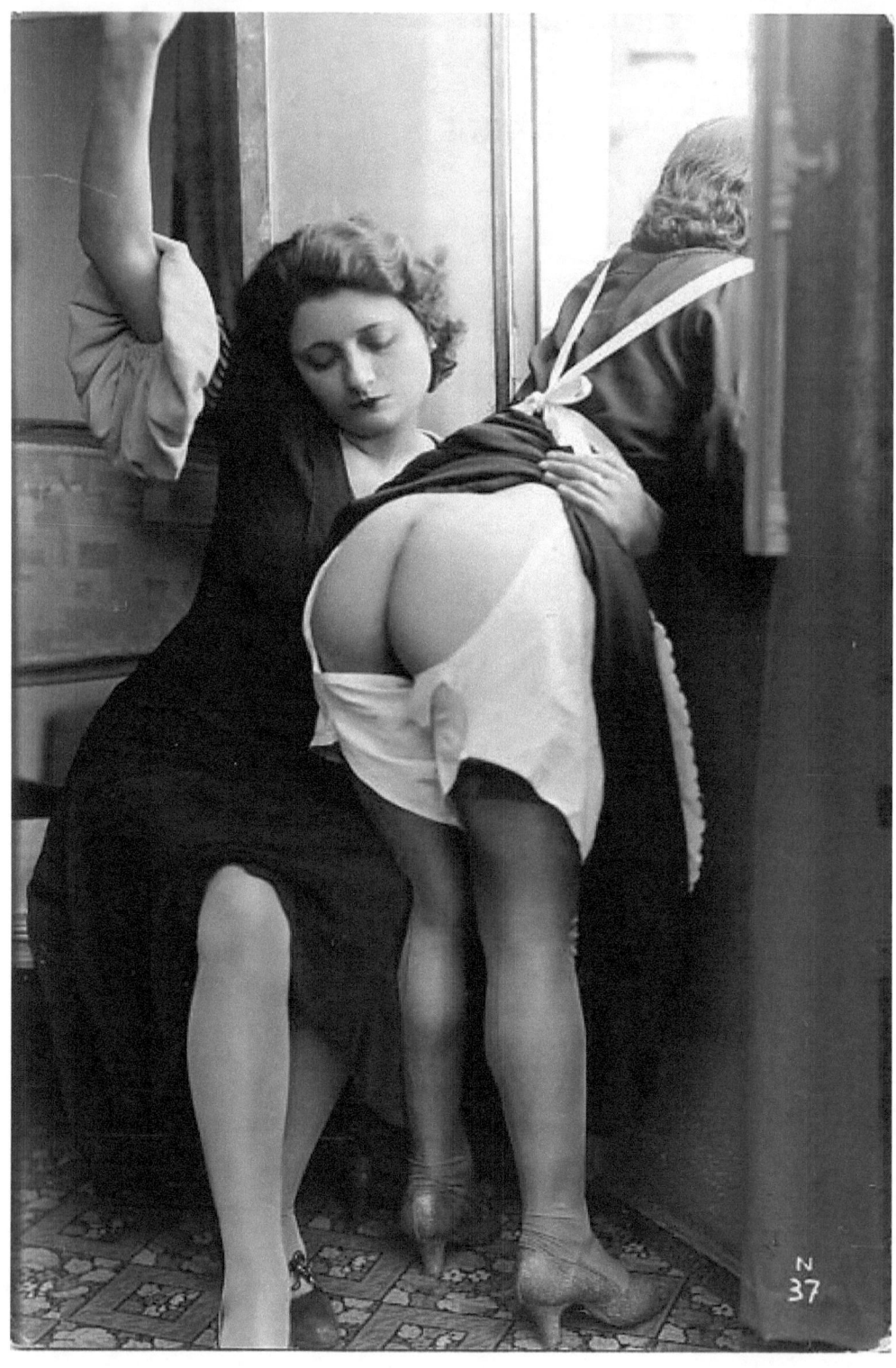

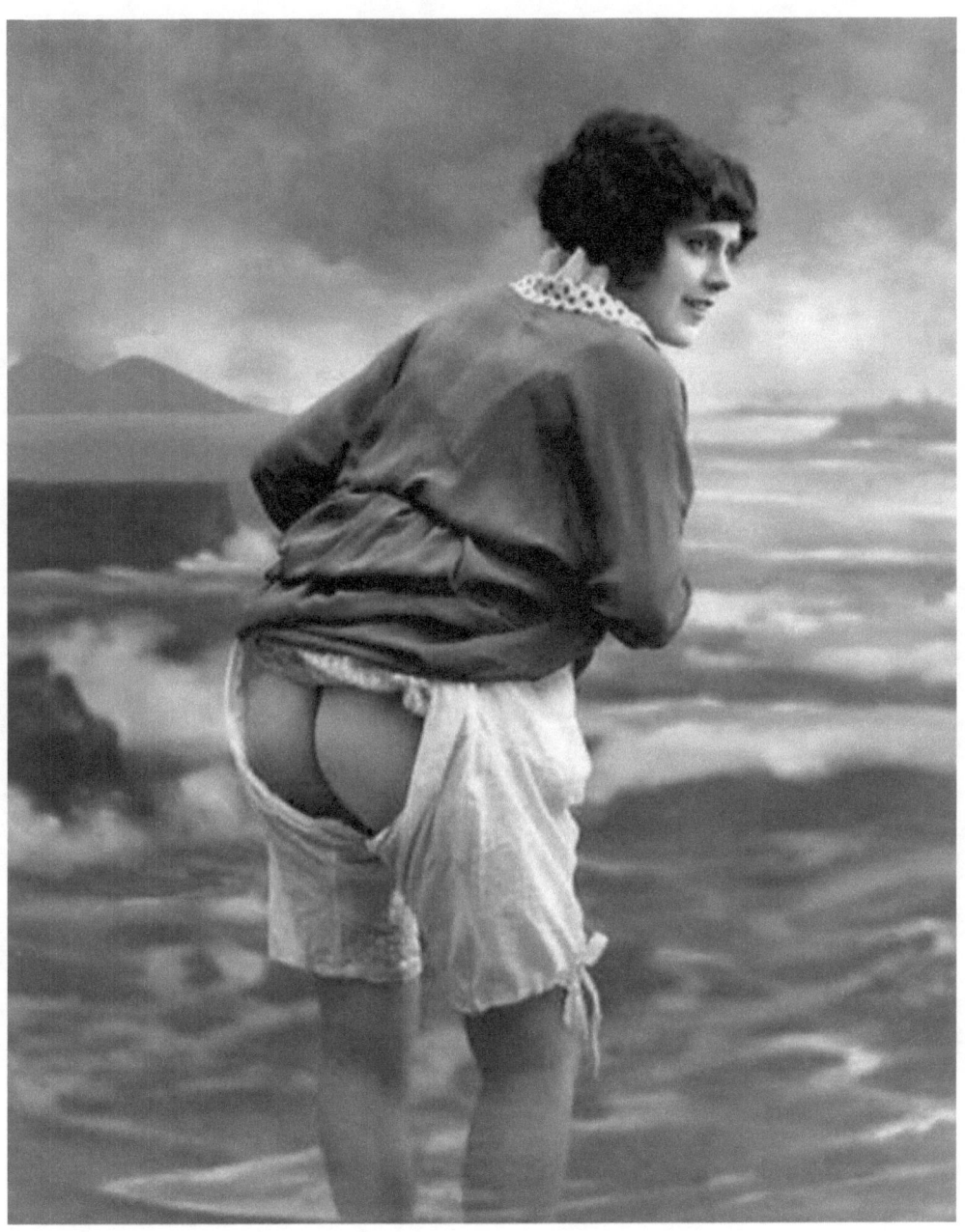

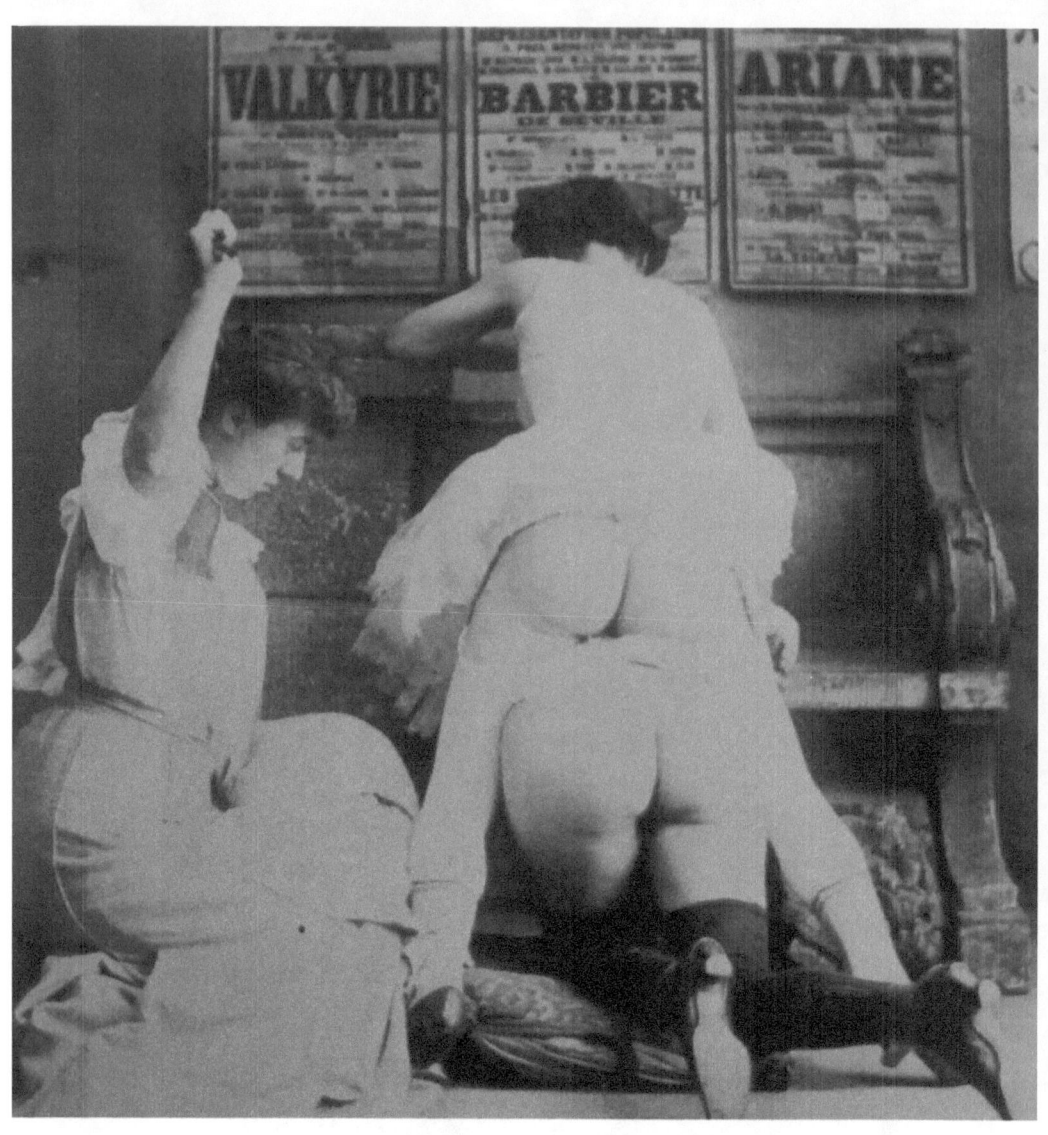

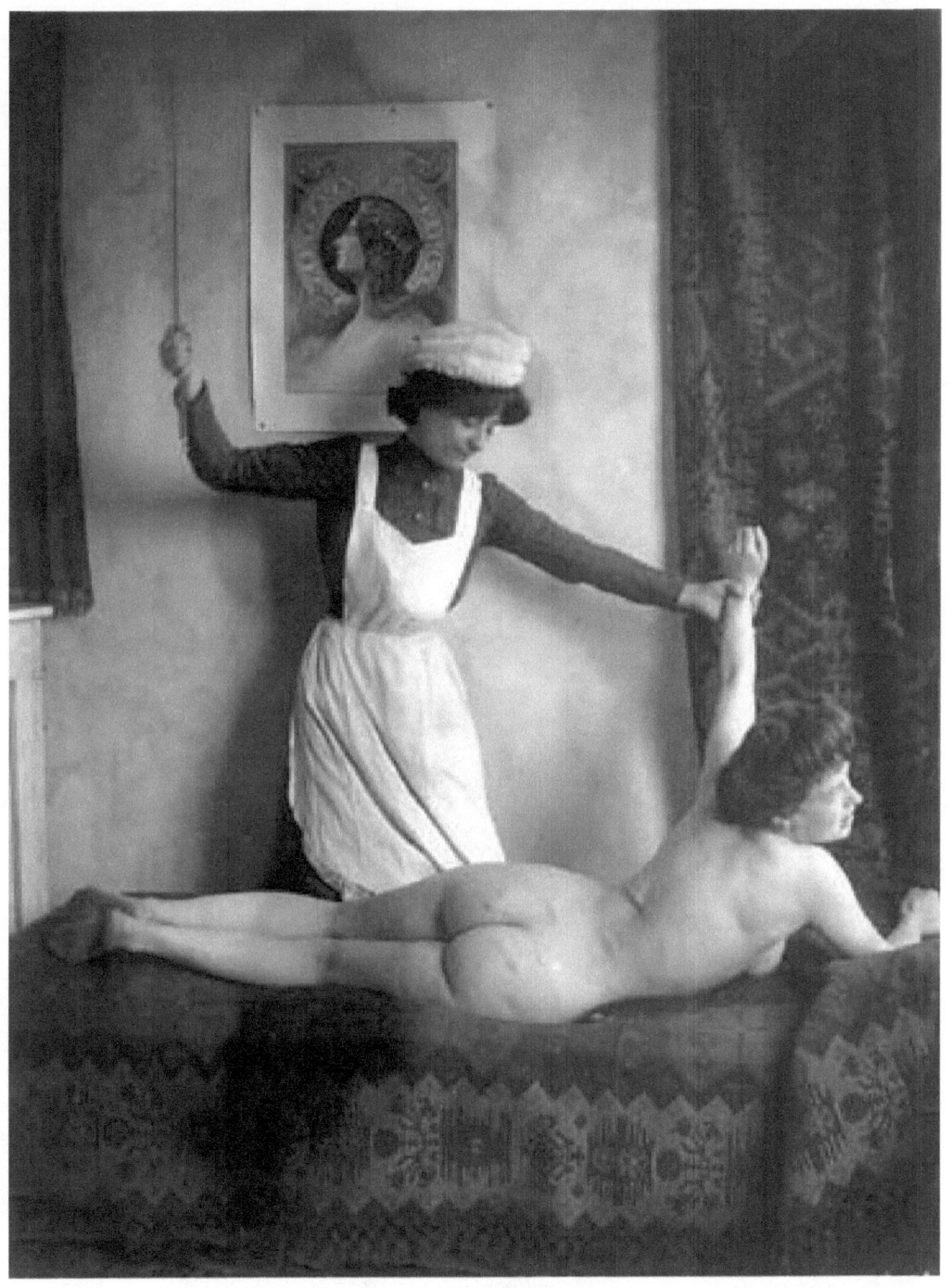

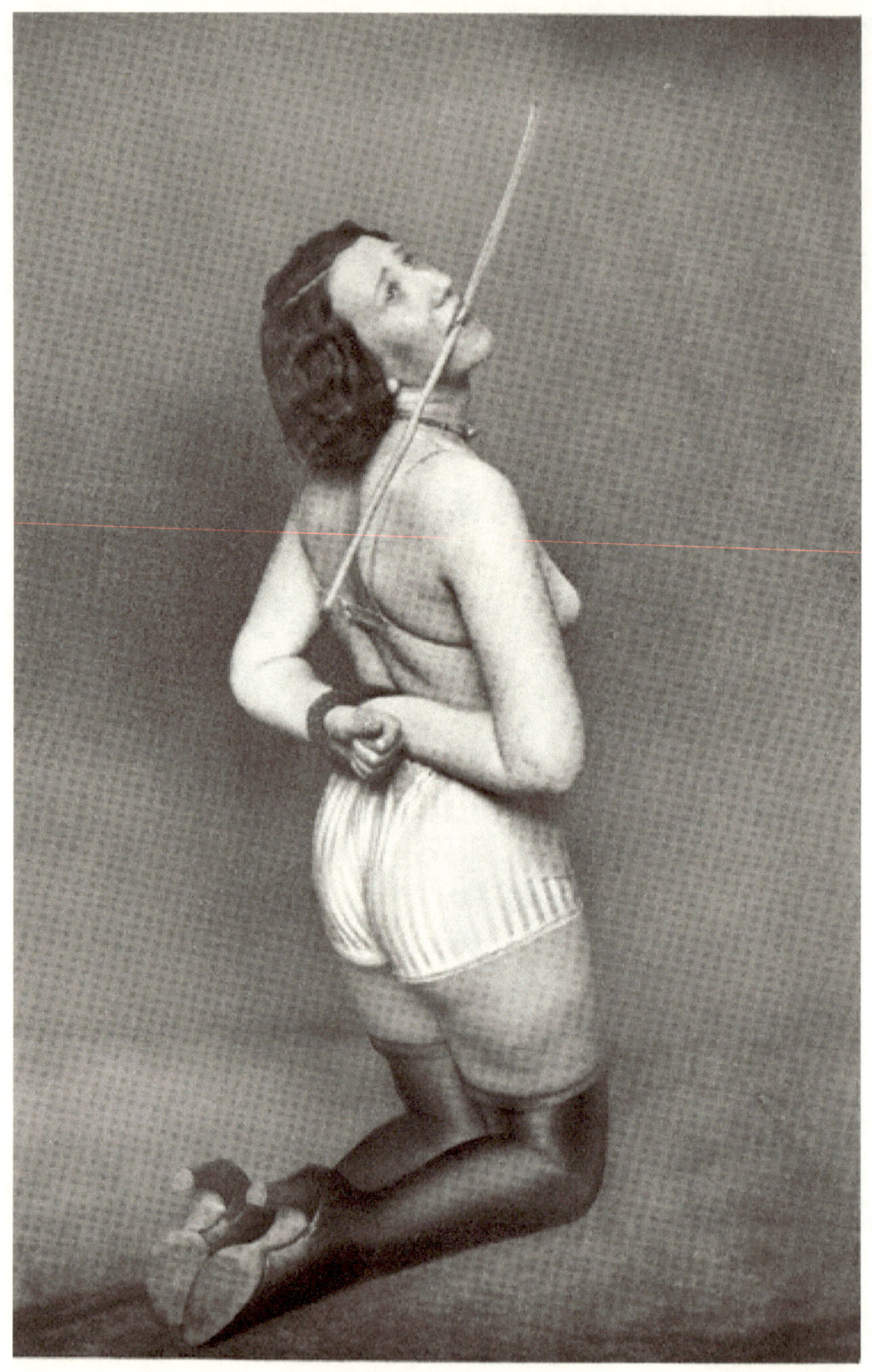

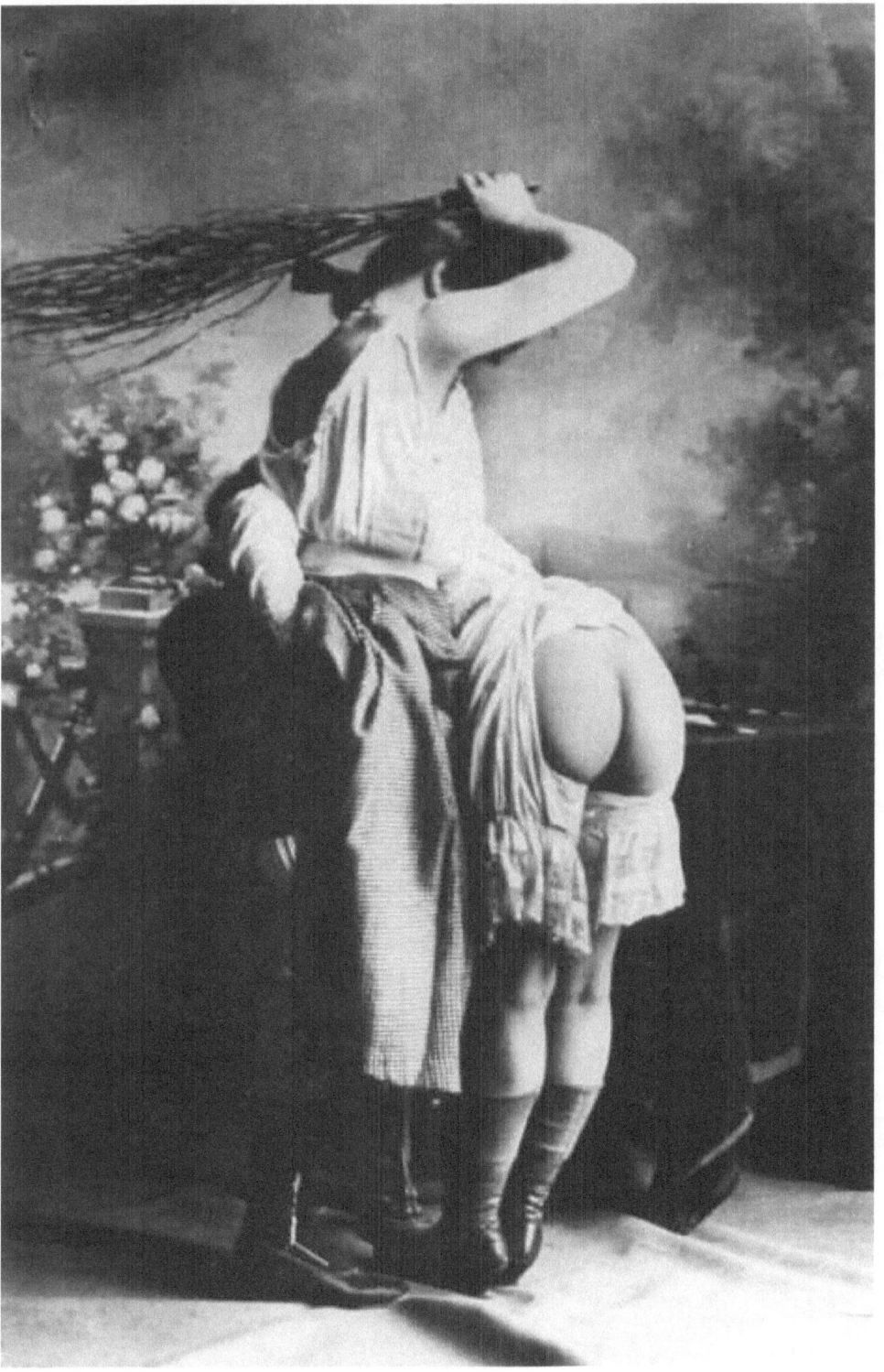

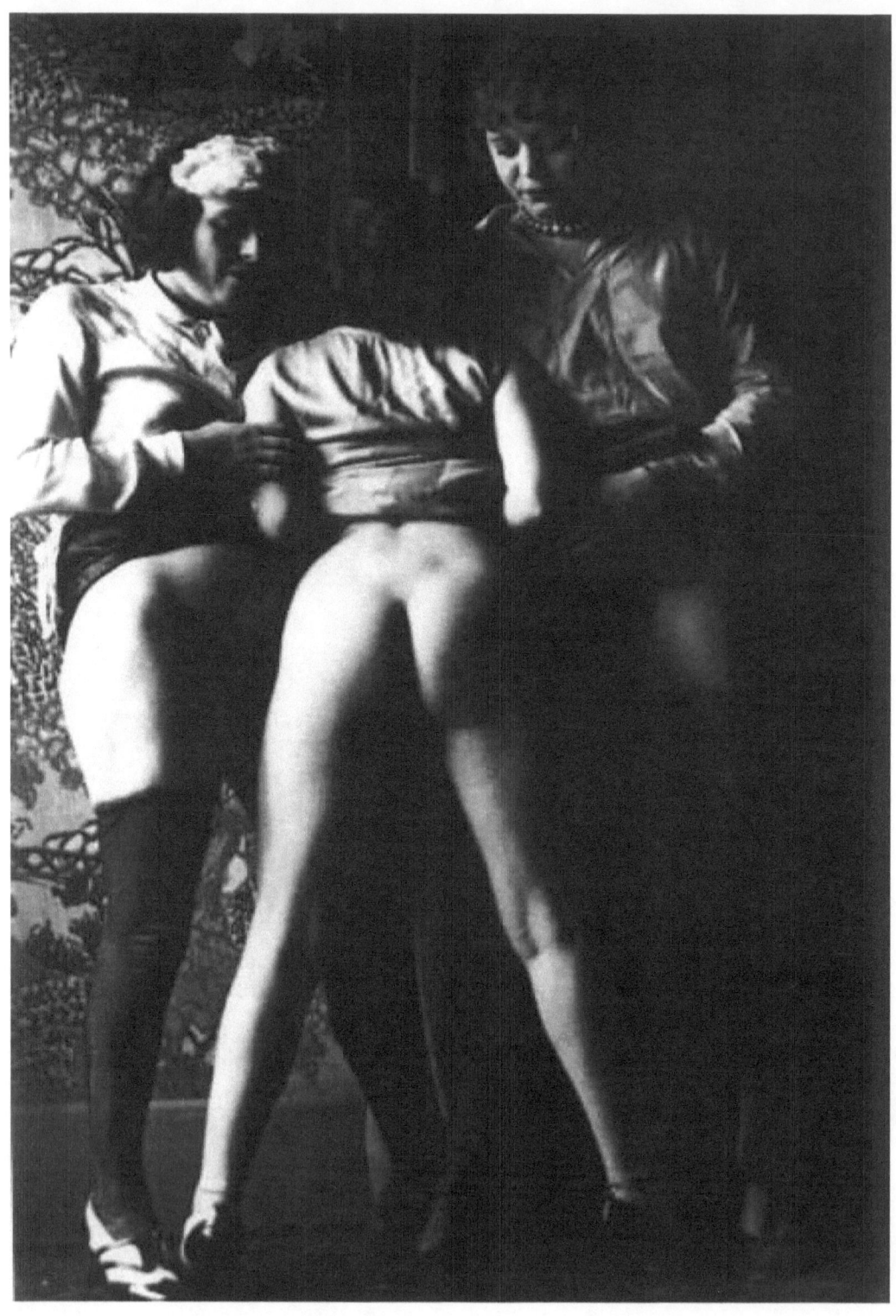

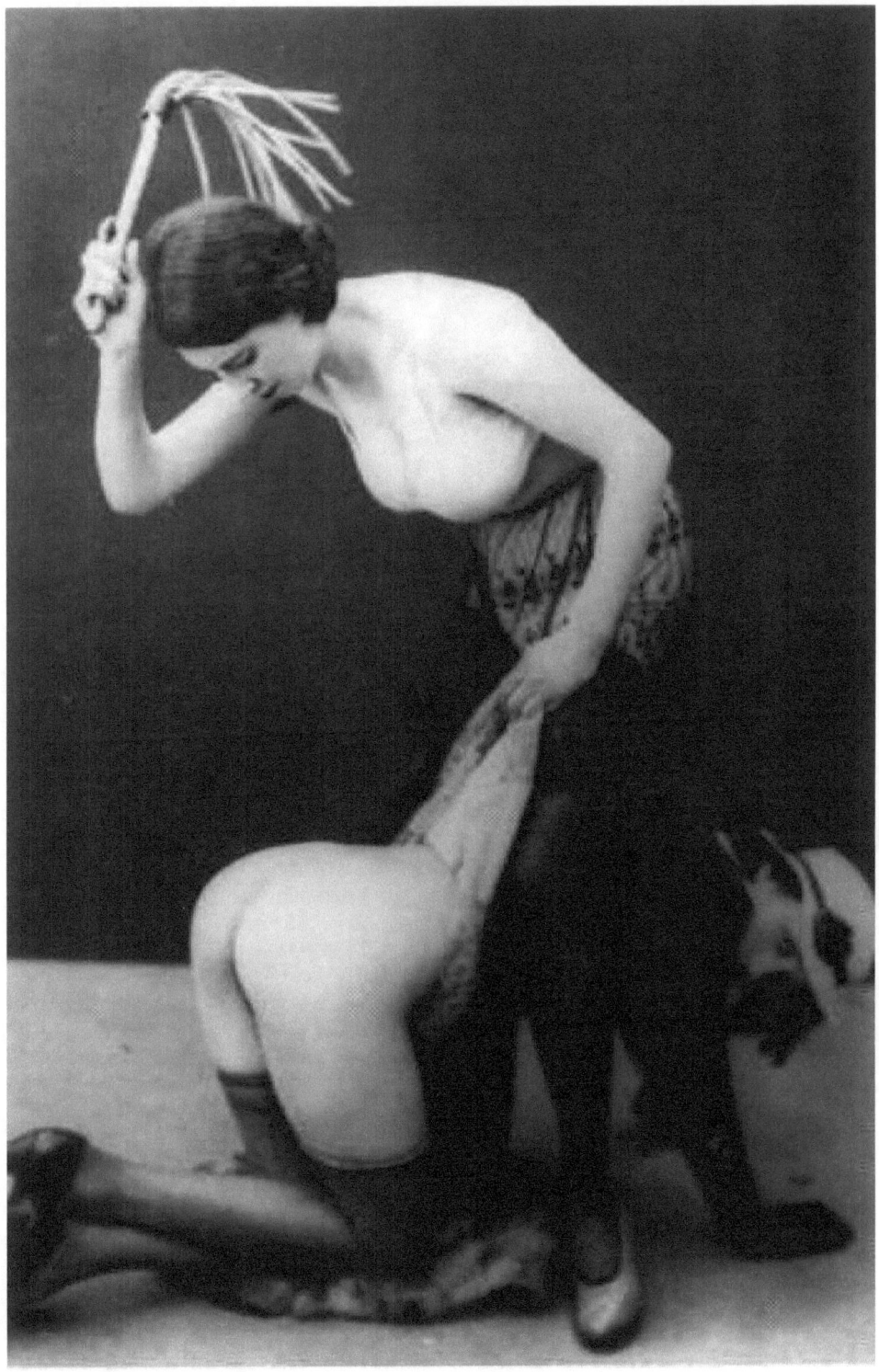

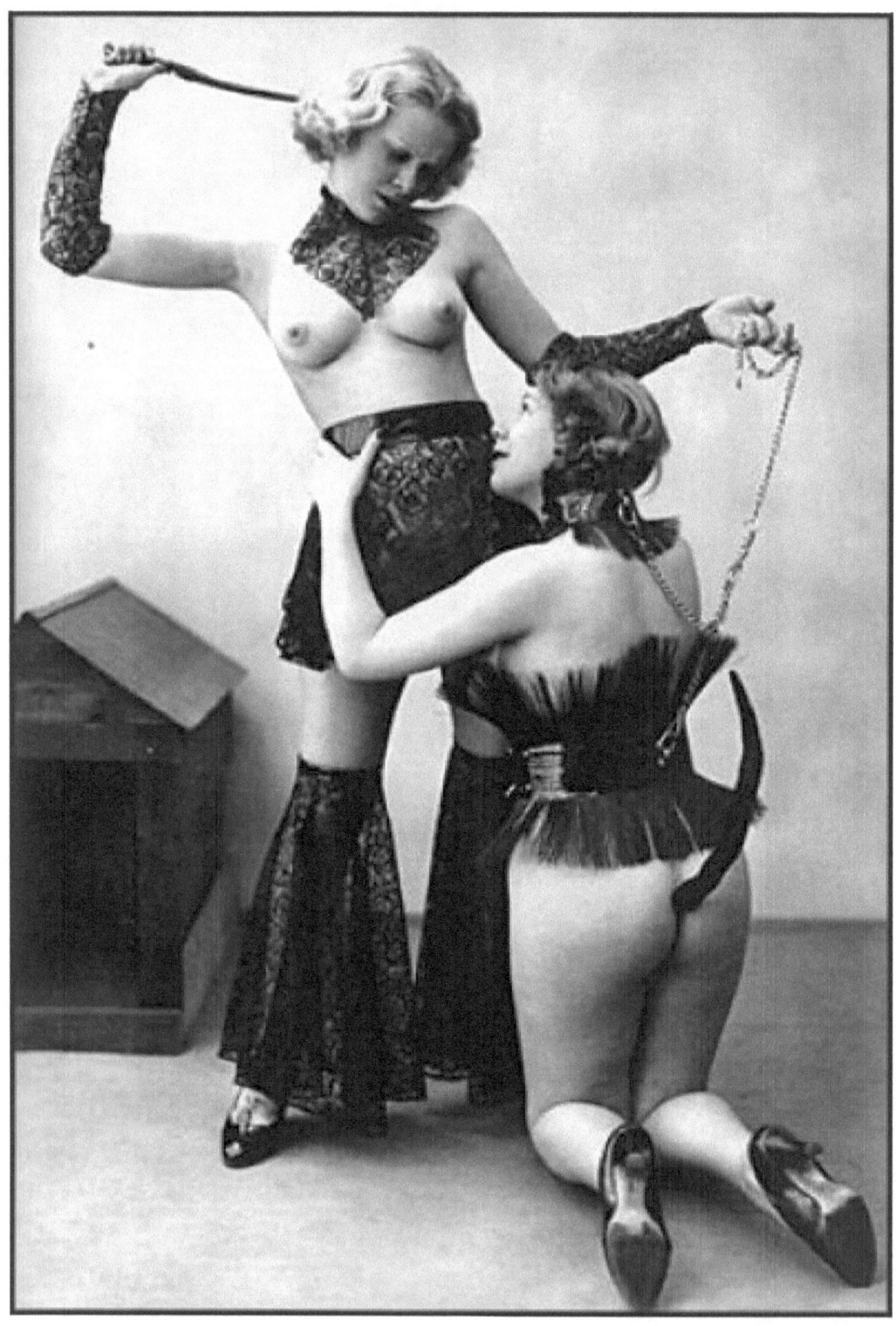

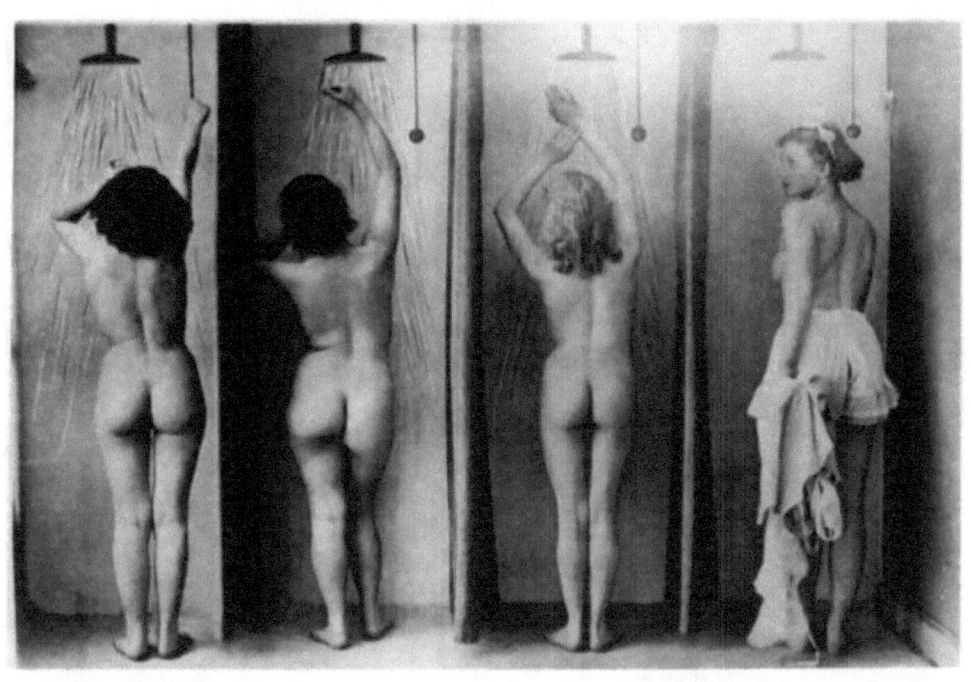

82

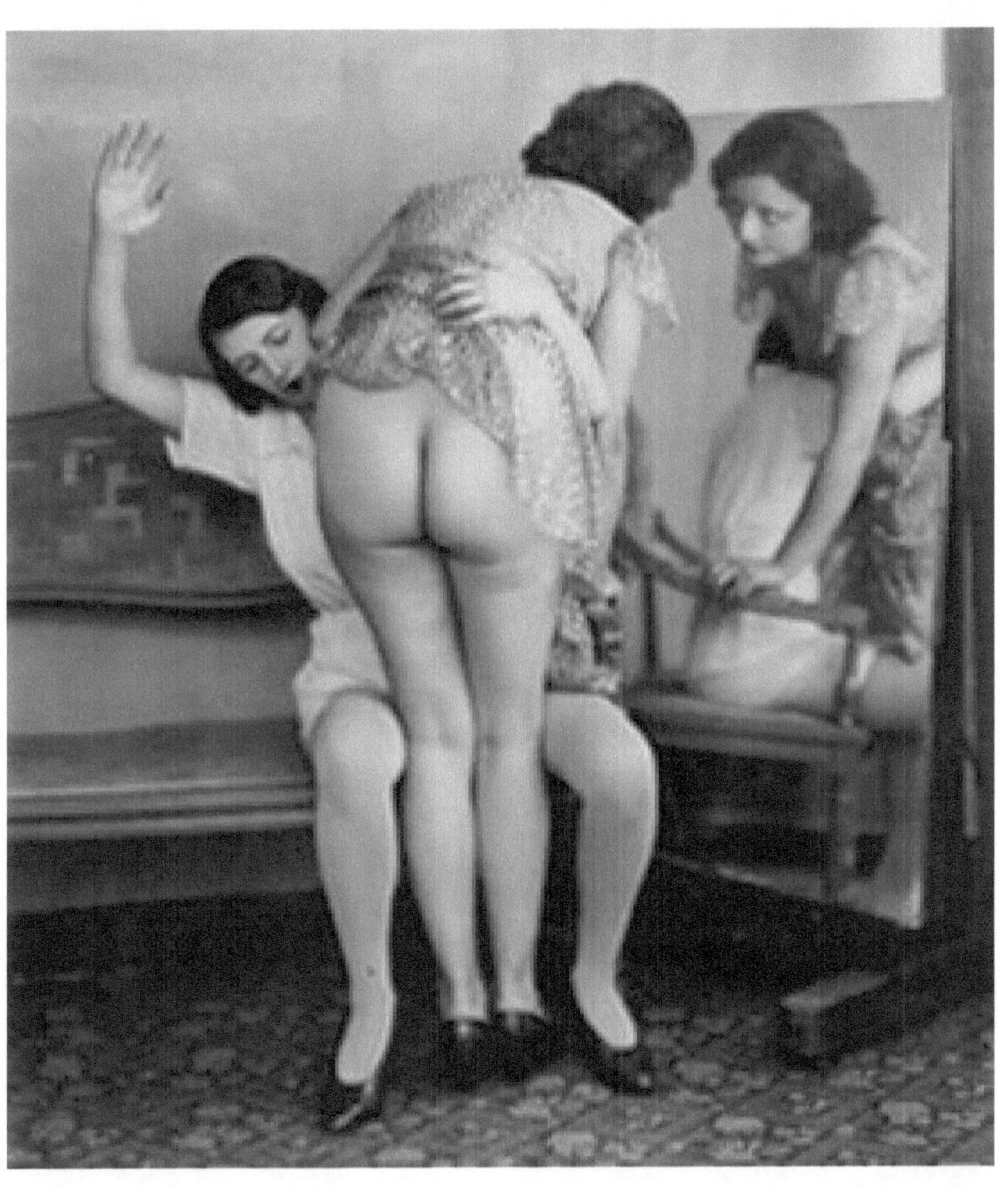

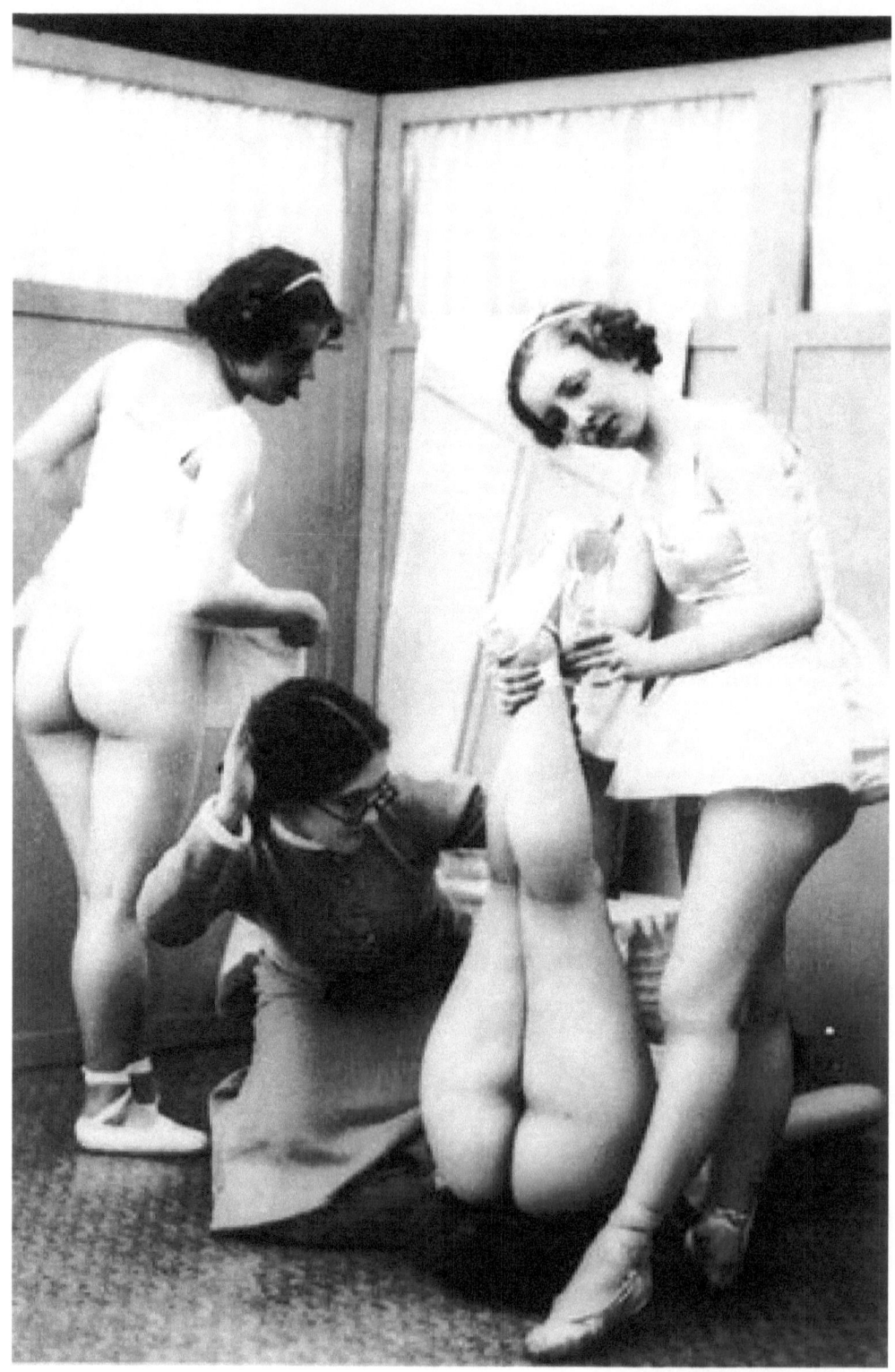

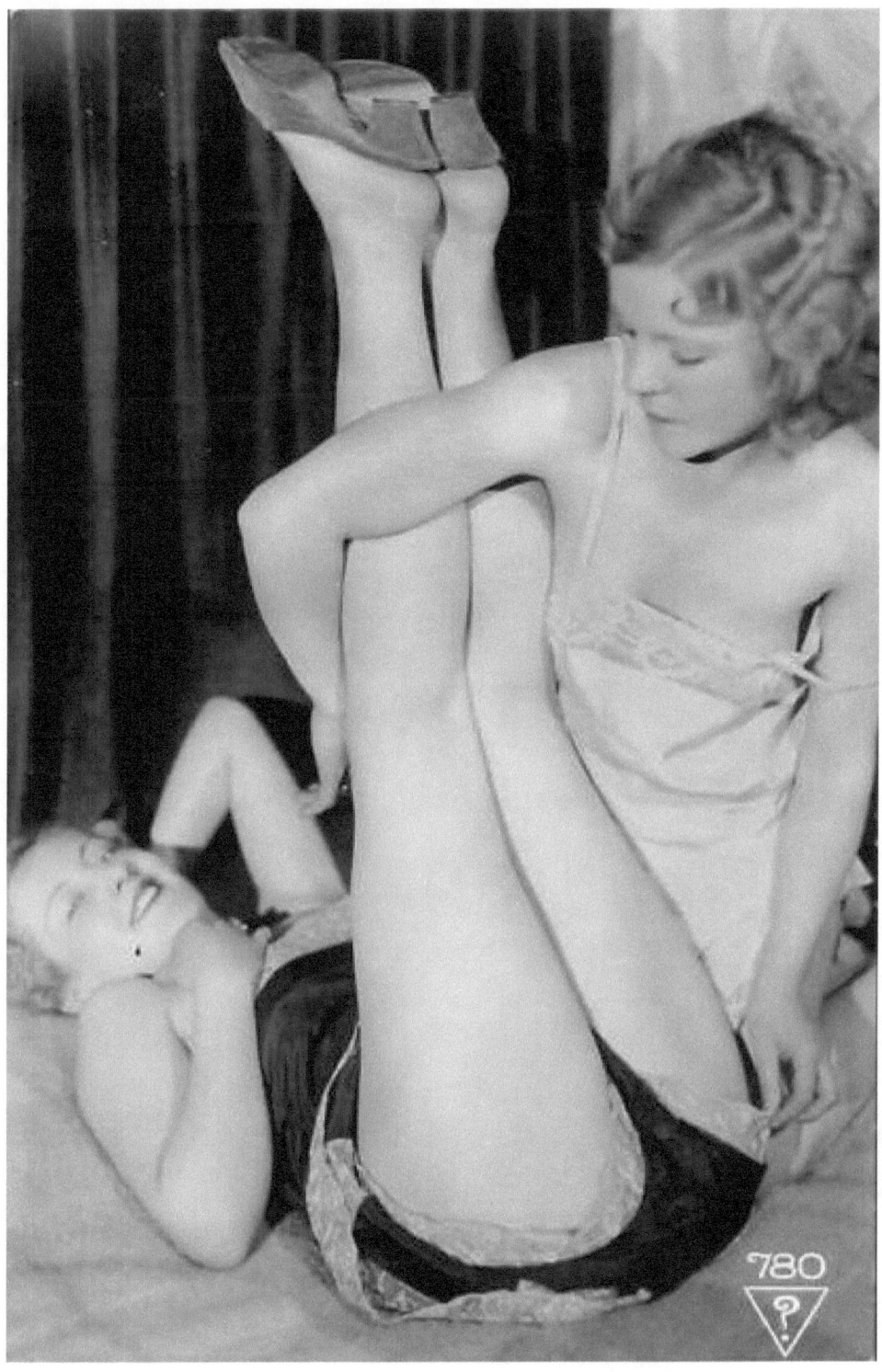

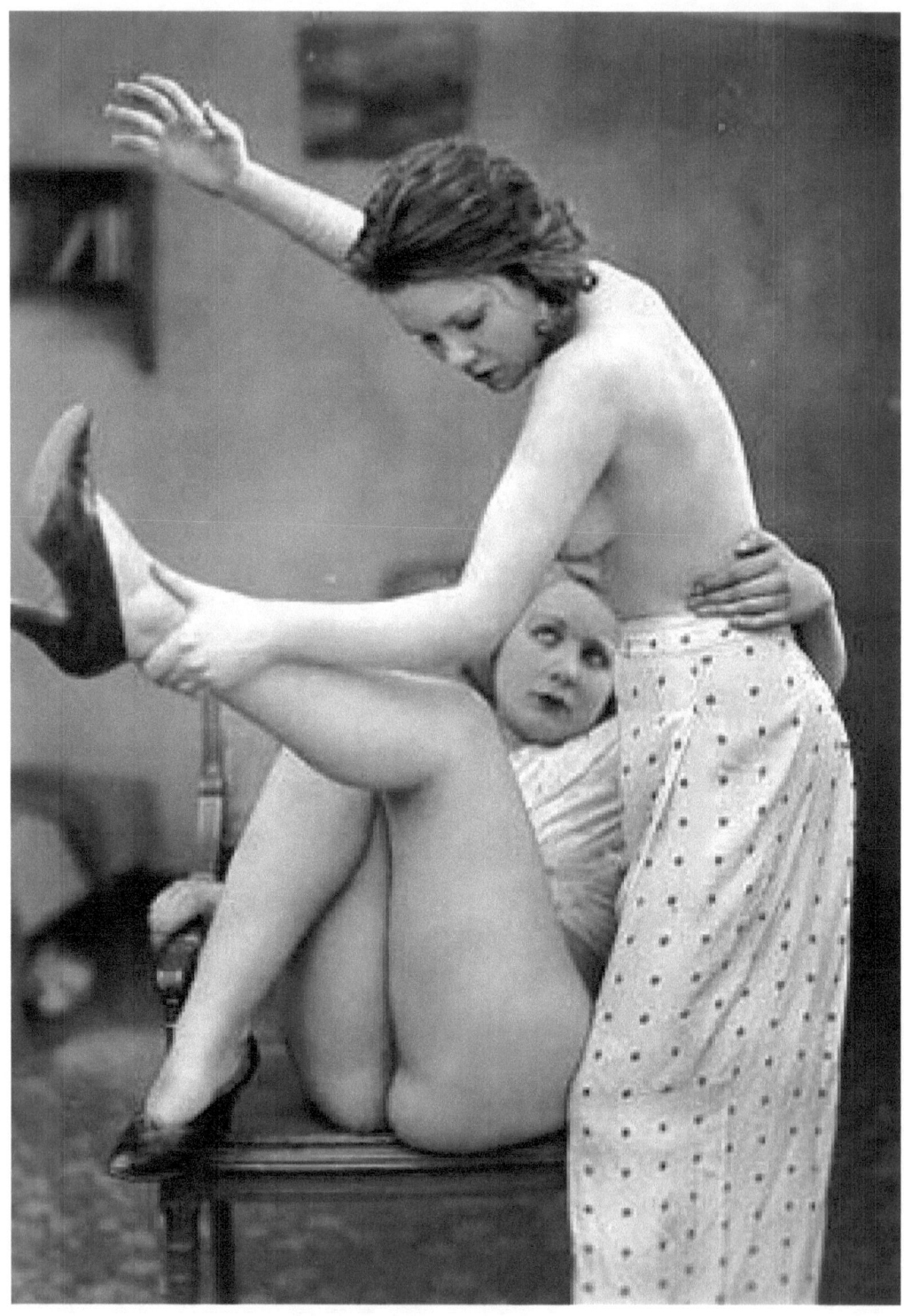

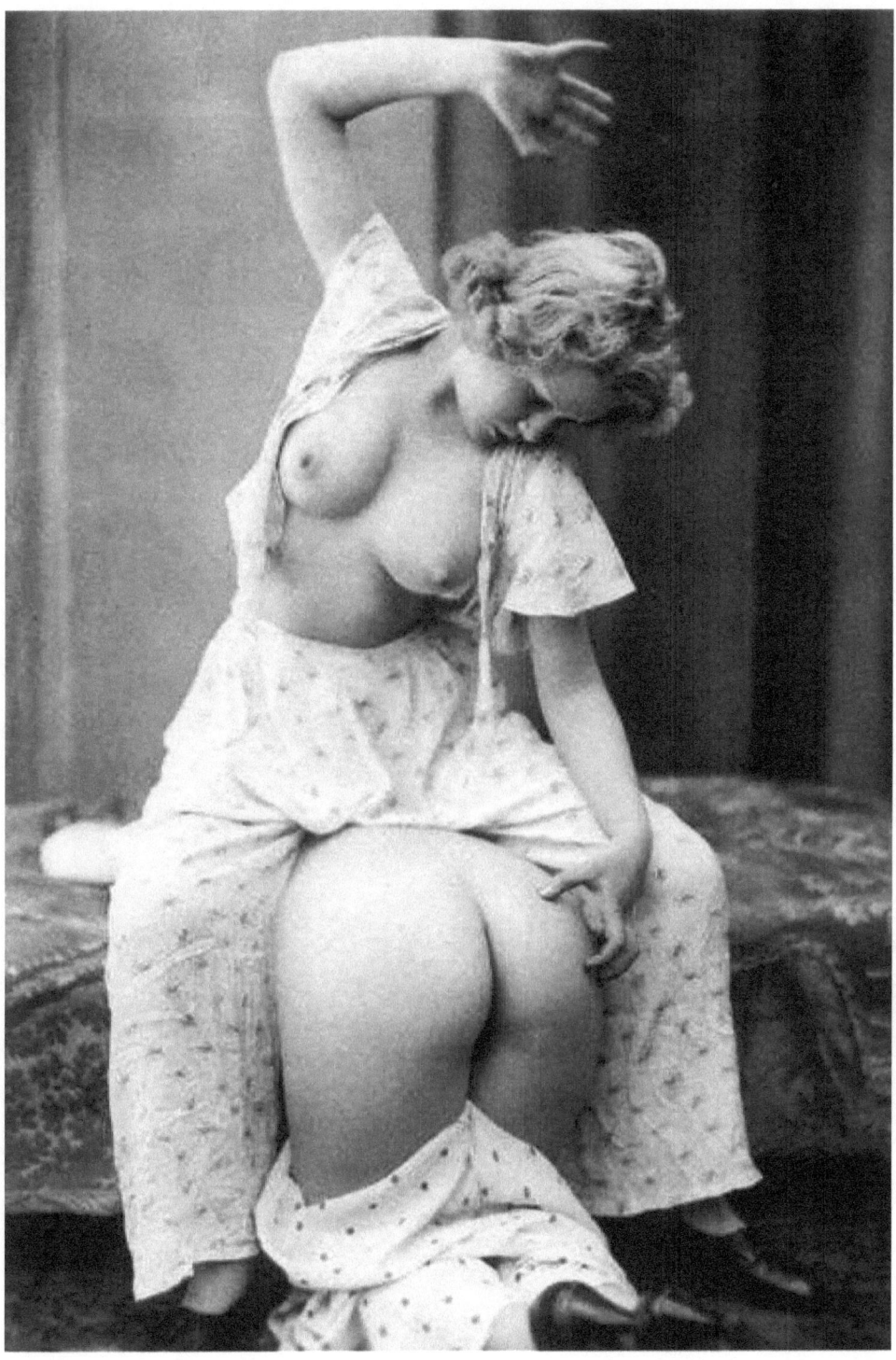

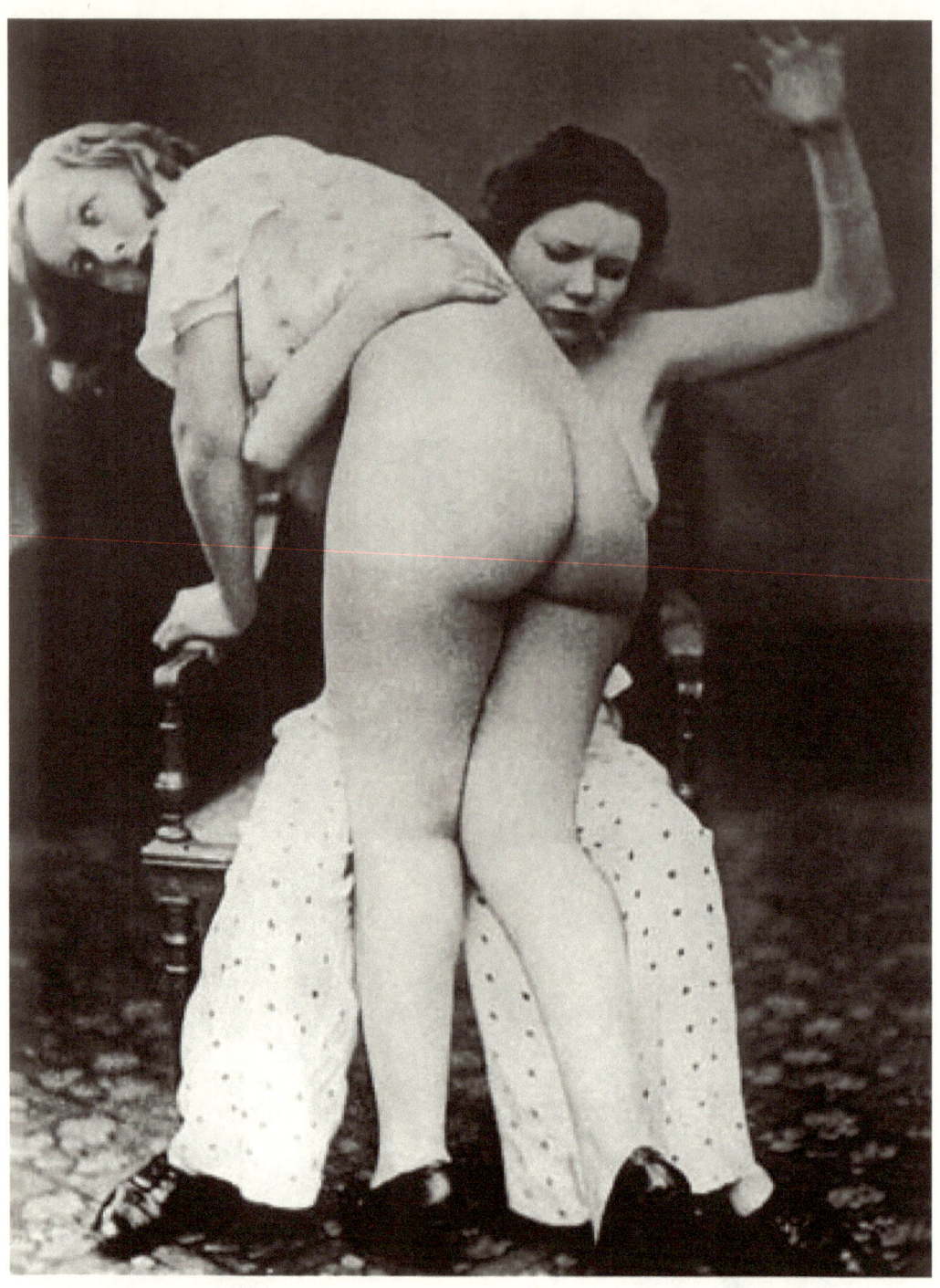

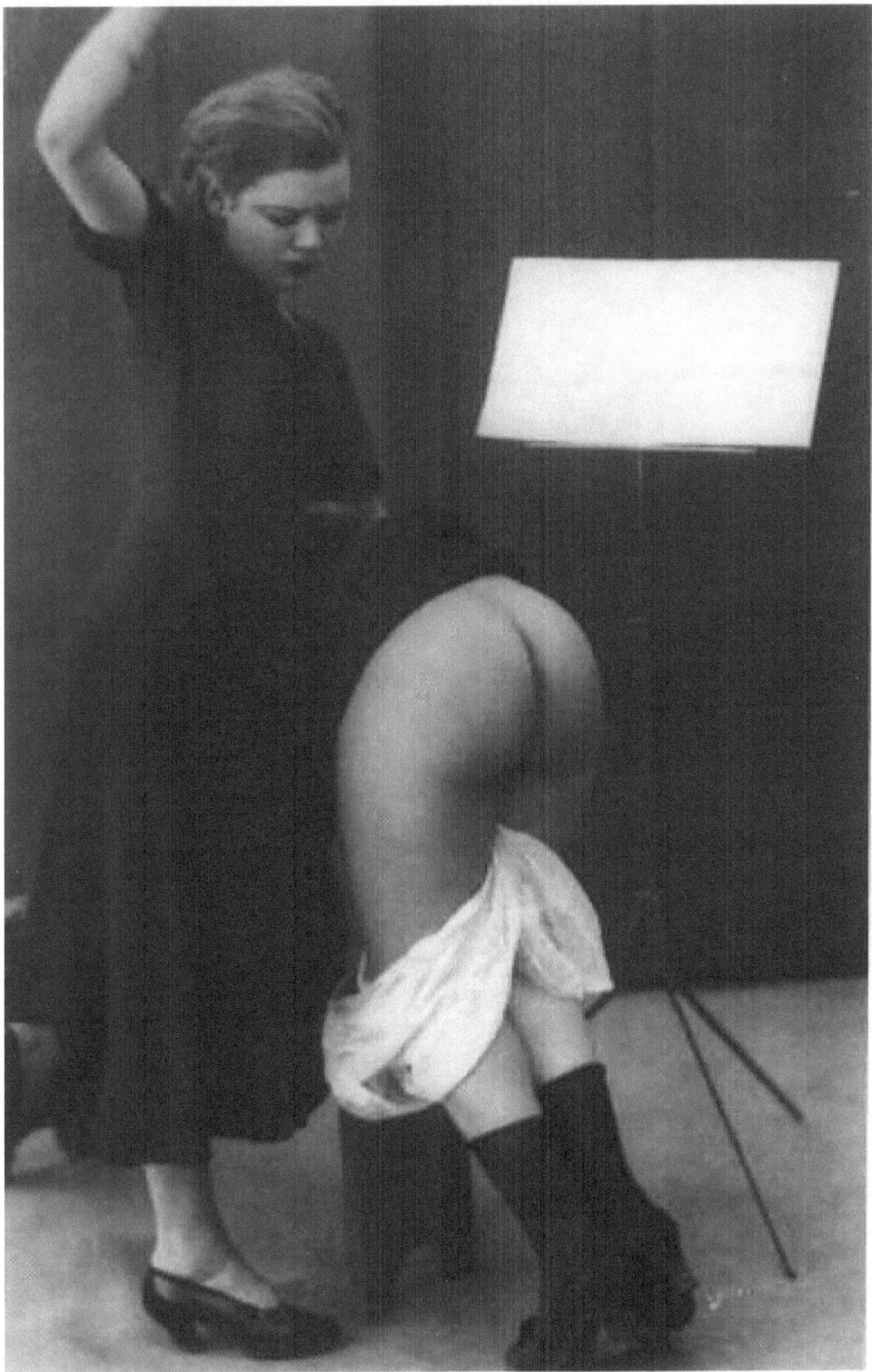

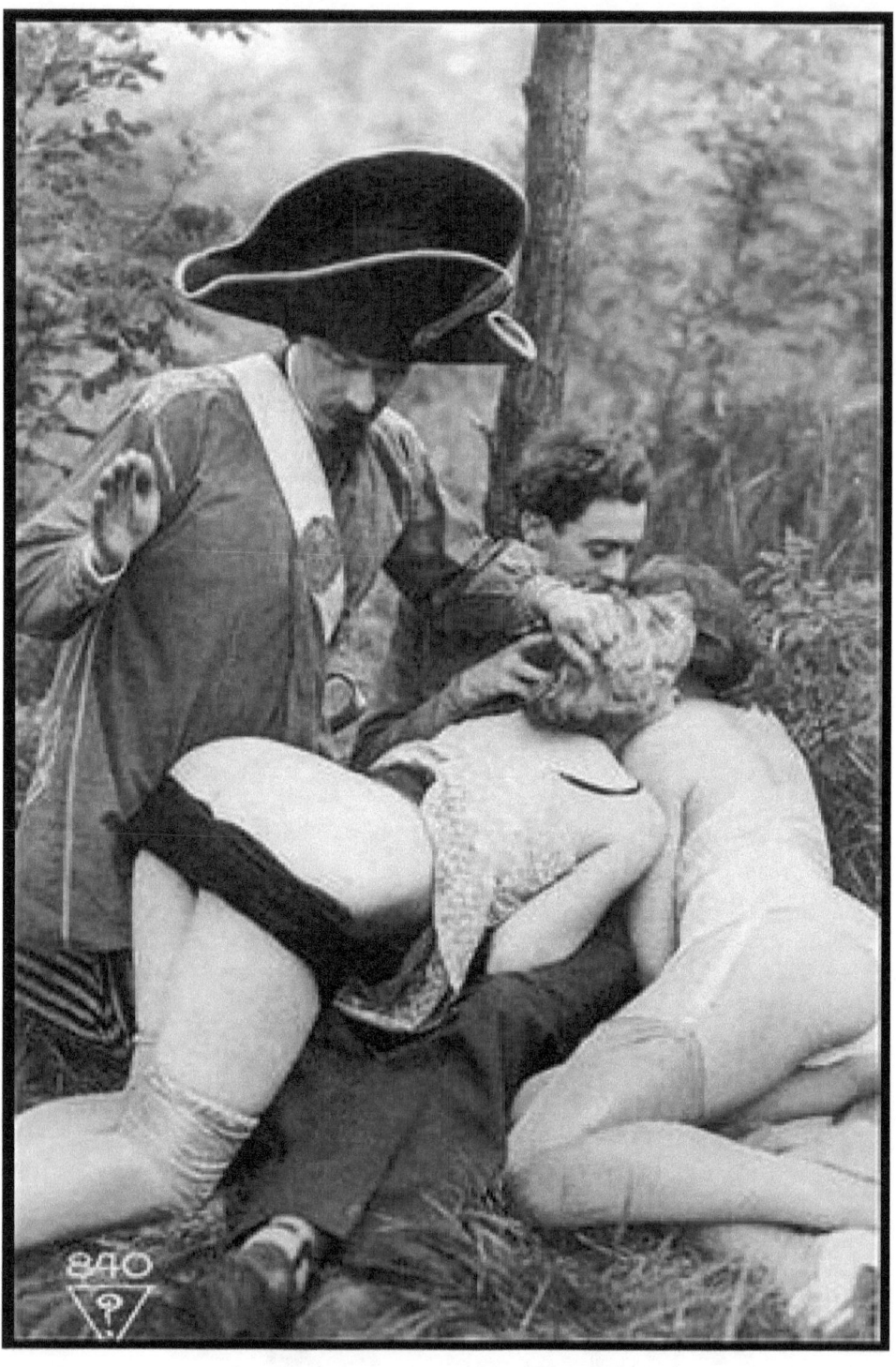

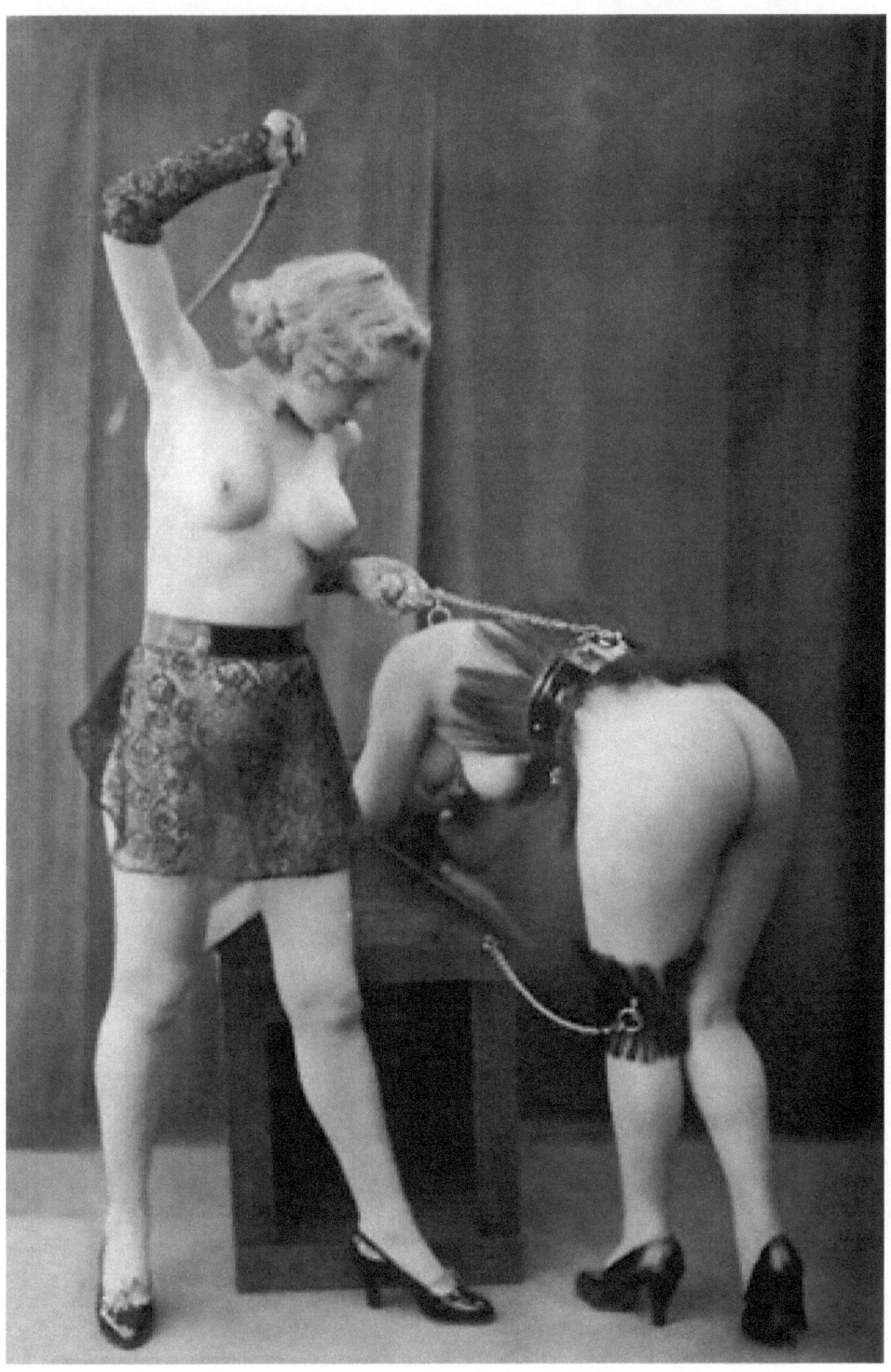

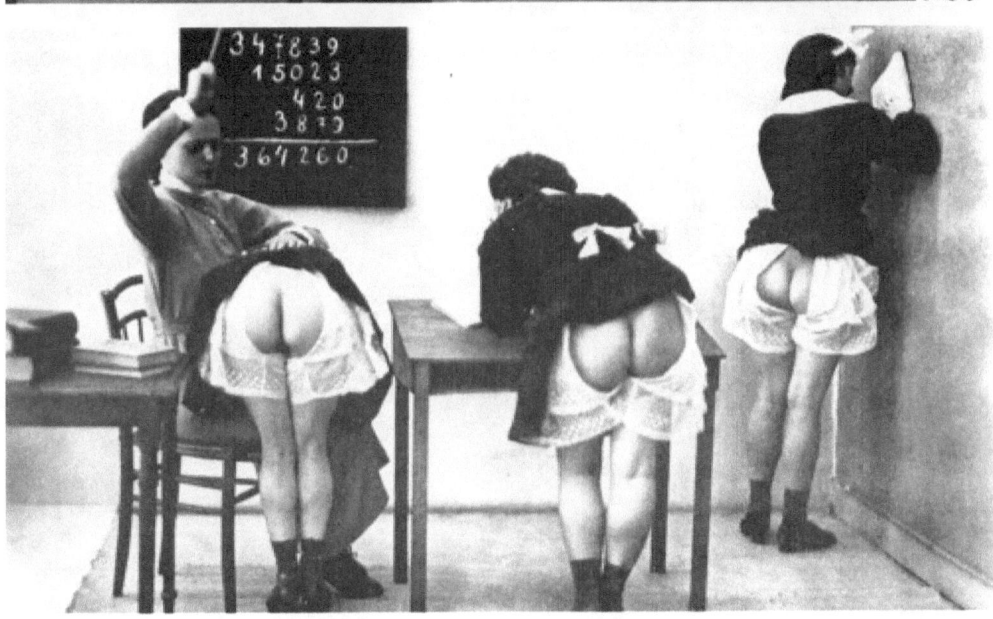

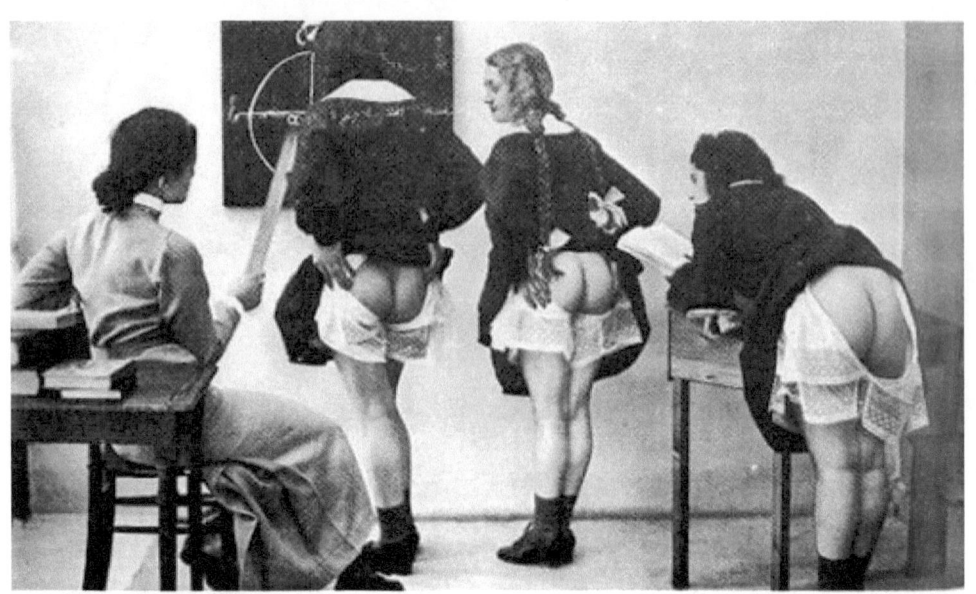

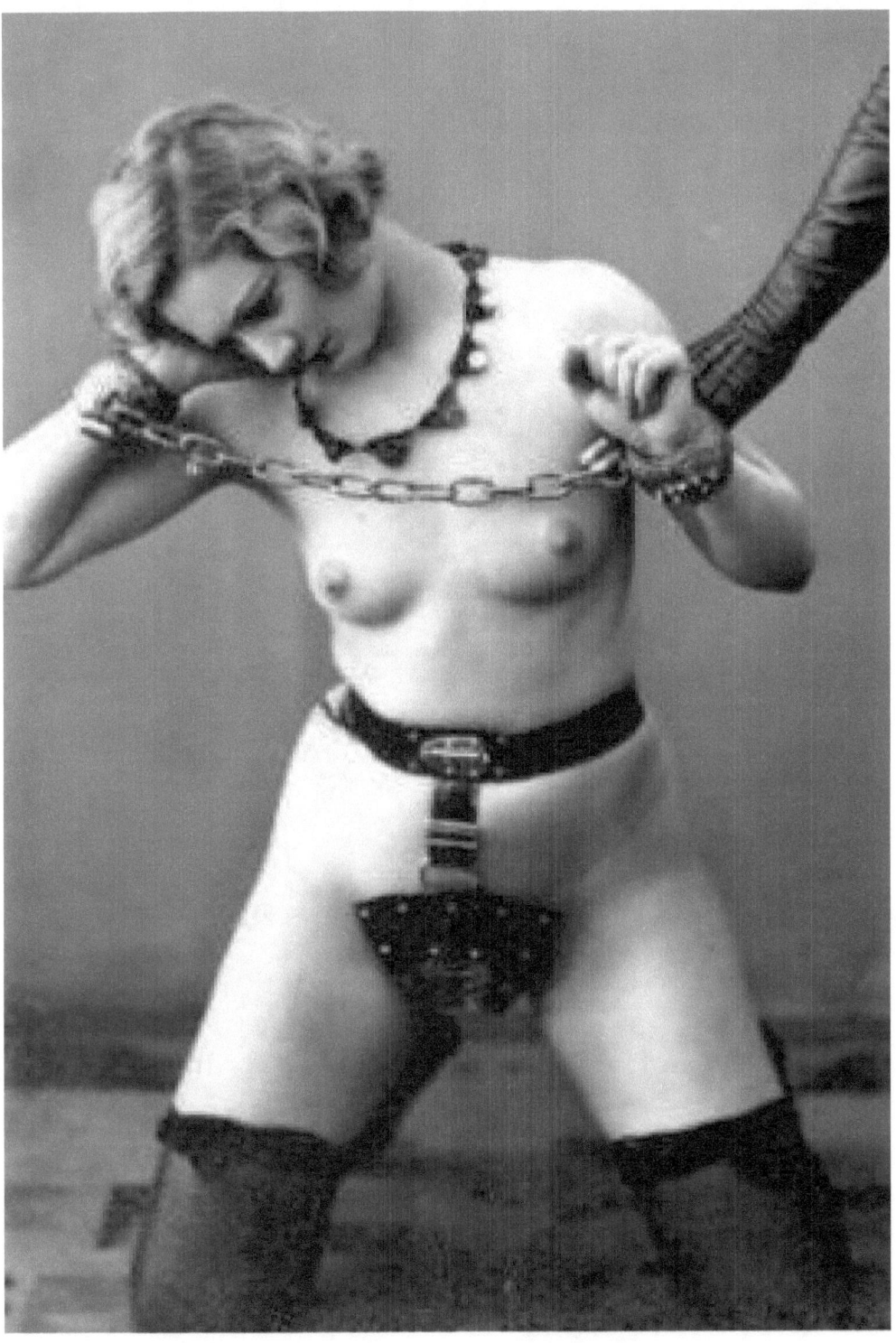

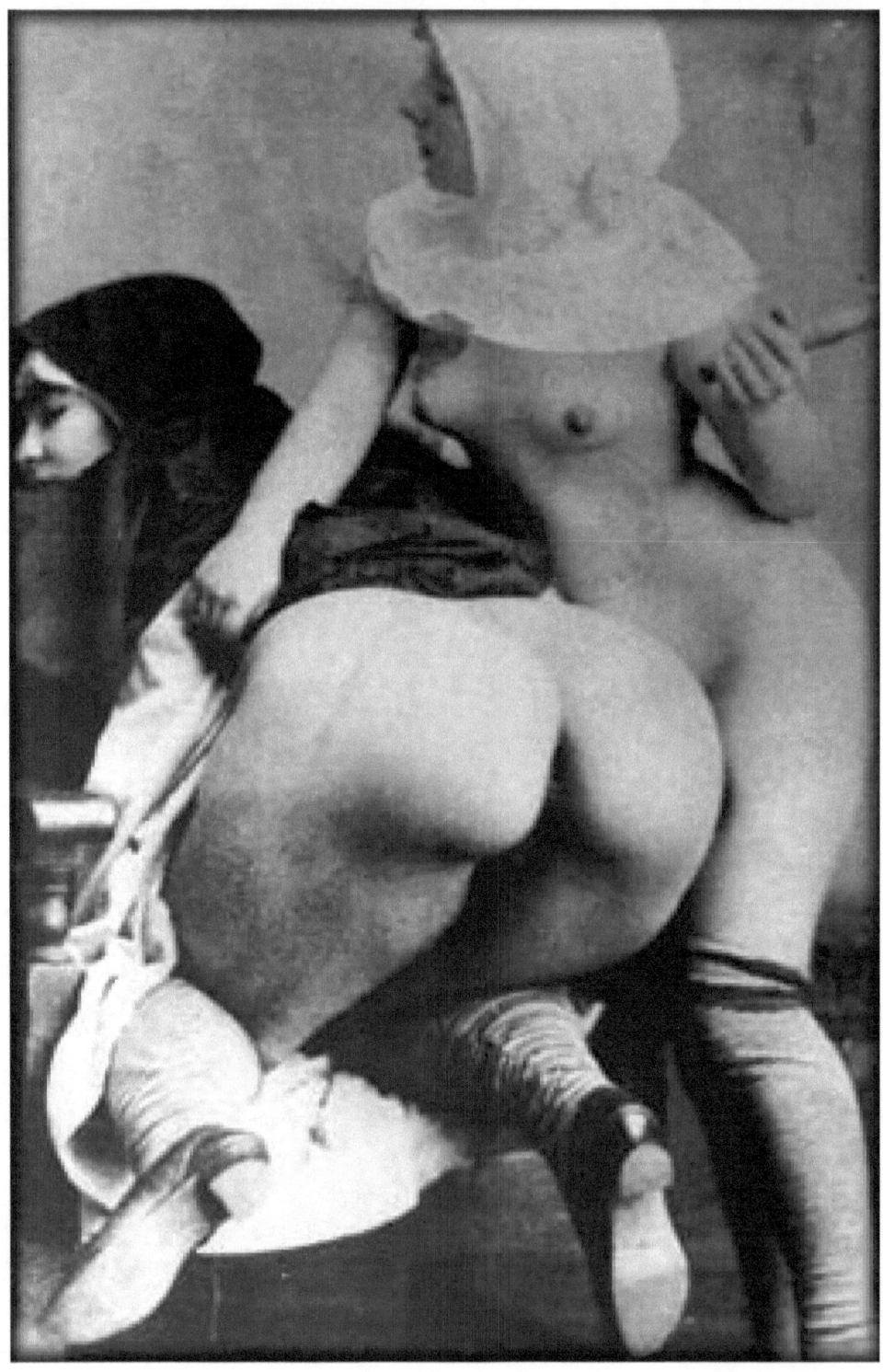

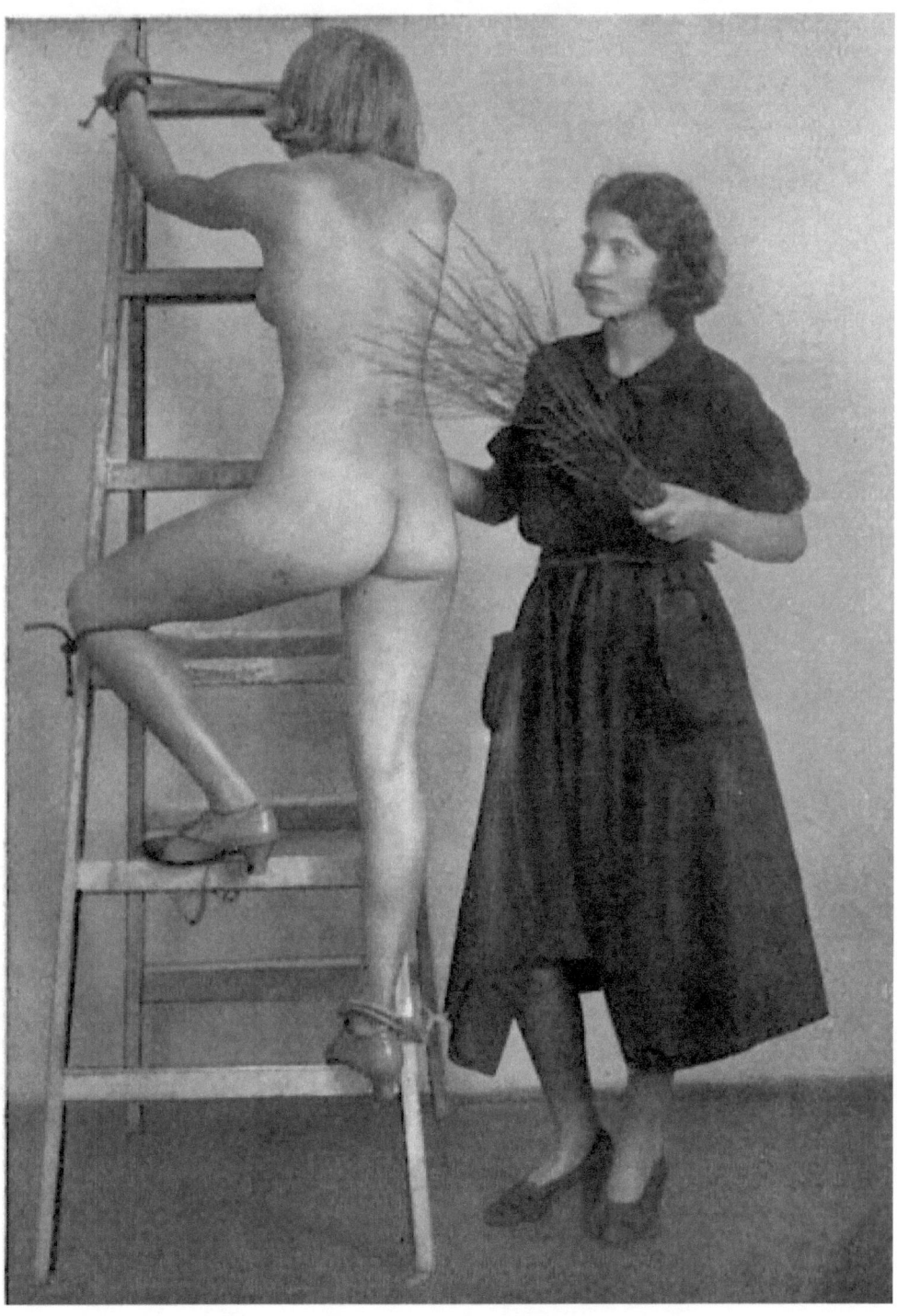

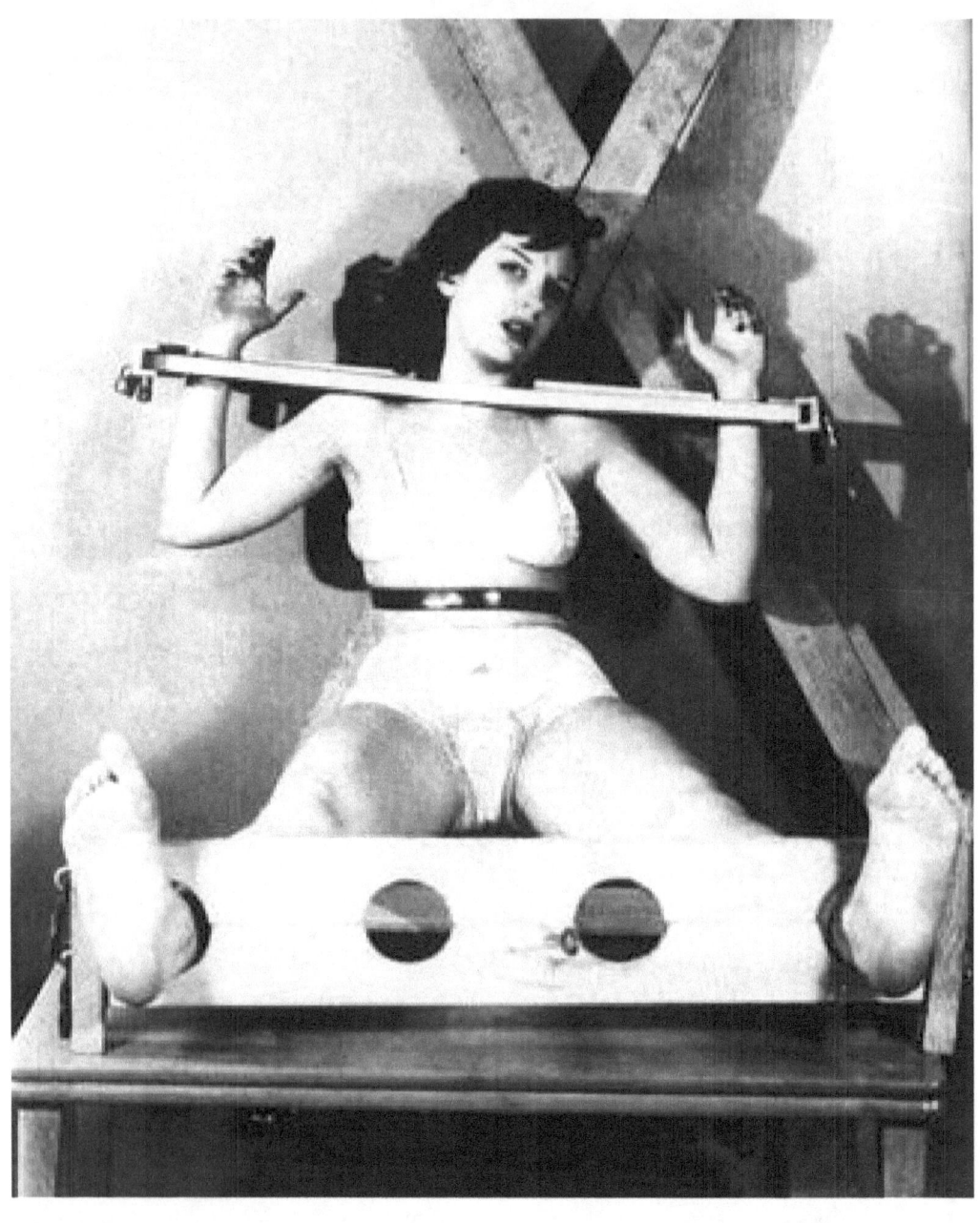

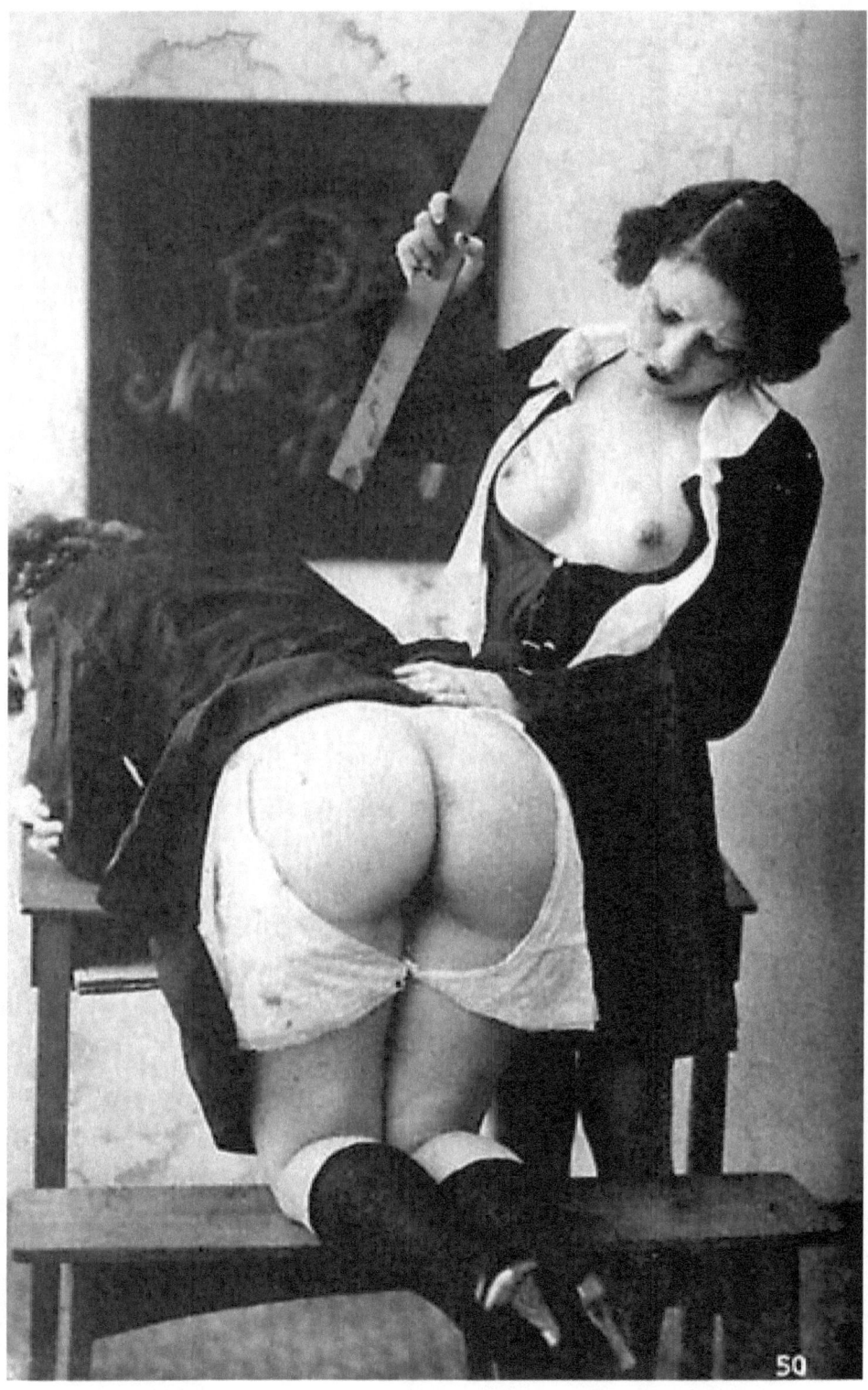

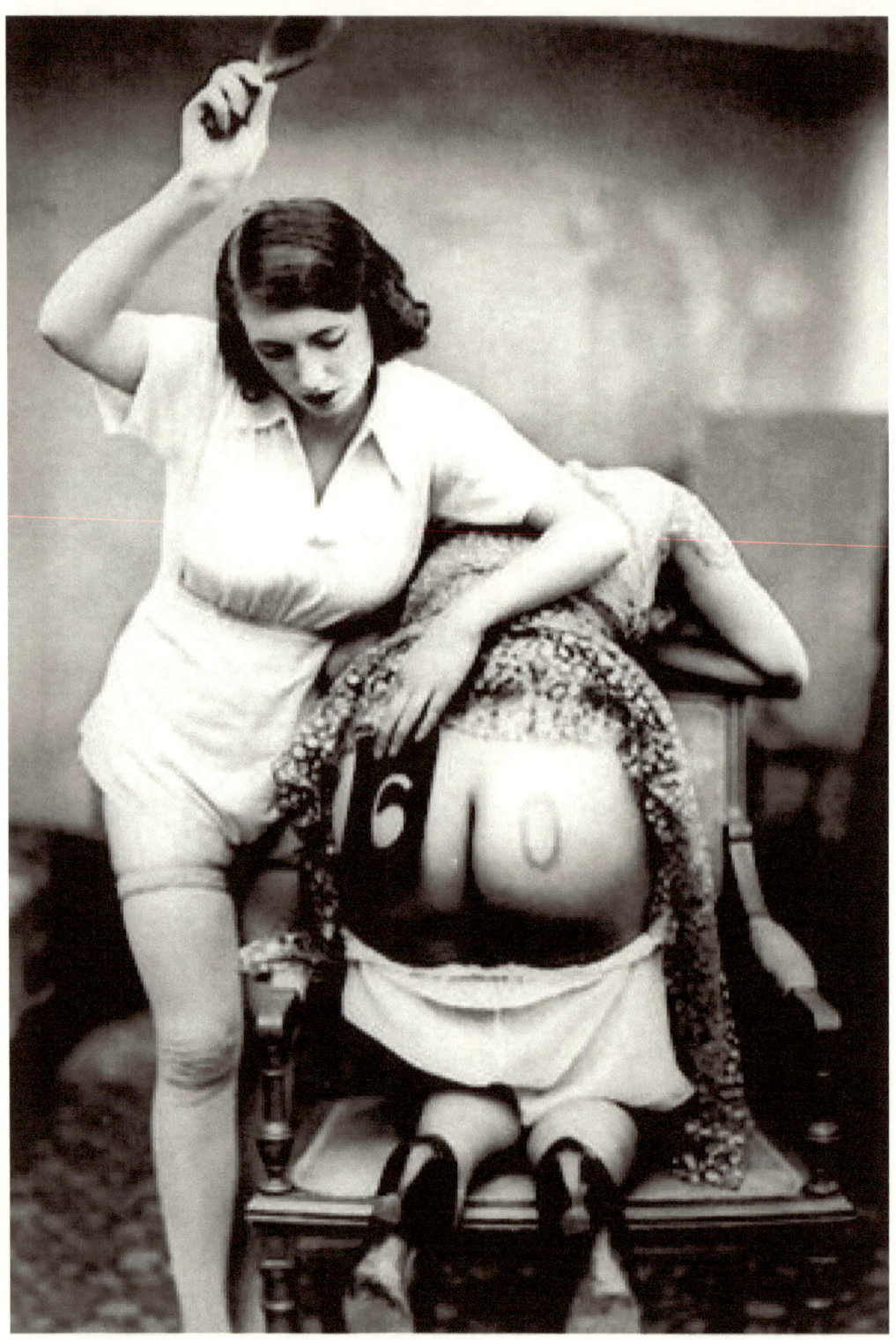

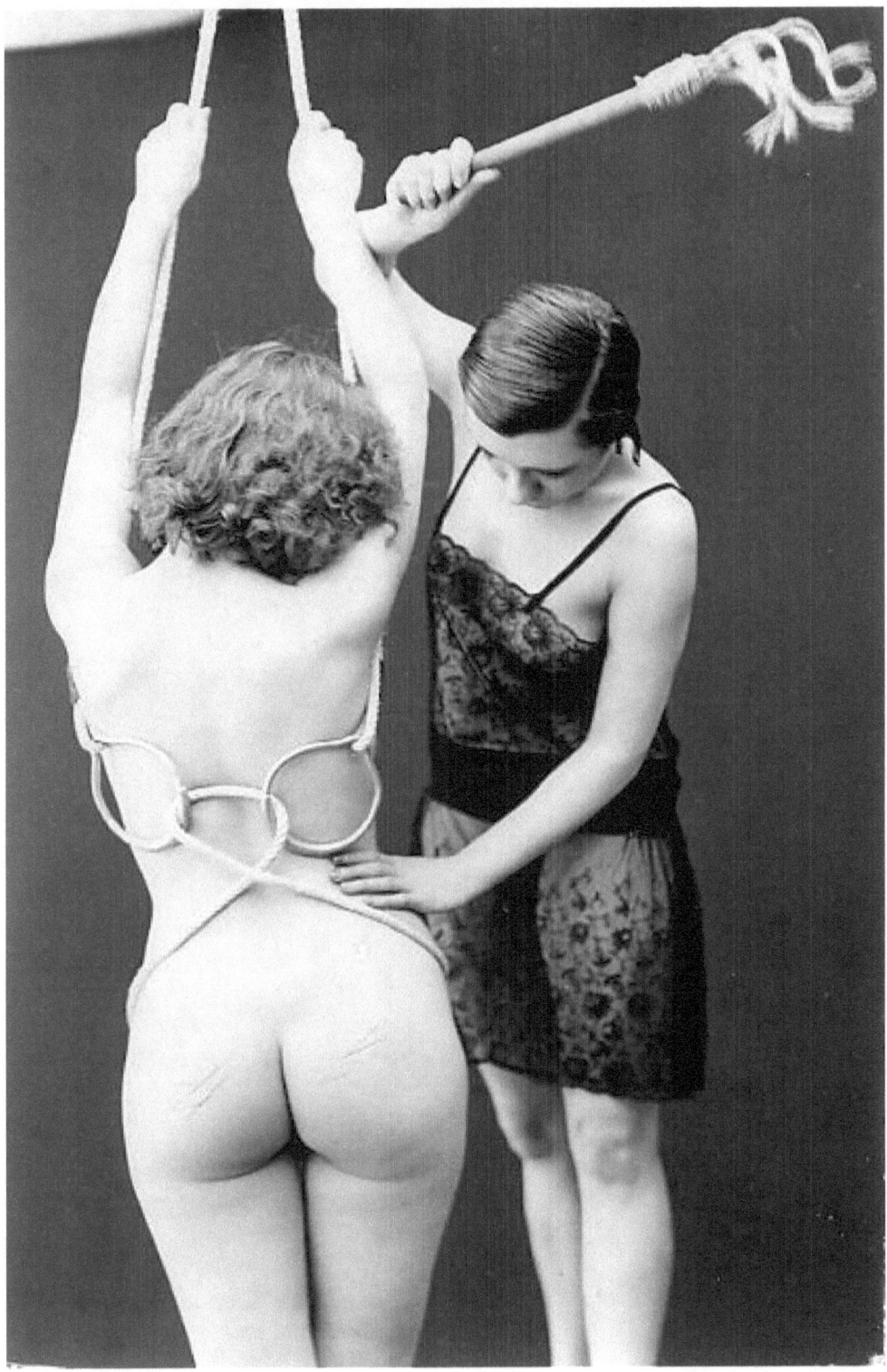

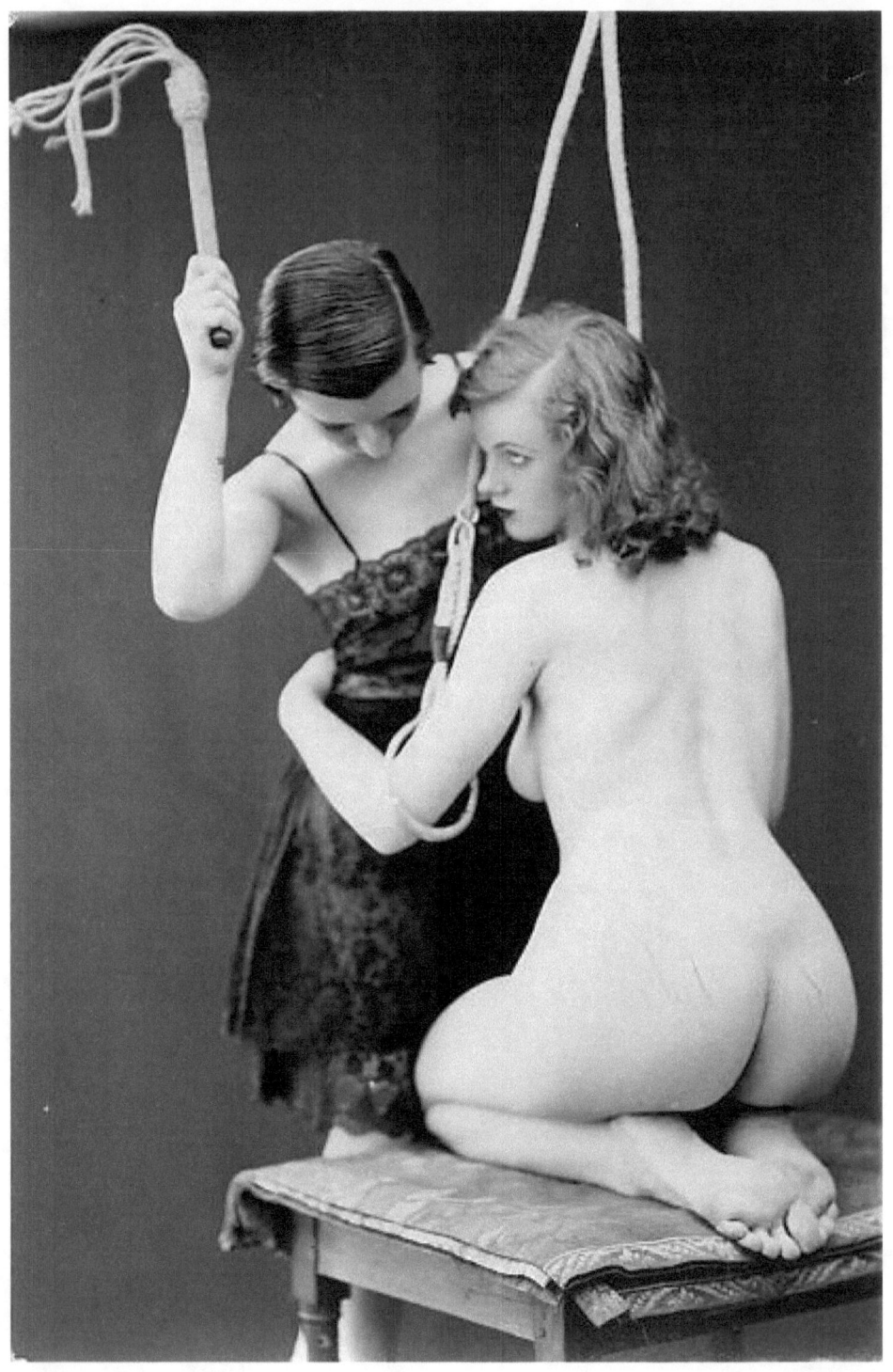

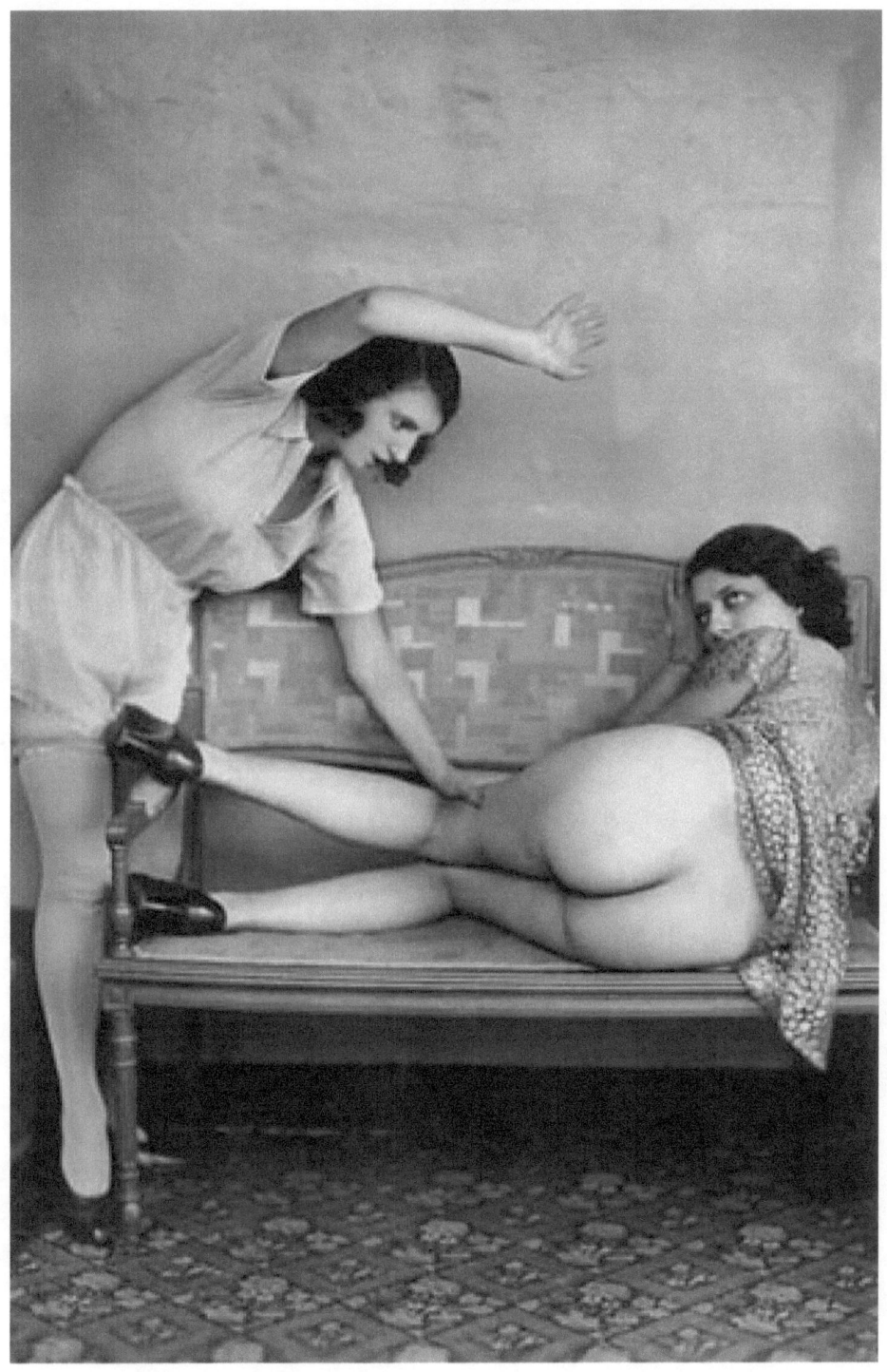

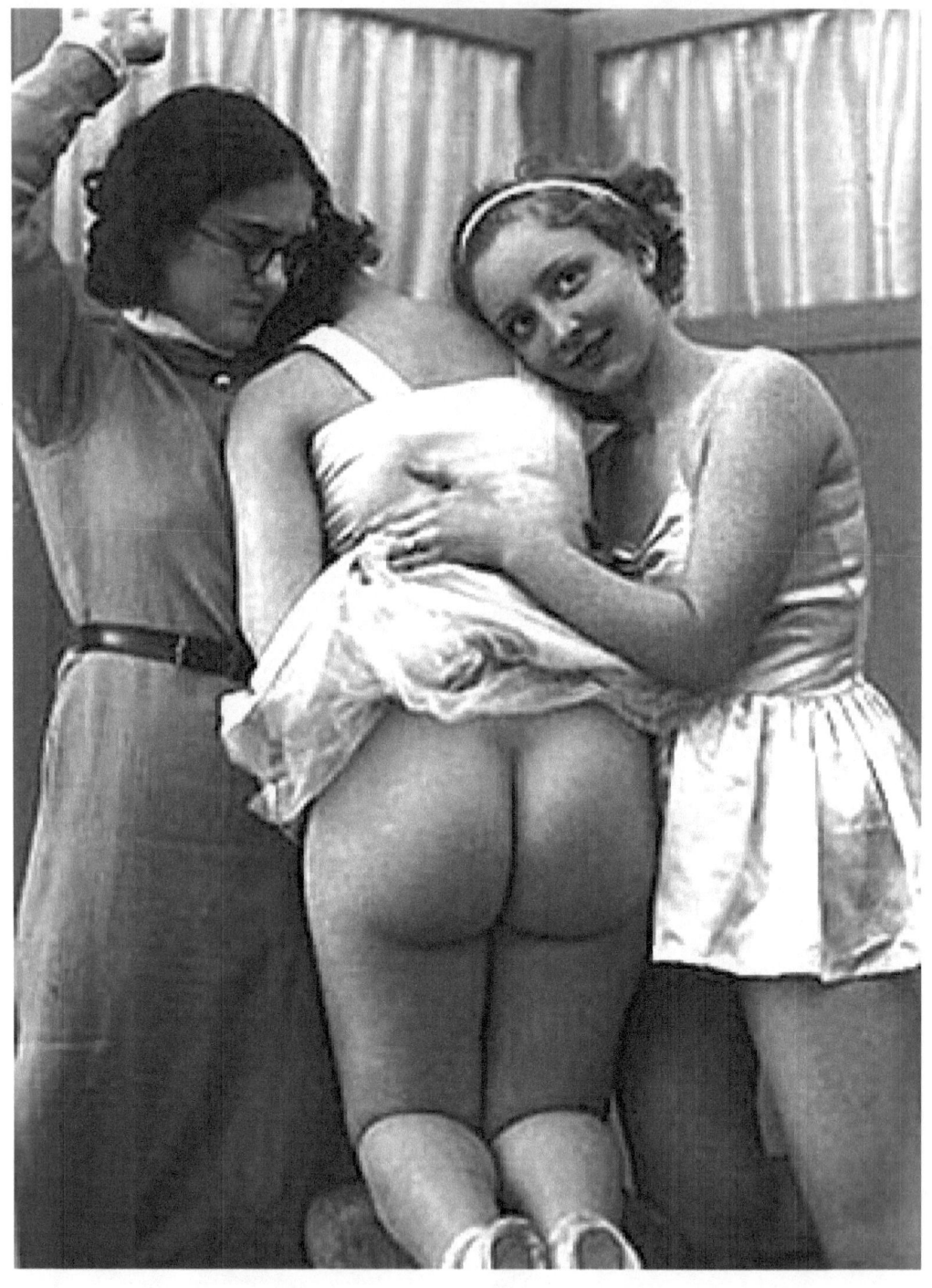

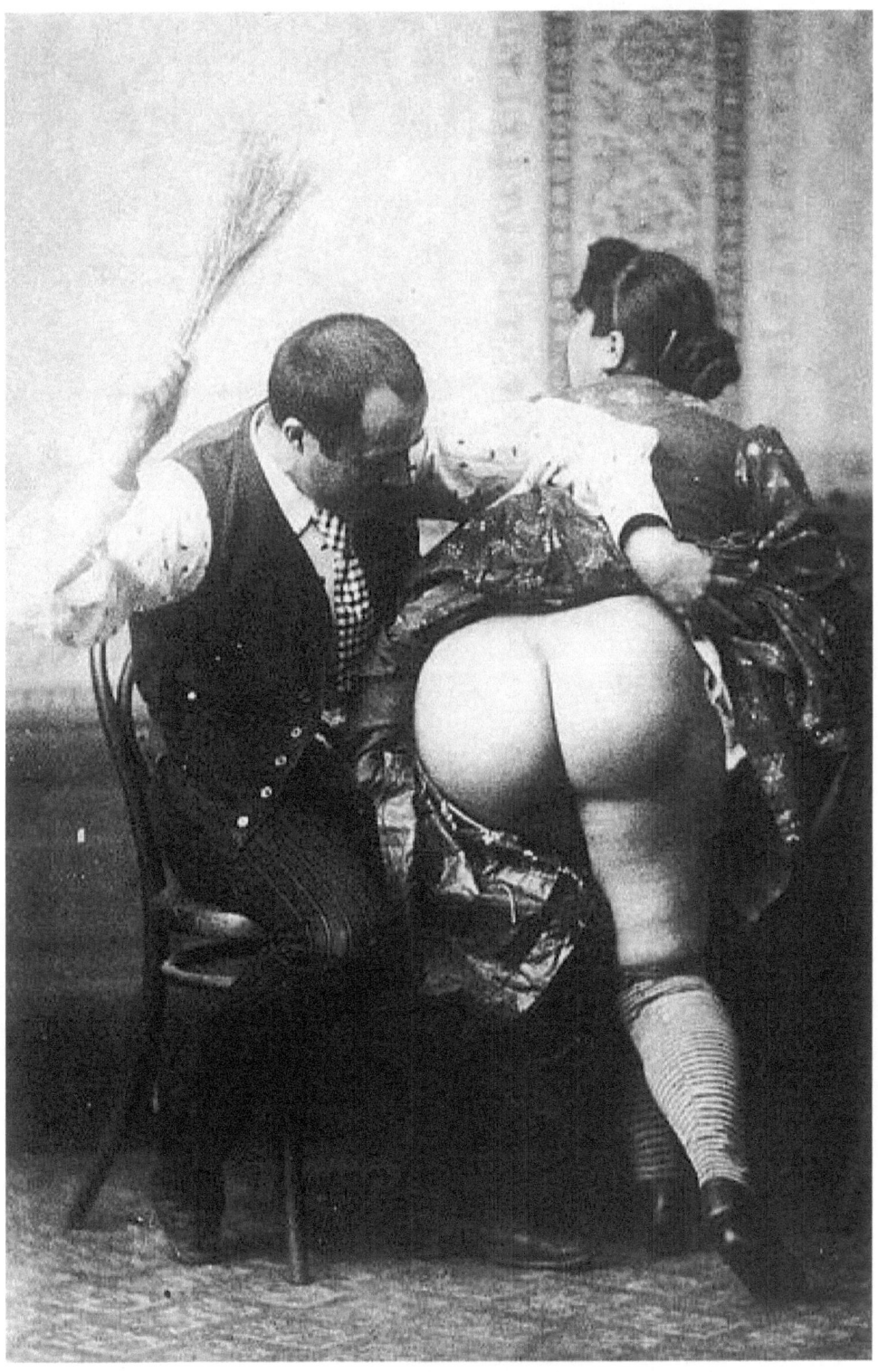

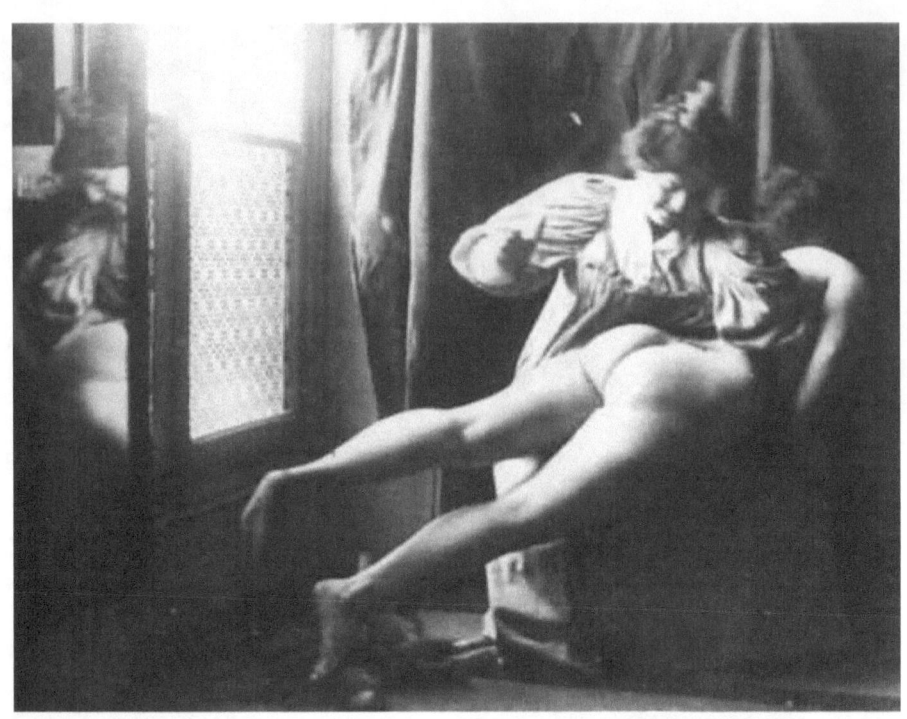

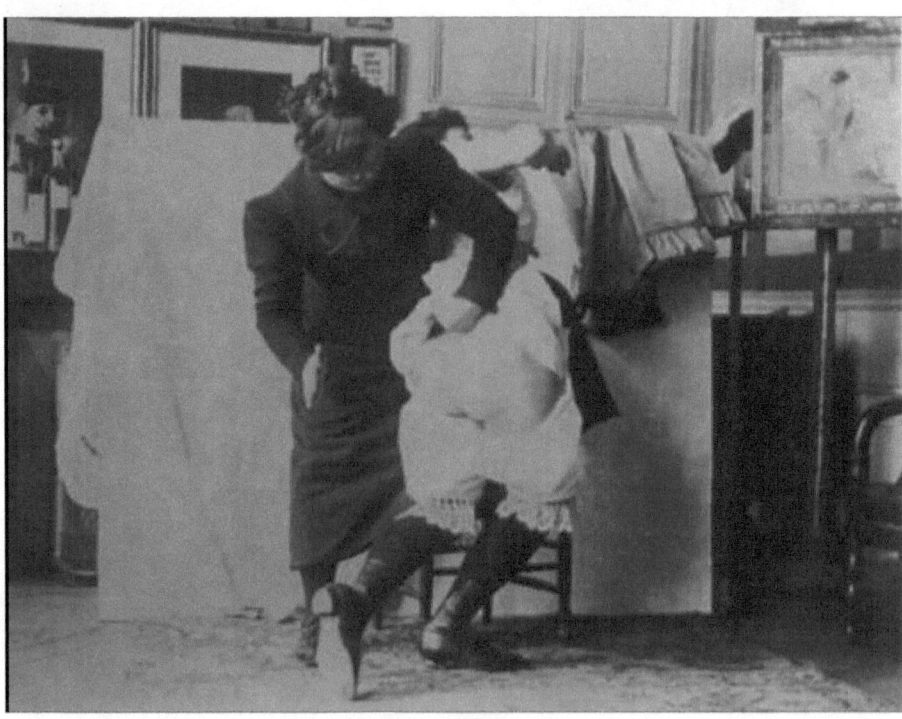

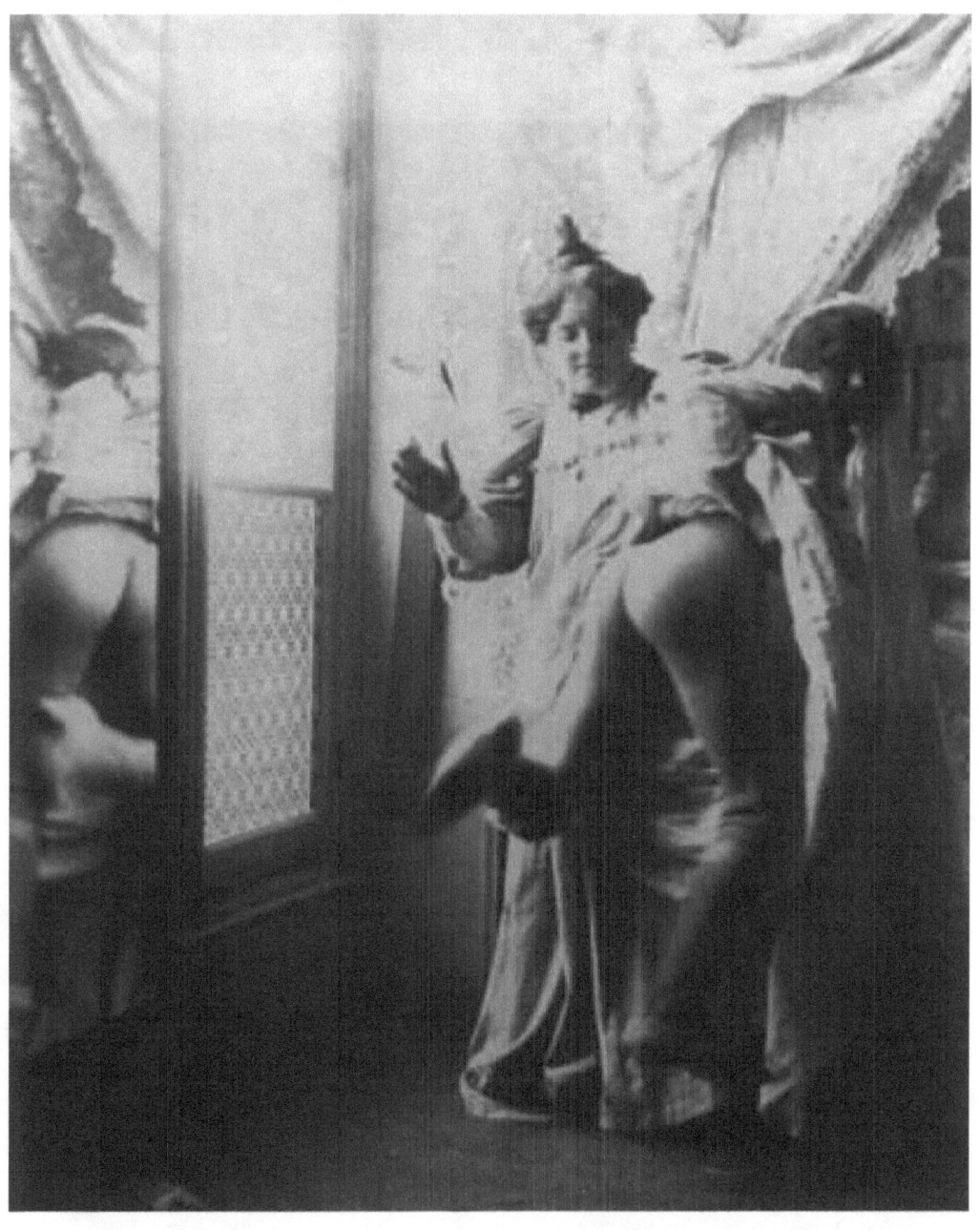

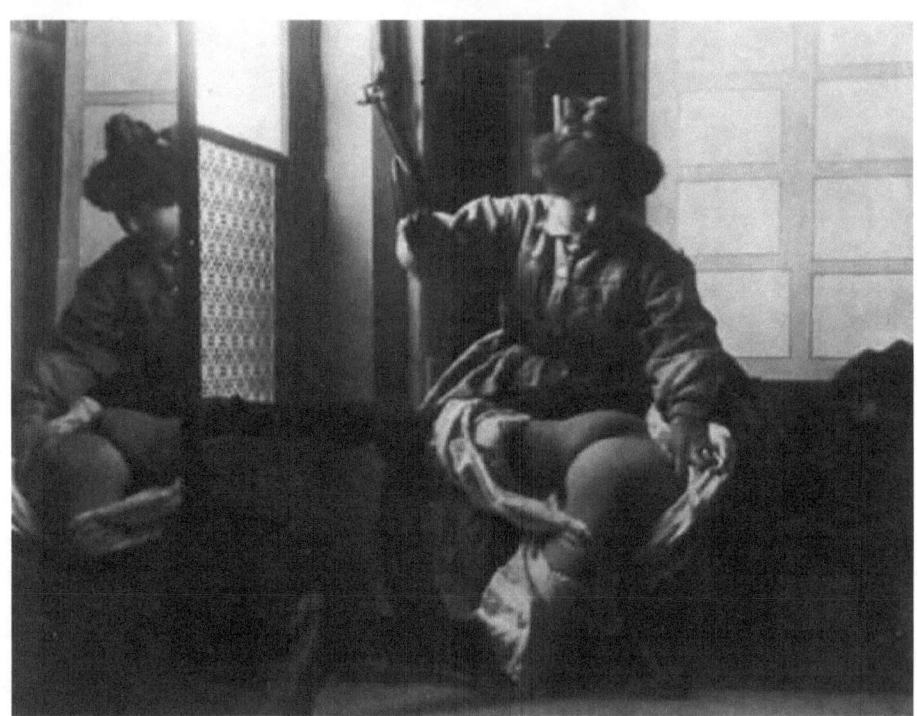
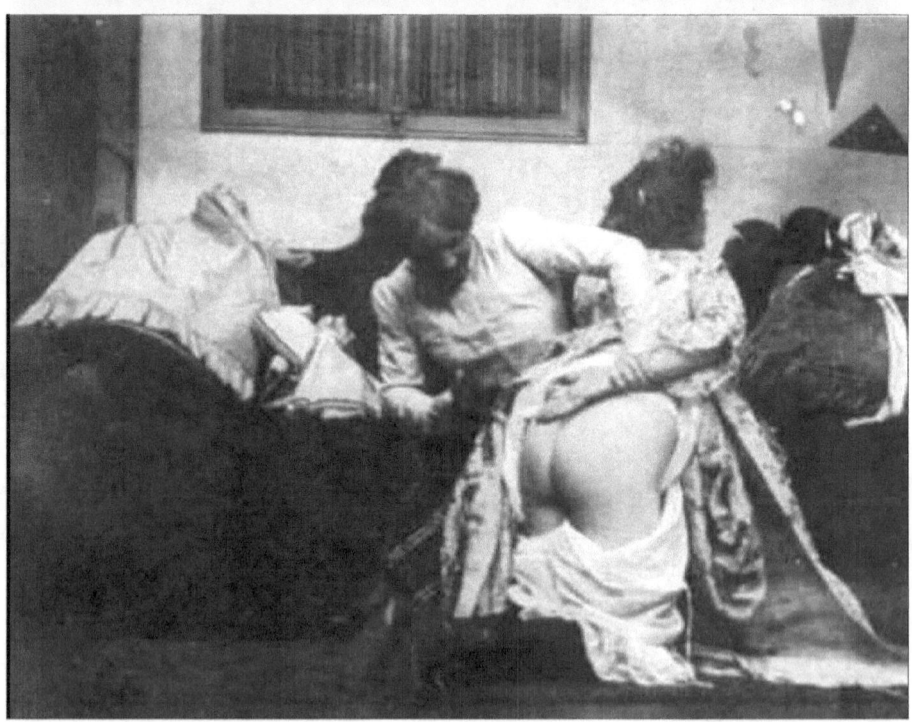

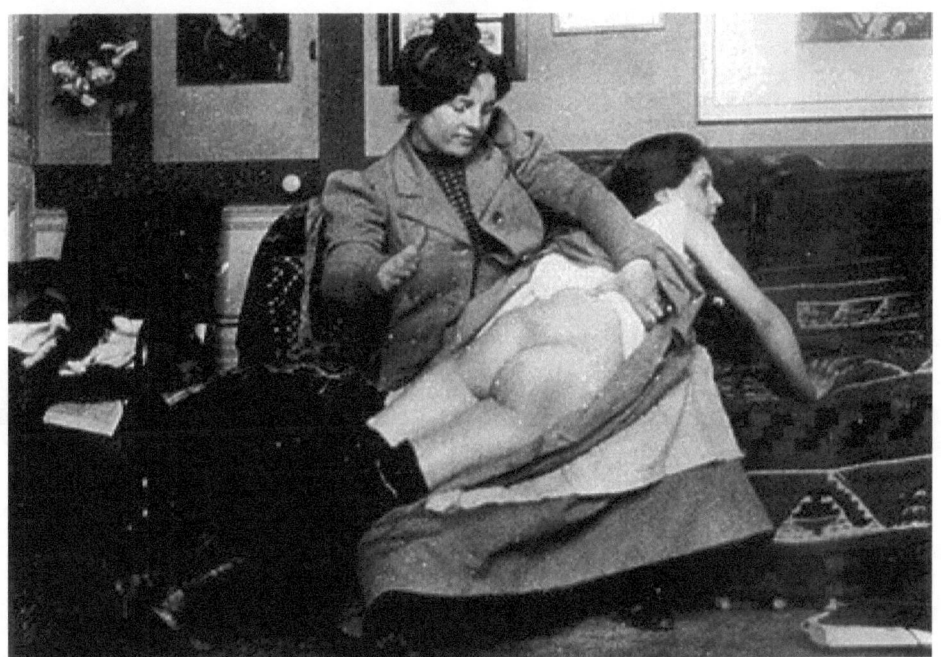

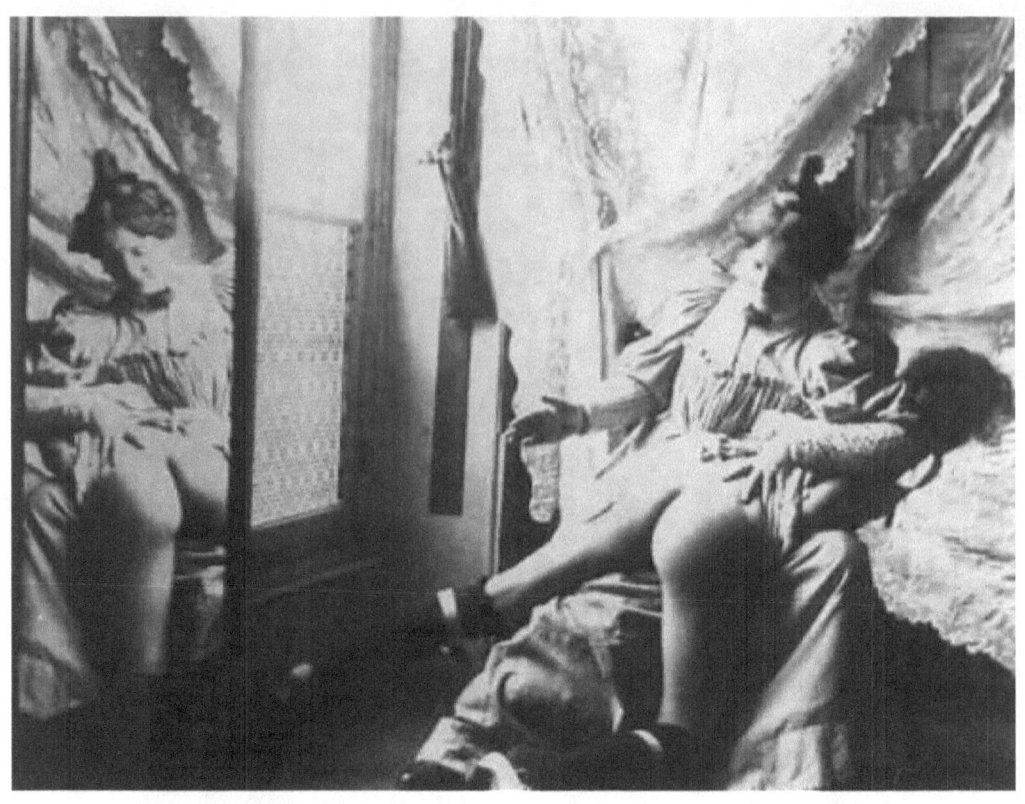

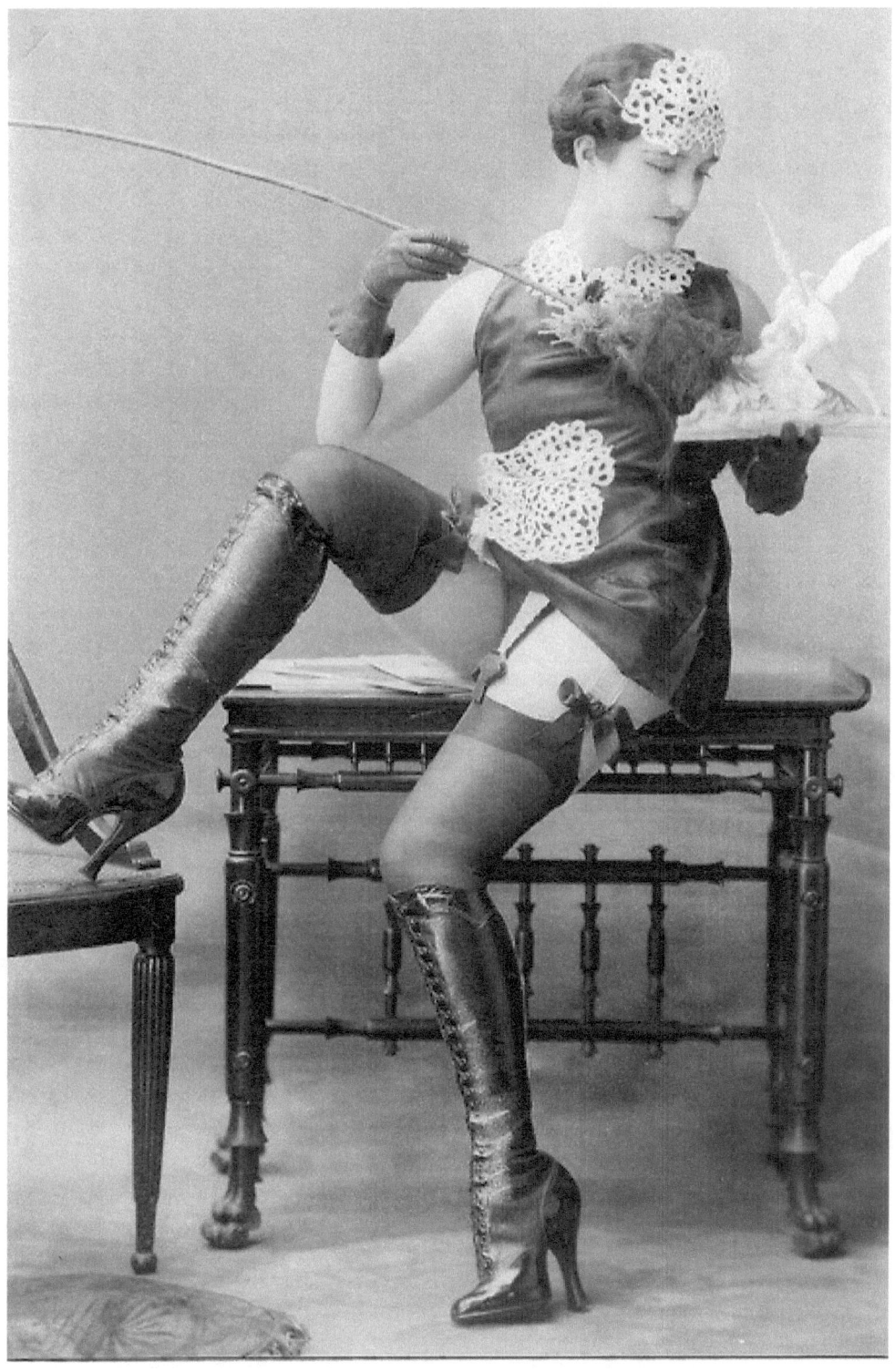

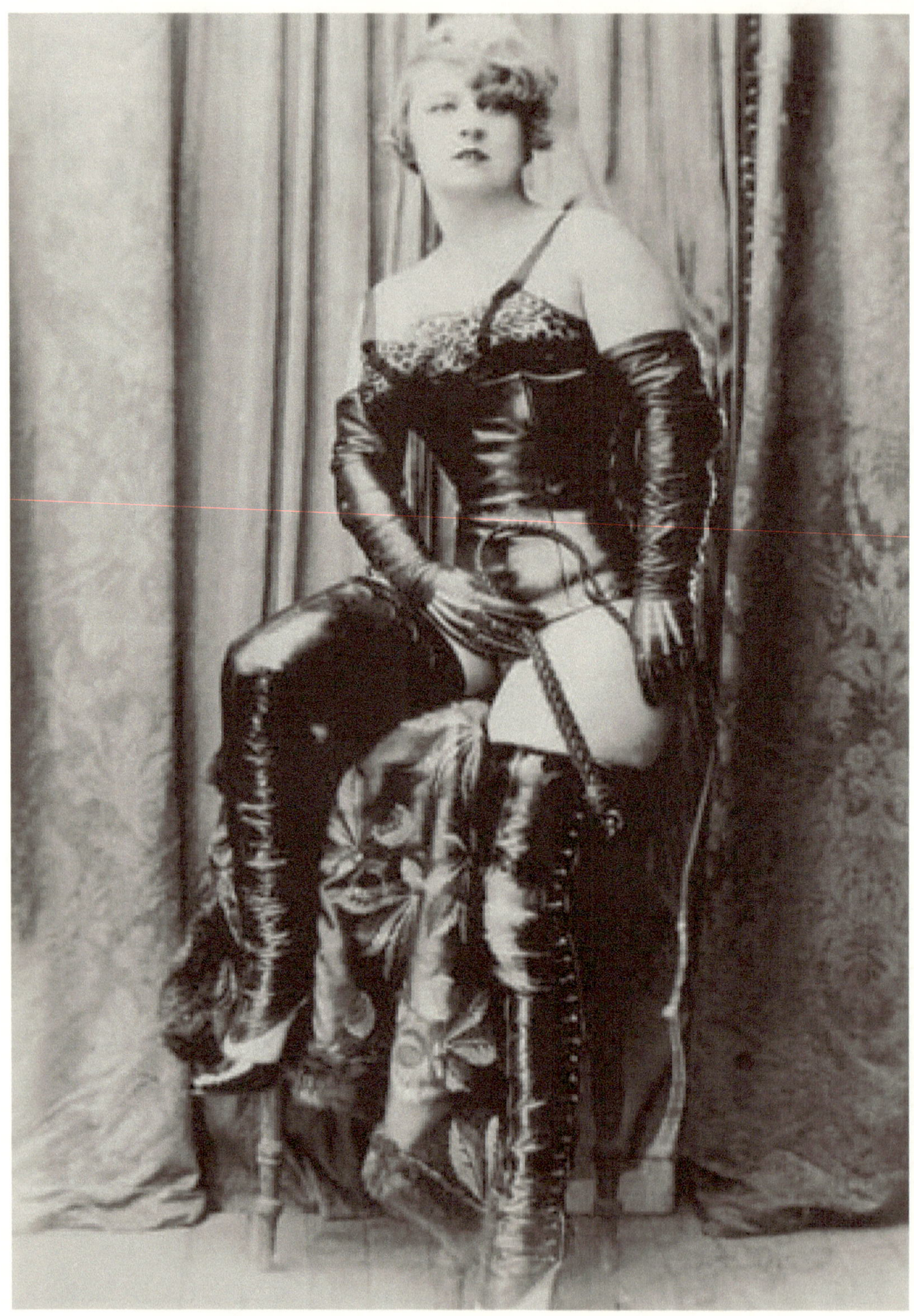

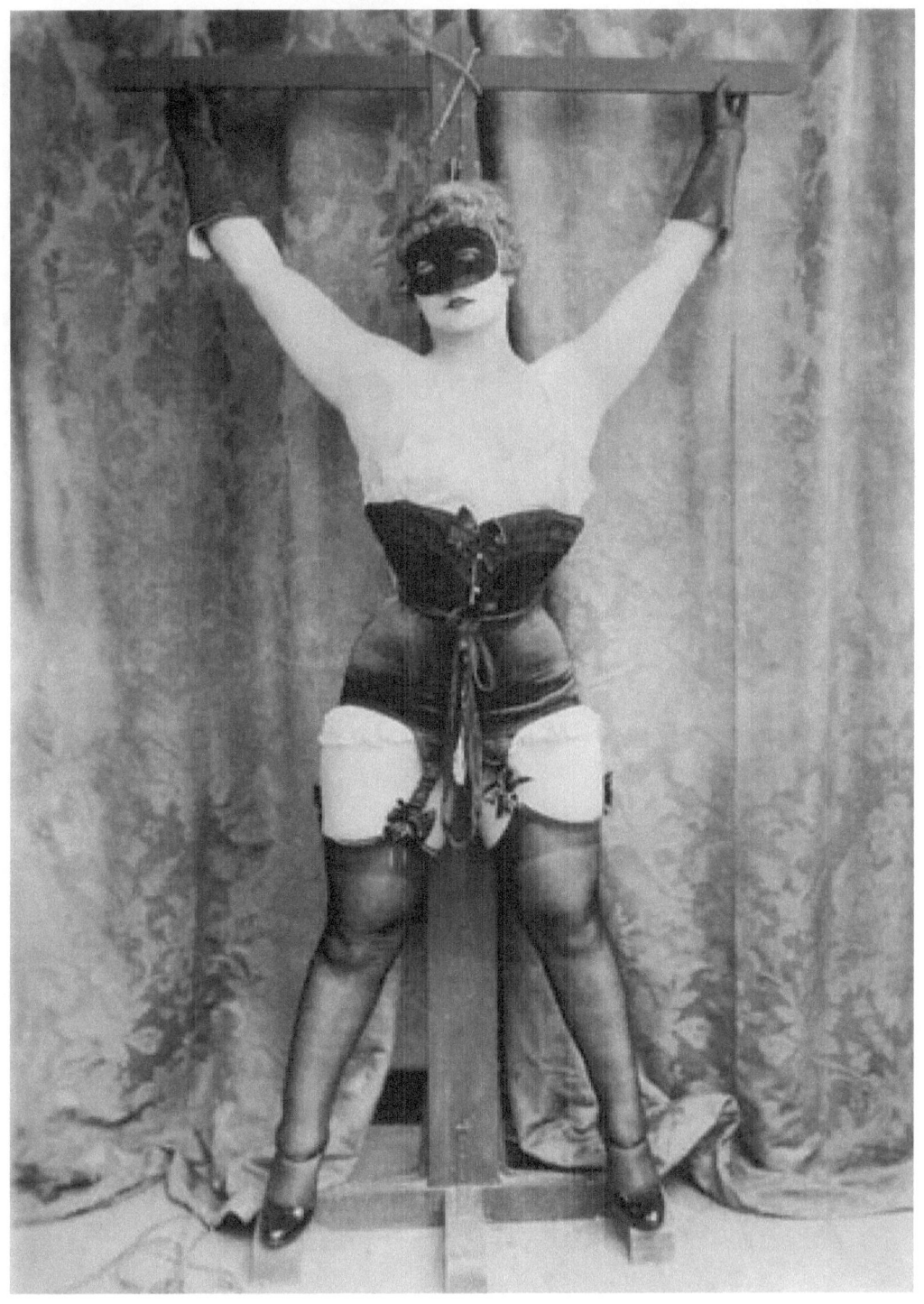

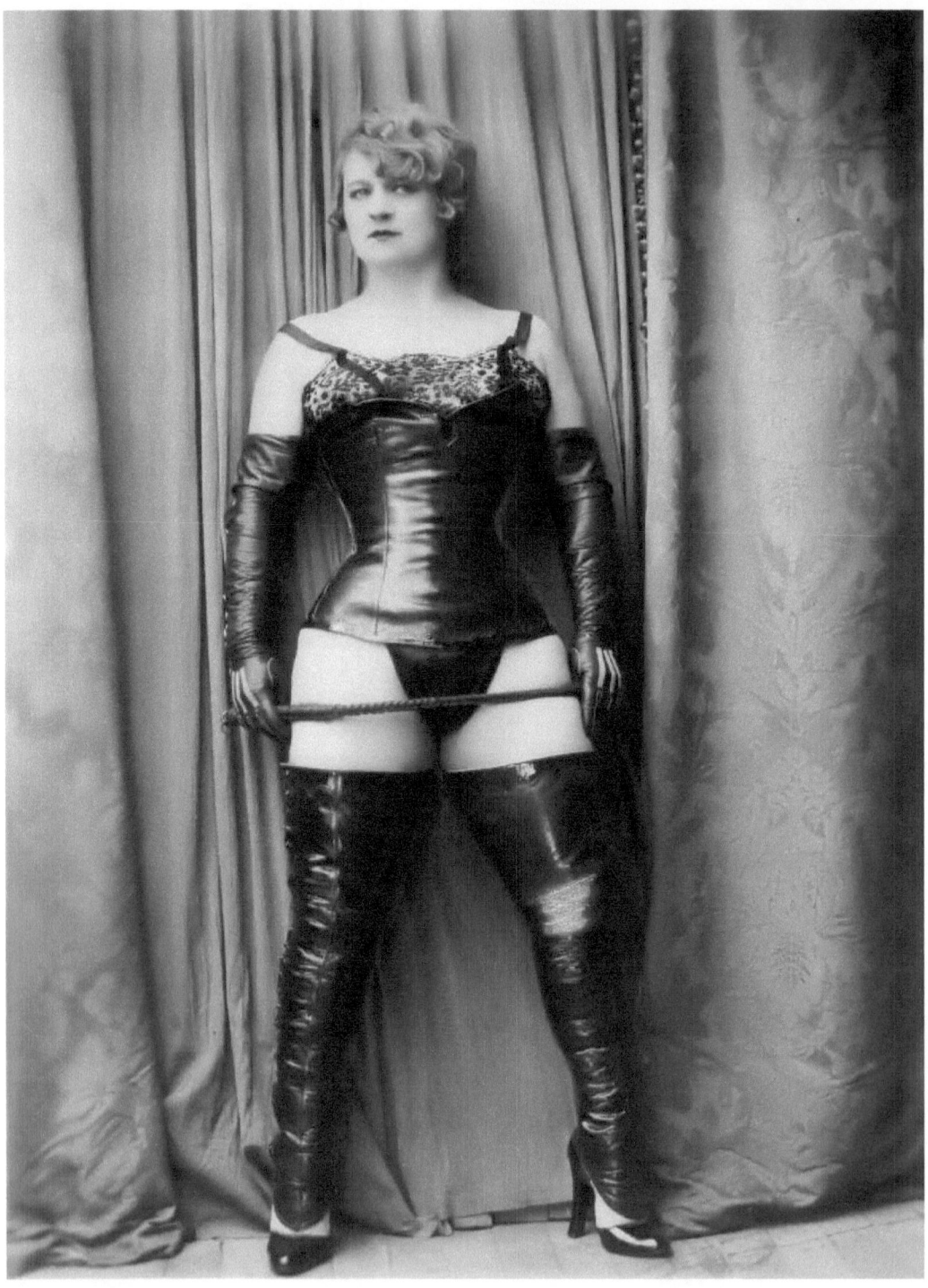

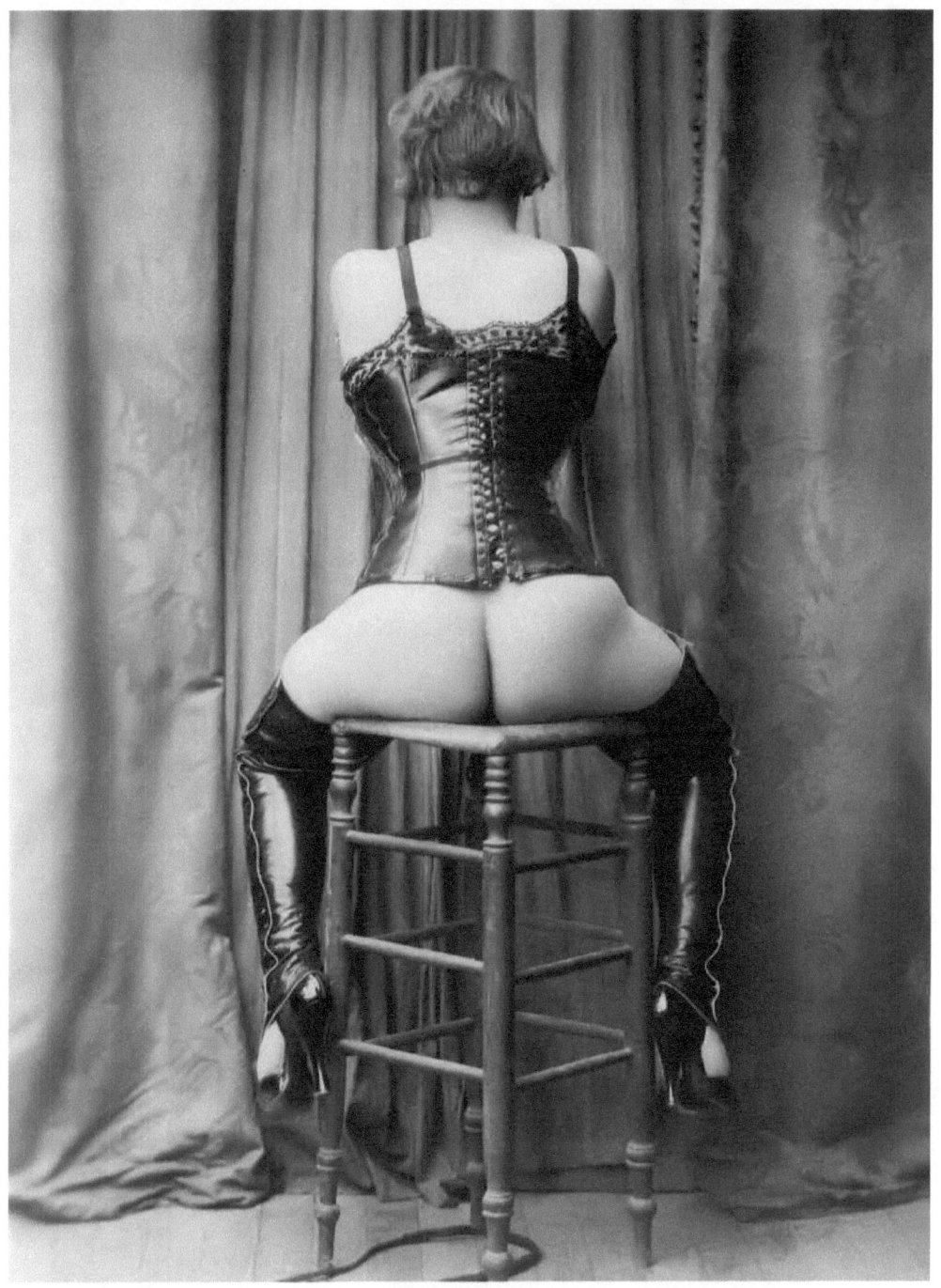

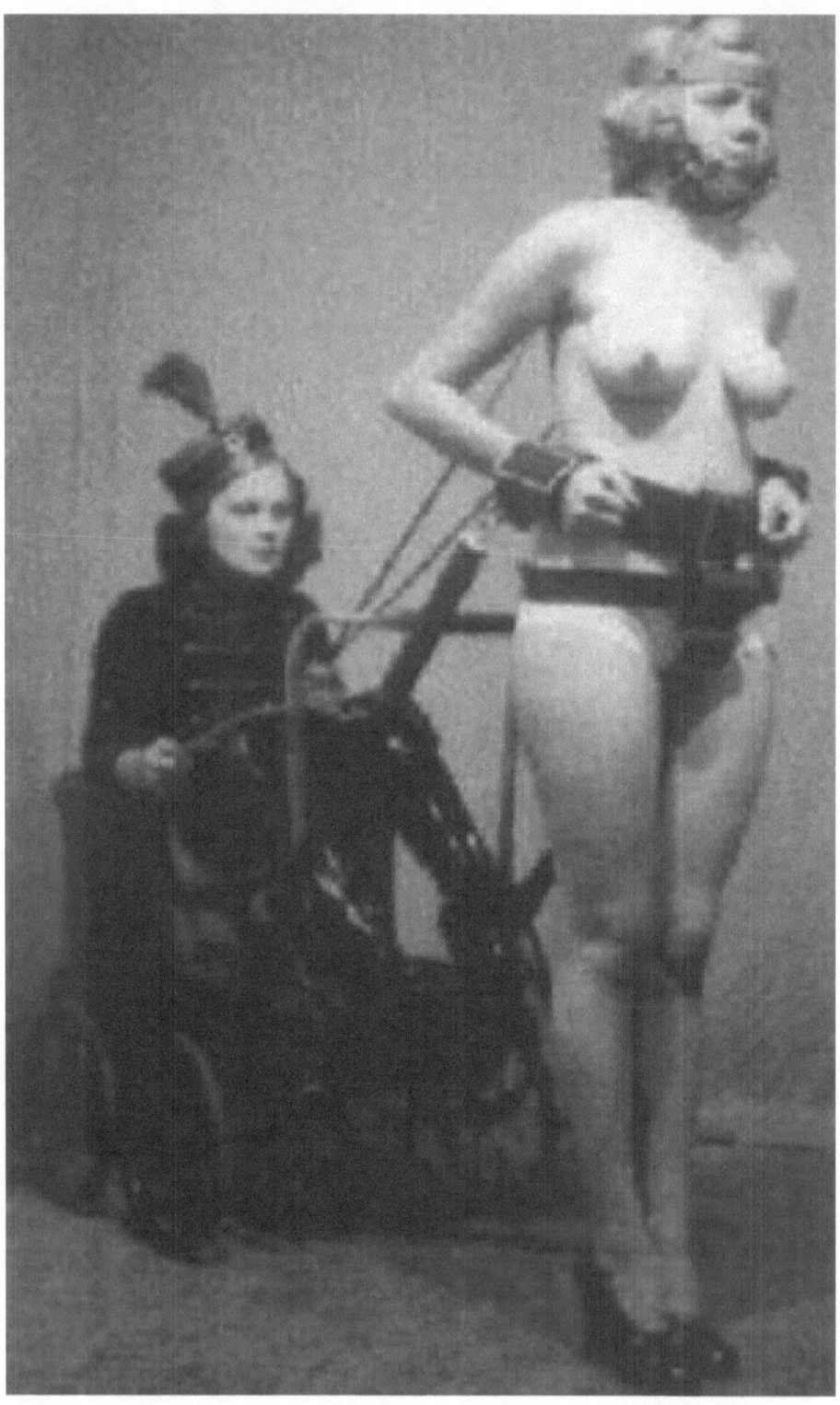

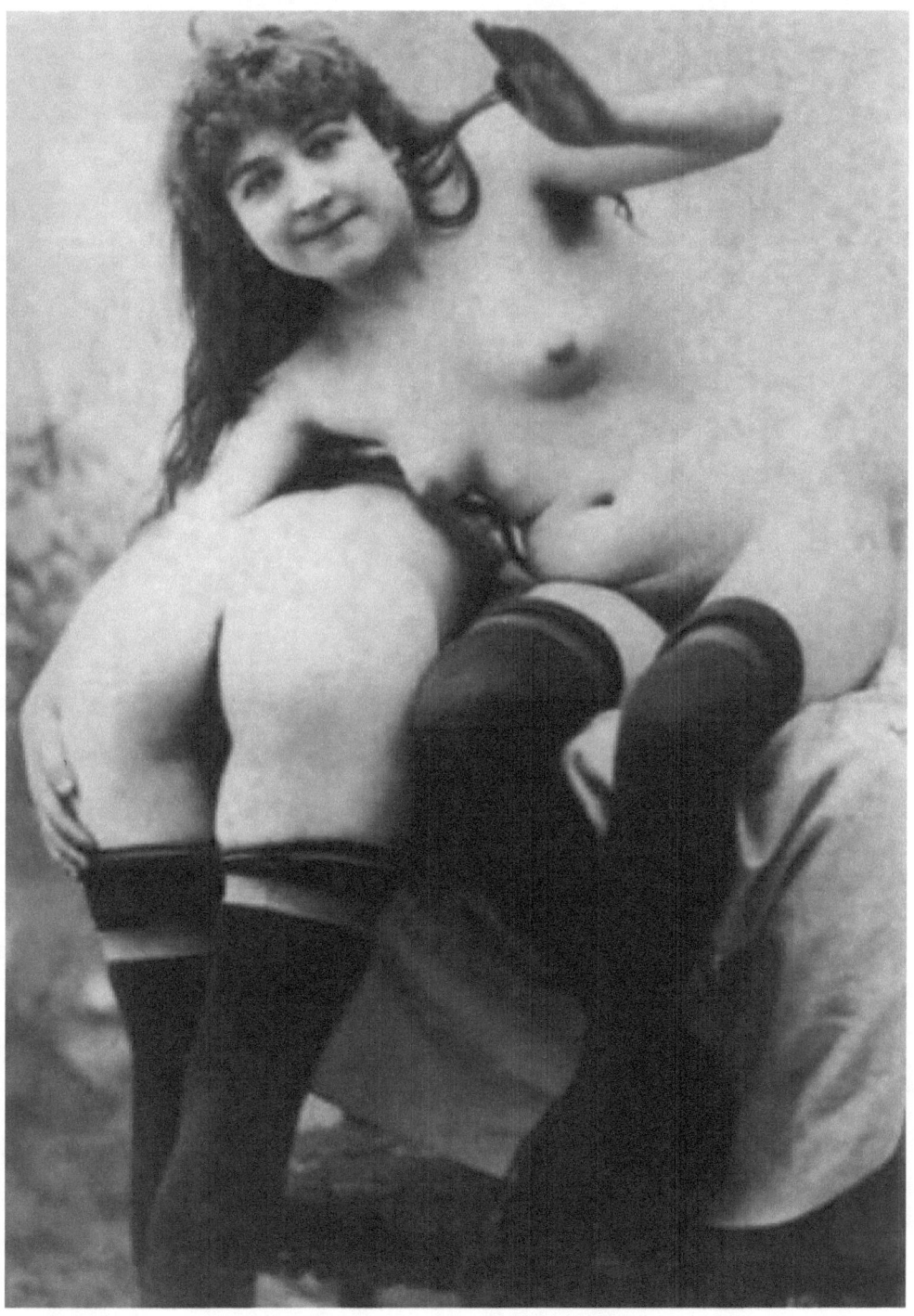

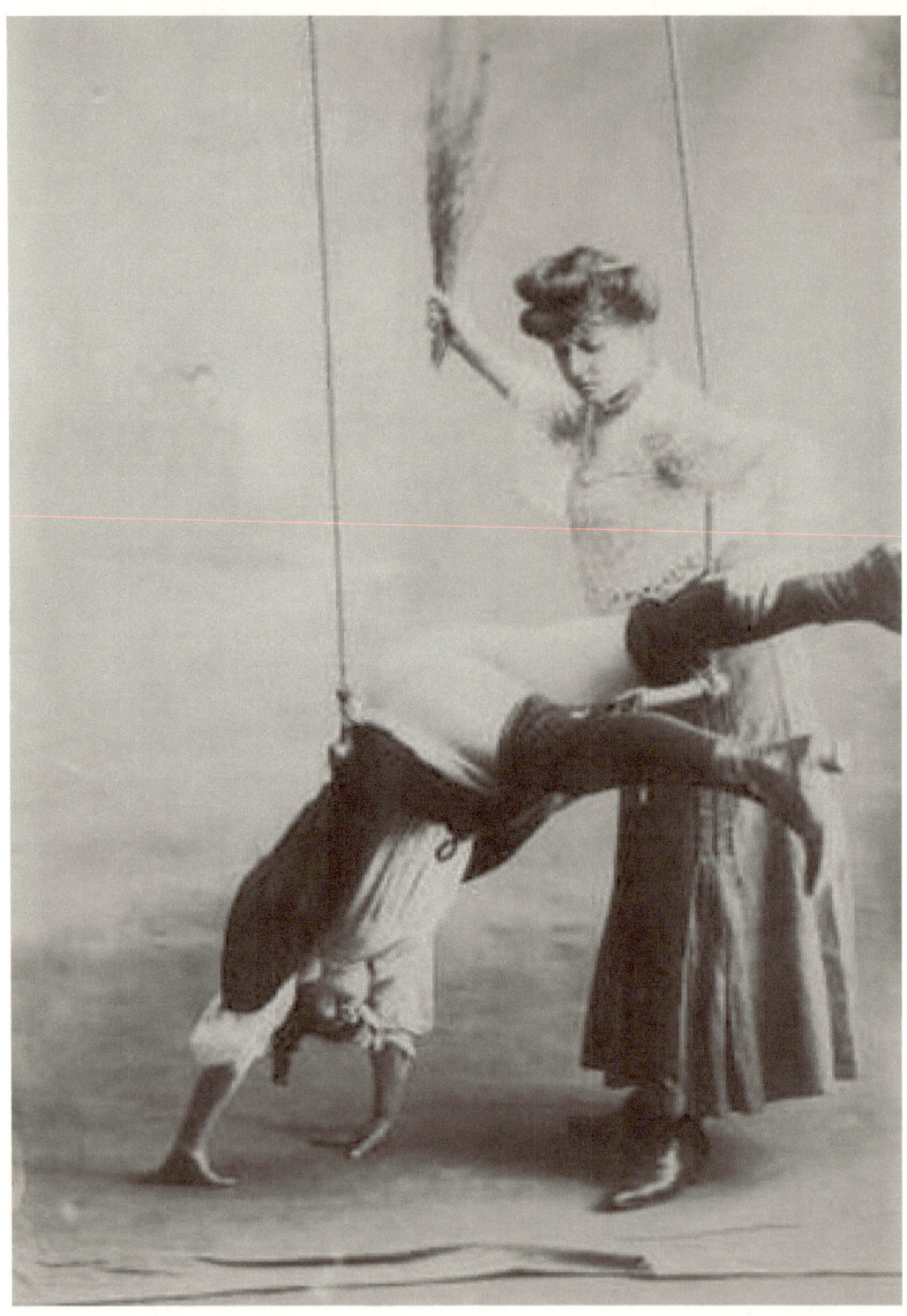

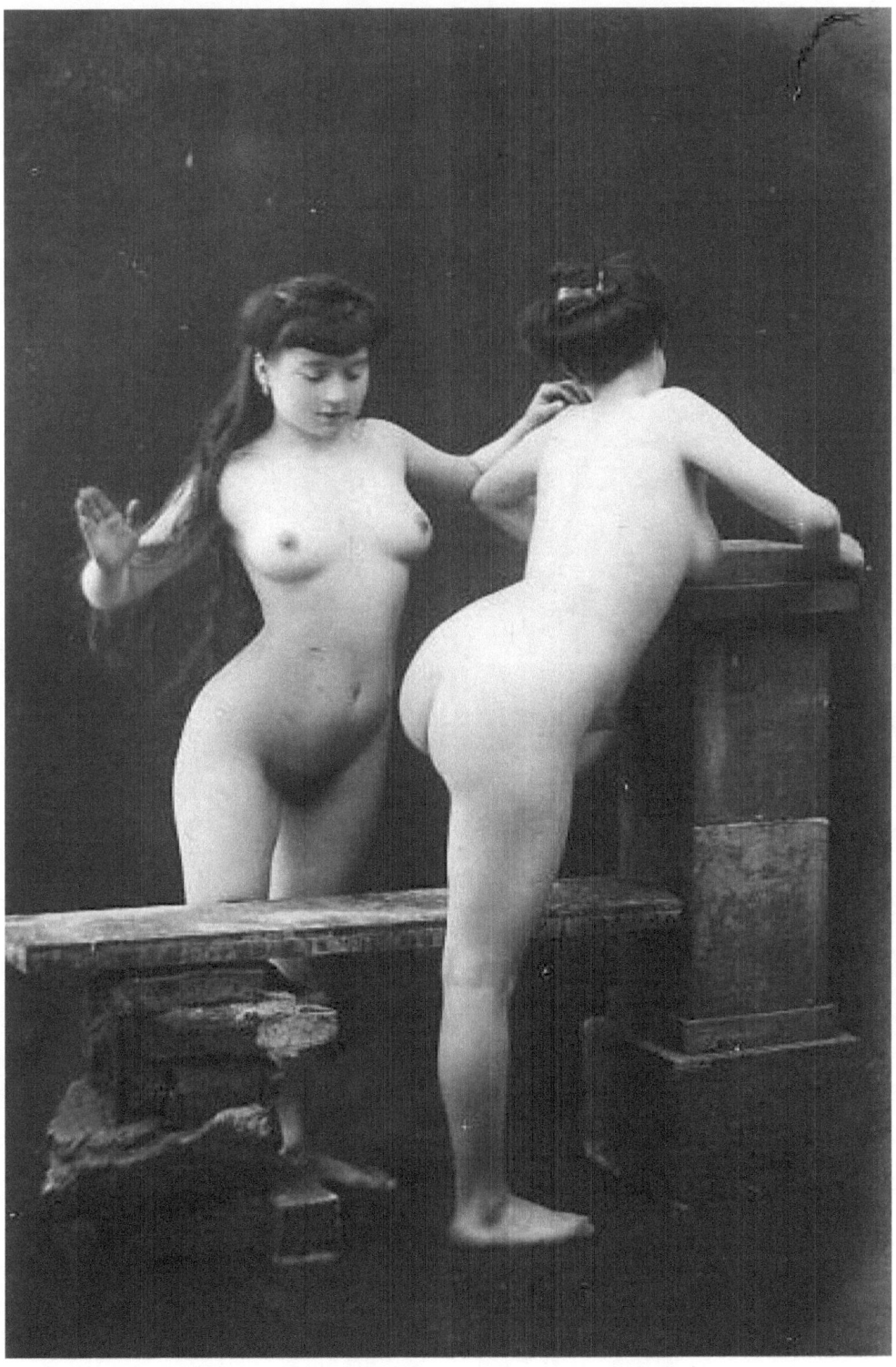

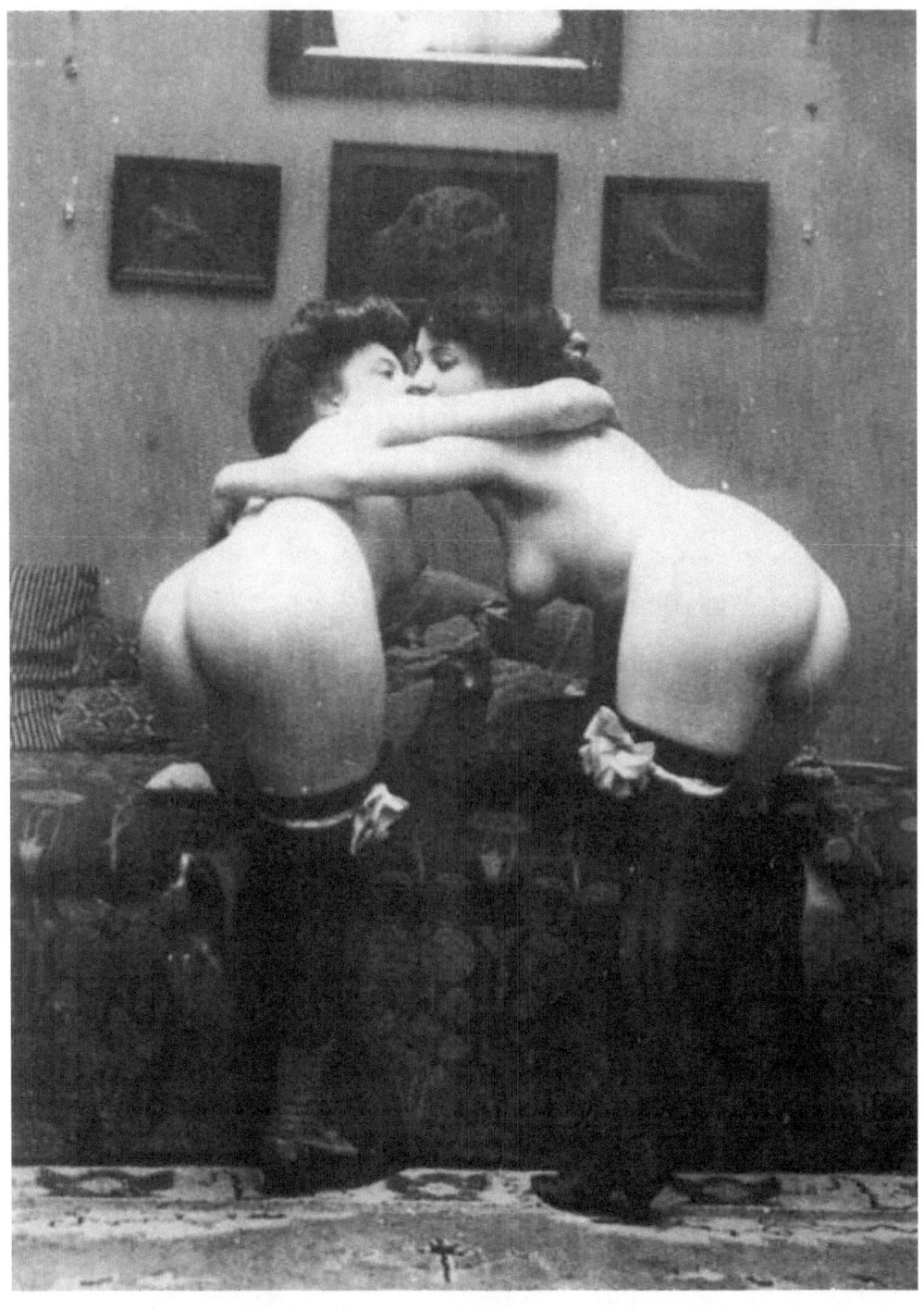

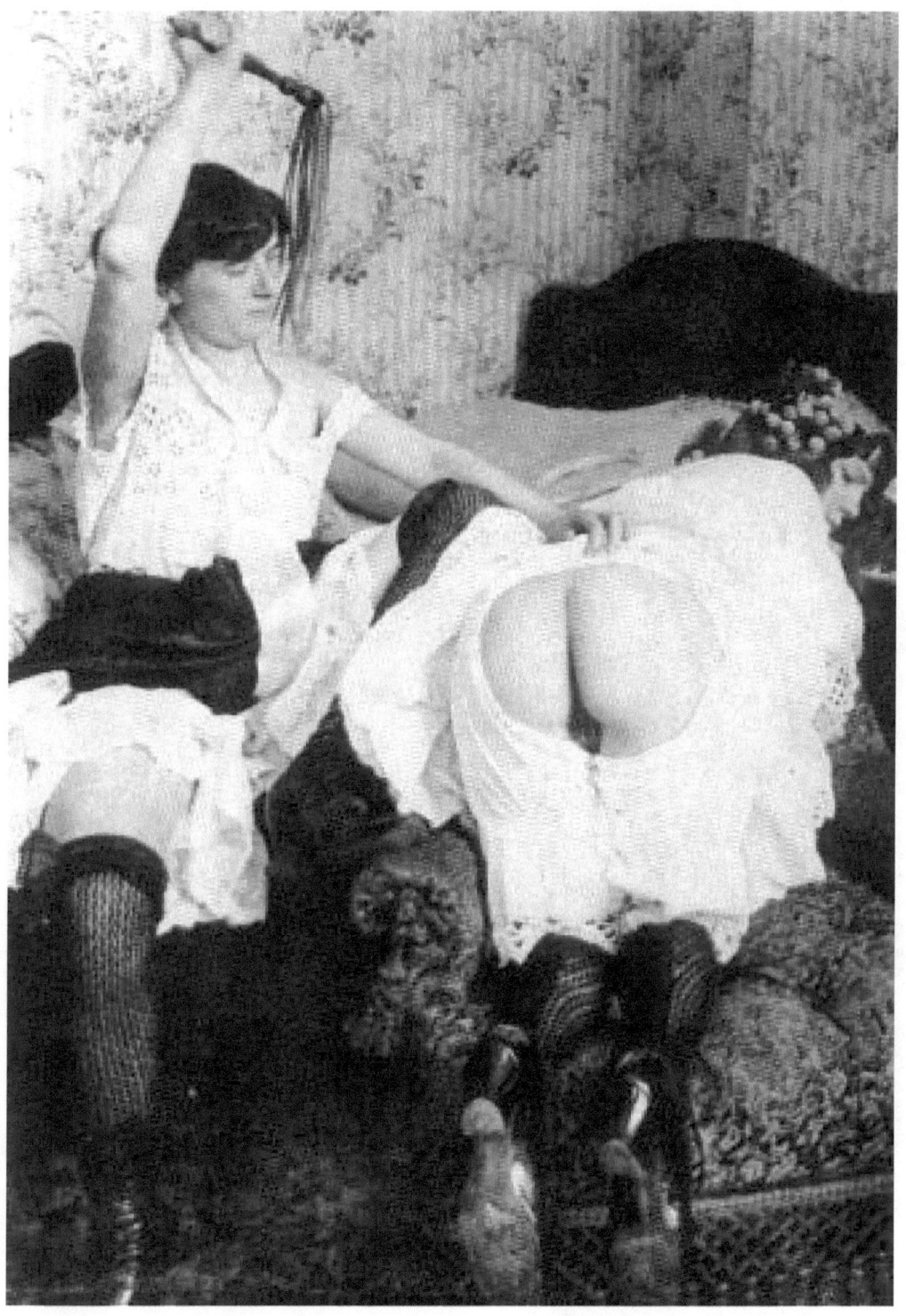

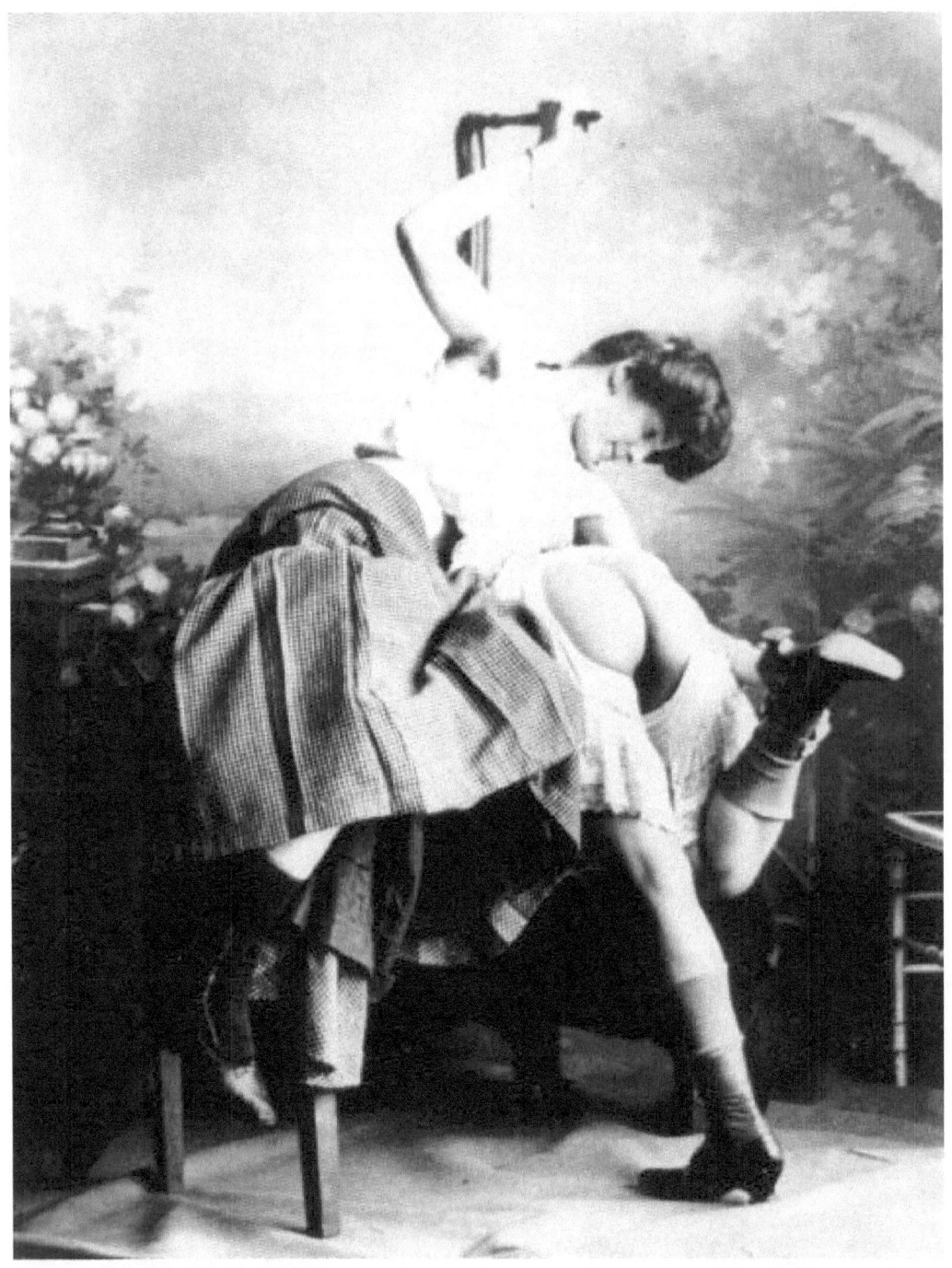

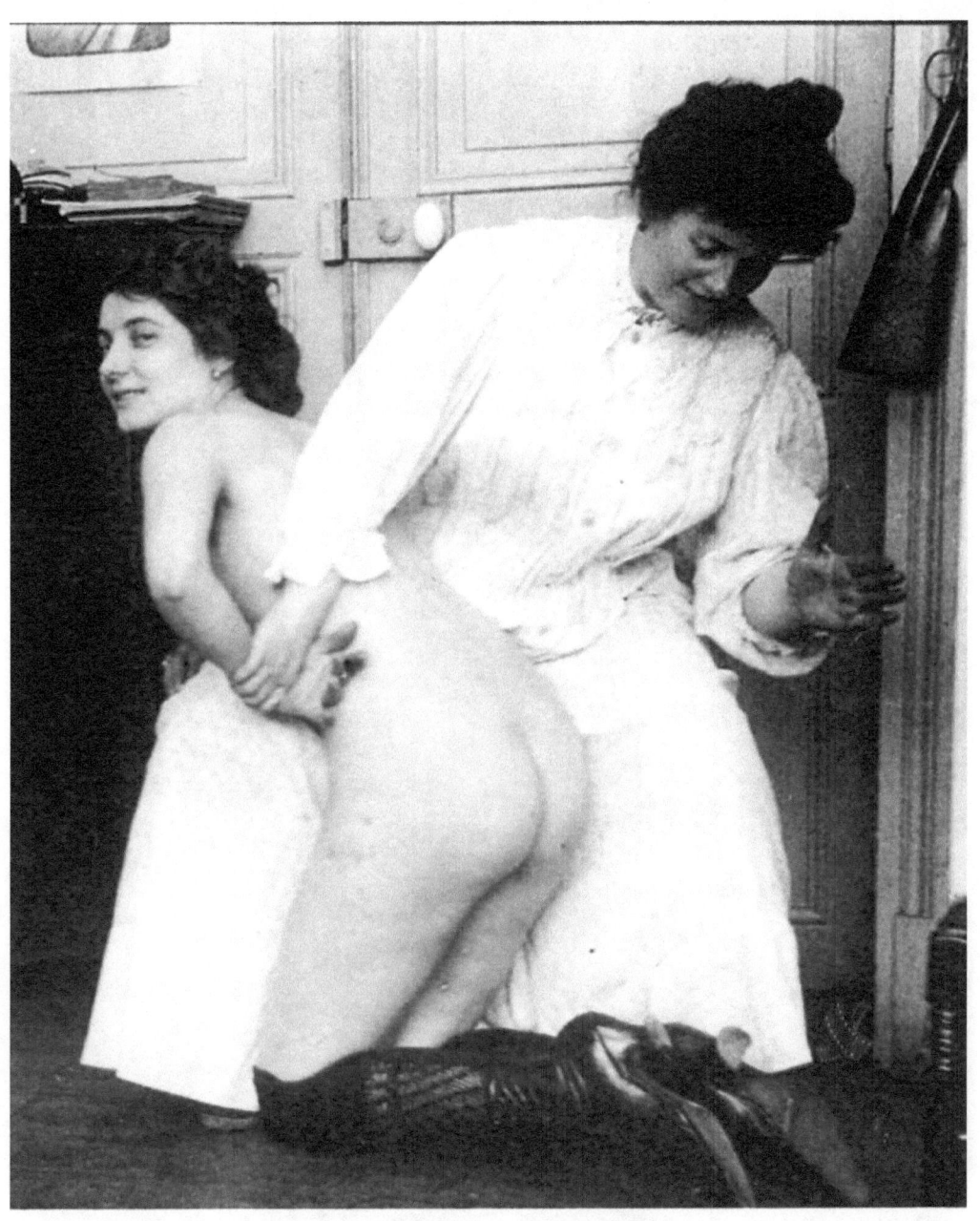

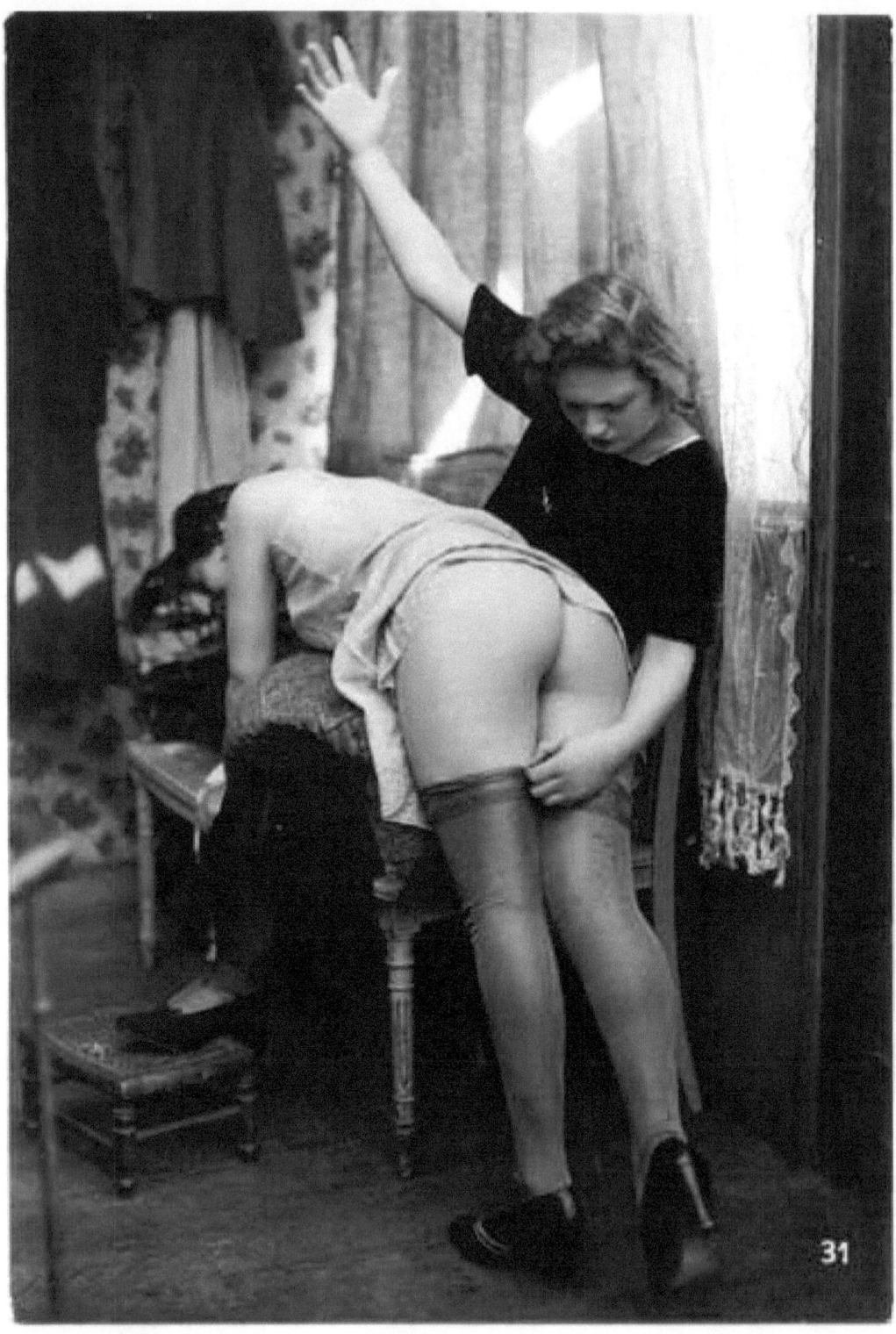

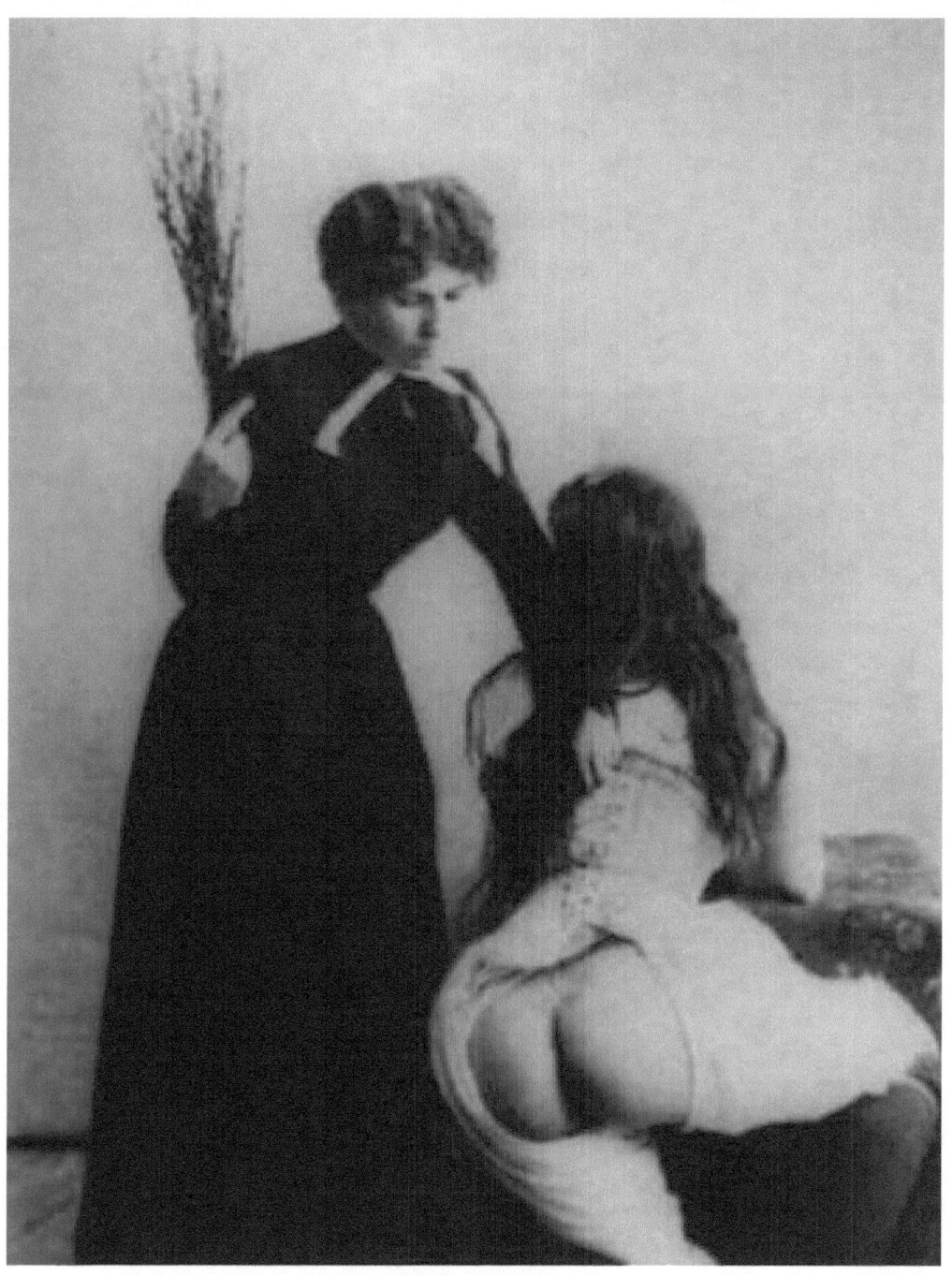

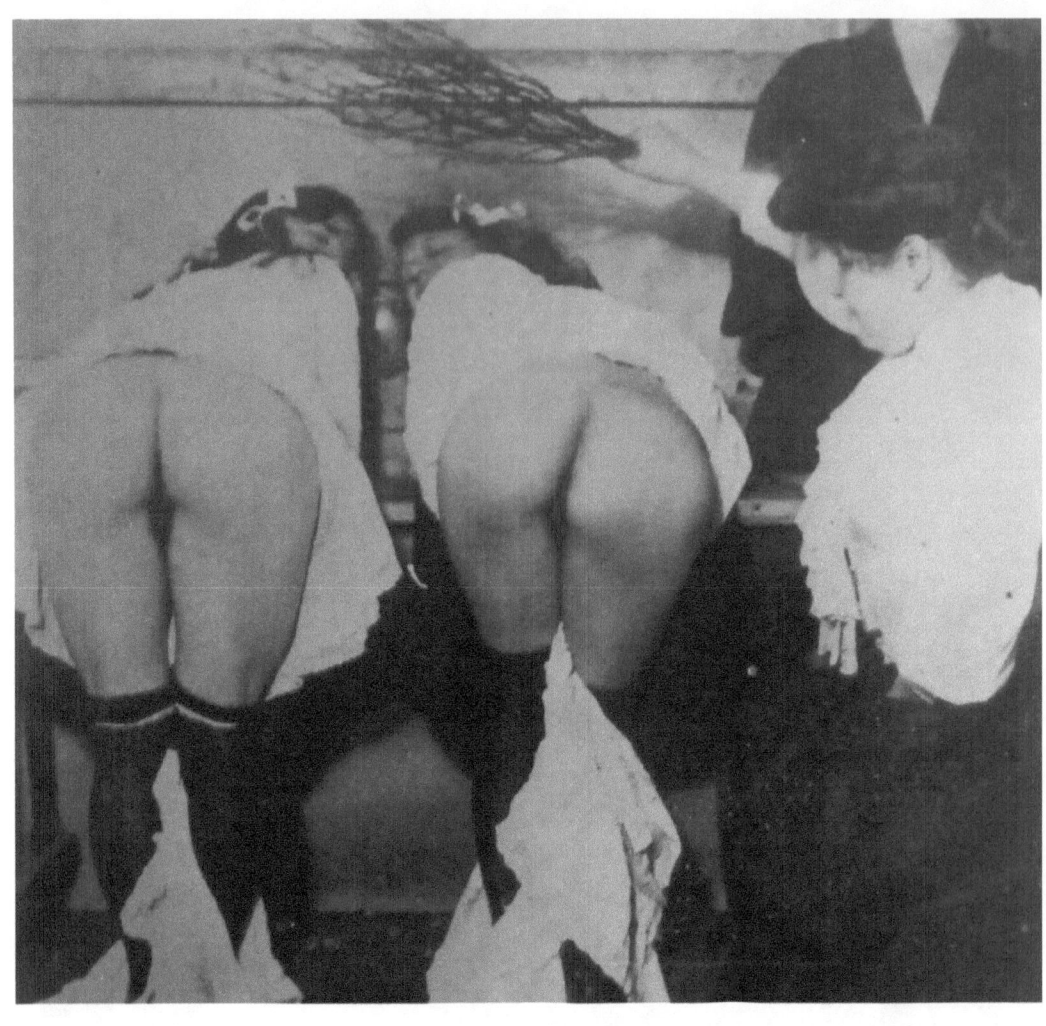

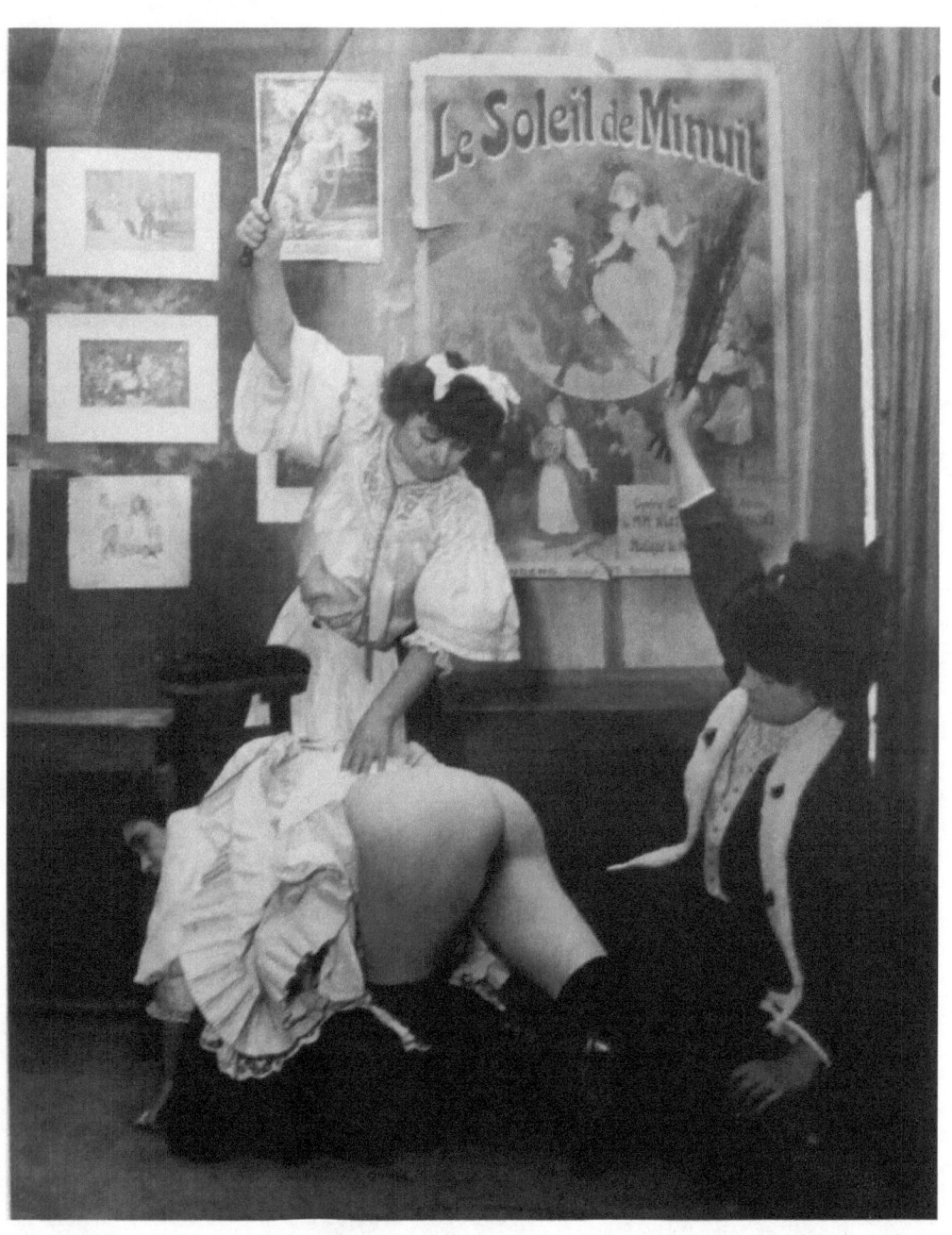

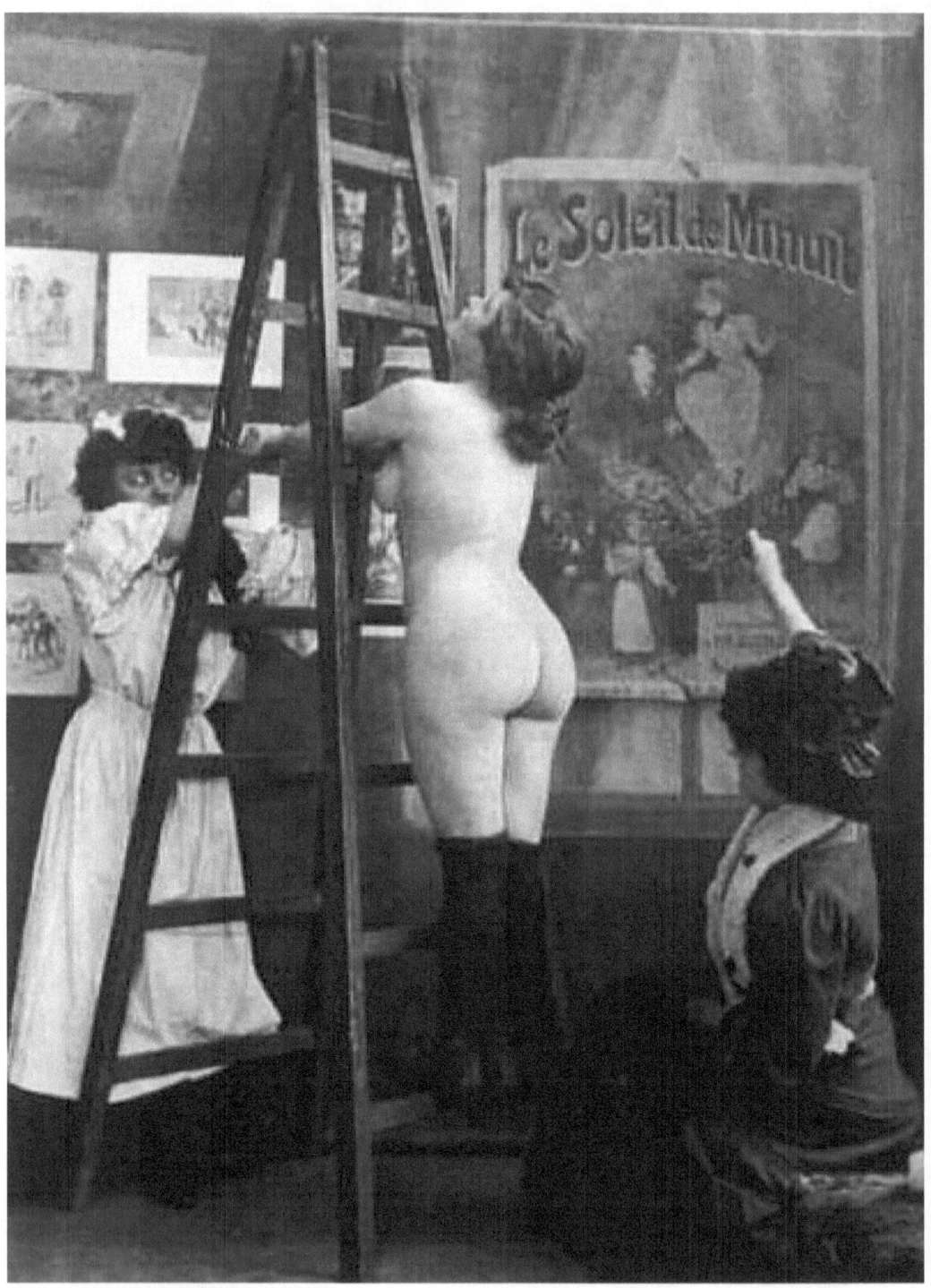

The following four pictures are a little bit newer. But not really new, if you know, what I mean.

They date from the times of the 1930ies to the 1960ies...

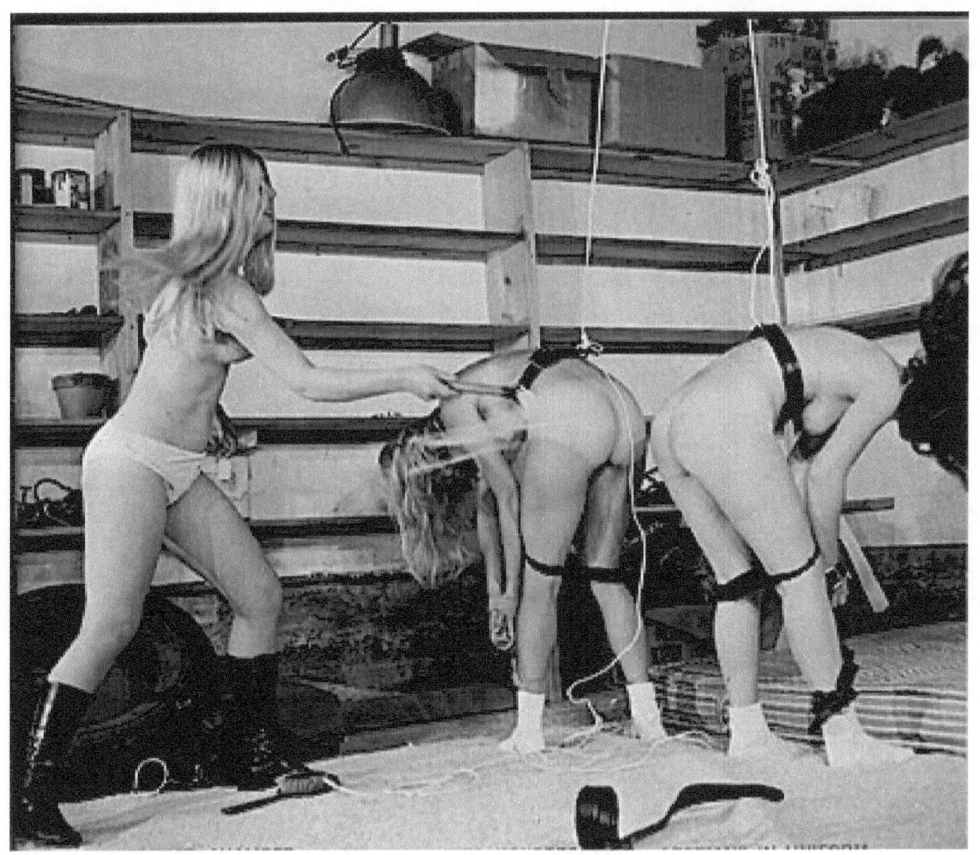

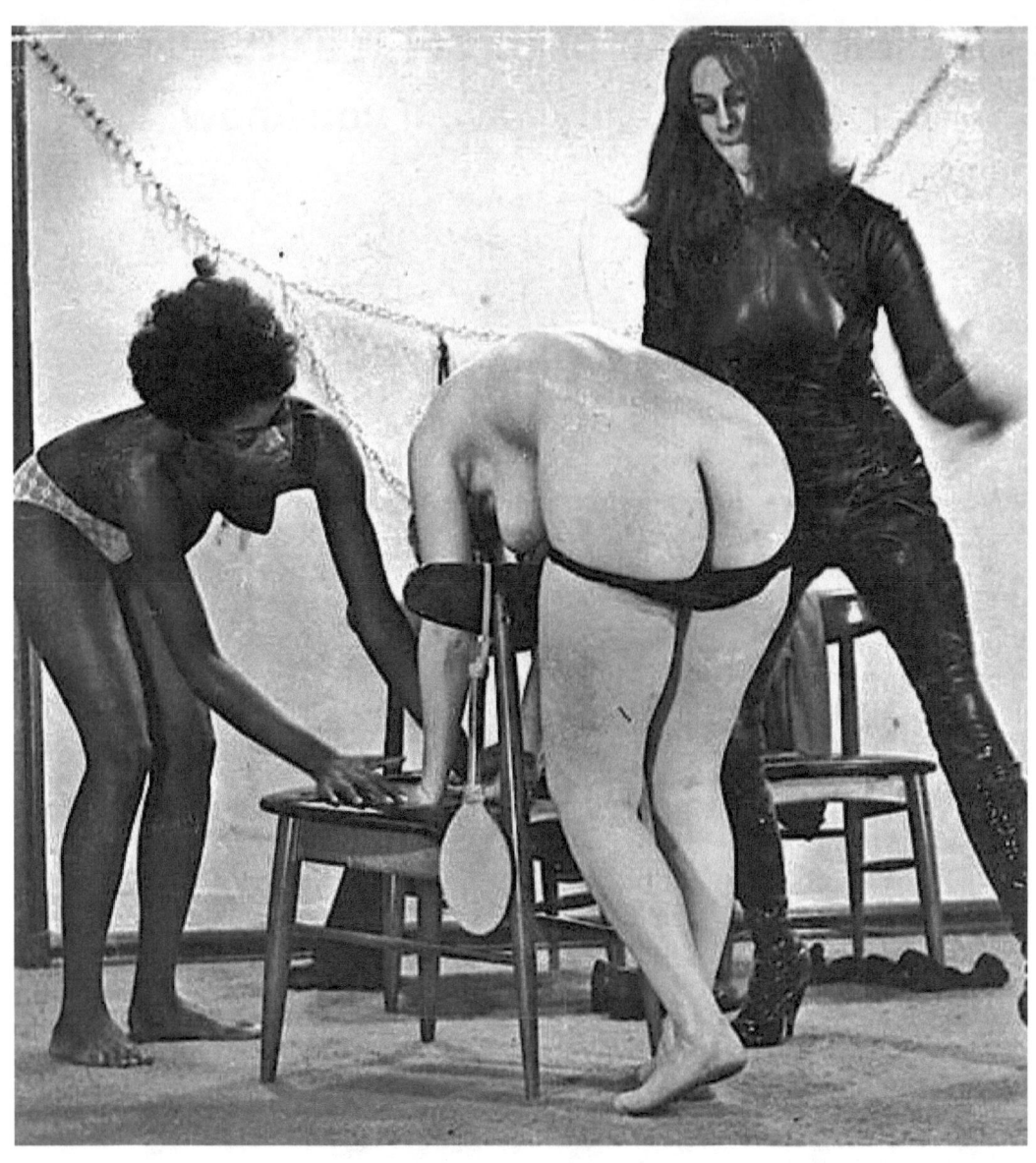

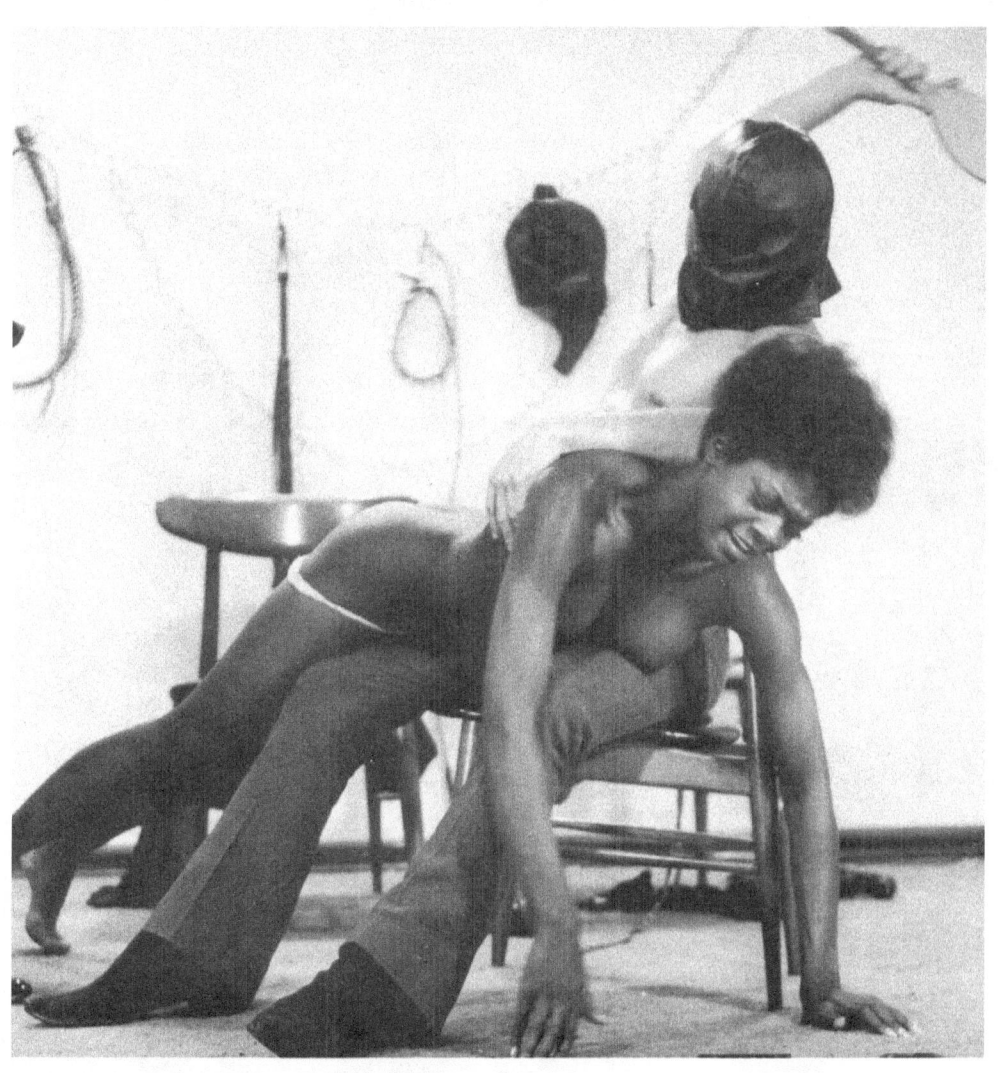

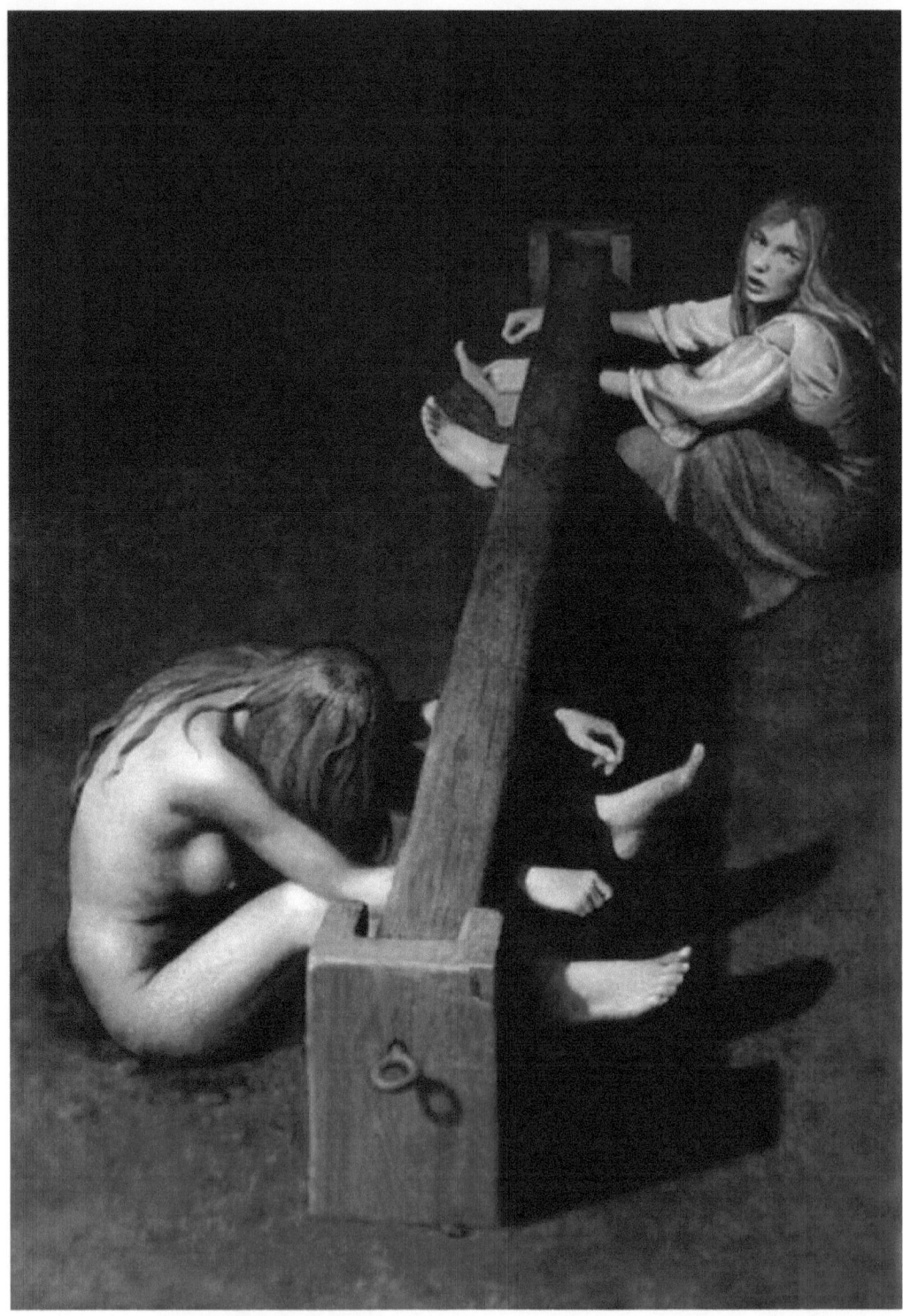

www.ingramcontent.com/pod-product-compliance
Lightning Source LLC
Chambersburg PA
CBHW030810180526
45163CB00003B/1213